D0896132

A GUIDE FOR PROFESSIONAL DIGITAL PHOTOGRAPHERS

Wedding Photojournalism

THE BUSINESS OF AESTHETICS

WITHDRAWN
FROM THE RECORDS OF THE
MID-CONTINENT PUBLIC LIBRARY

Paul D. Van Hoy II

AMHERST MEDIA, INC. ■ BUFFALO, NY

Mid-Continent Public Library
15616 East Highway 24
Independence, MO 64050

DEDICATION

To my two dearest friends, Jason and Jordan, who have always generously provided me with their abundant love, support, and encouragement. You are my brothers for life.

A very special thanks to my close friends and colleagues Walter Mladina, Alex Miokovic, Angela Carter, Gwen Anderson, Susanne Knowlton, and Brady Dillsworth. Thank you all for your wisdom, advice, insights, and all the confidence you've placed in me throughout the years.

Last but not least, I'd like to thank my lovely kitty cat Indy who kept my lap warm through many long, arduous hours of editing photos and writing this book.

Copyright © 2011 by Paul D. Van Hoy II.
All photographs by the author unless otherwise noted.
All rights reserved.

Published by:
Amherst Media, Inc.
P.O. Box 586
Buffalo, N.Y. 14226
Fax: 716-874-4508
www.AmherstMedia.com

Publisher: Craig Alesse
Senior Editor/Production Manager: Michelle Perkins
Assistant Editor: Barbara A. Lynch-Johnt
Editorial assistance provided by Chris Gallant, Sally Jarzab, and John S. Loder

ISBN-13: 978-1-60895-294-6
Library of Congress Control Number: 2010940513

Printed in Korea.
10 9 8 7 6 5 4 3 2 1

No part of this publication may be reproduced, stored, or transmitted in any form or by any means, electronic, mechanical, photocopied, recorded or otherwise, without prior written consent from the publisher.

Notice of Disclaimer: The information contained in this book is based on the author's experience and opinions. The author and publisher will not be held liable for the use or misuse of the information in this book.

Check out Amherst Media's blogs at: http://portrait-photographer.blogspot.com/
http://weddingphotographer-amherstmedia.blogspot.com/

TABLE OF CONTENTS

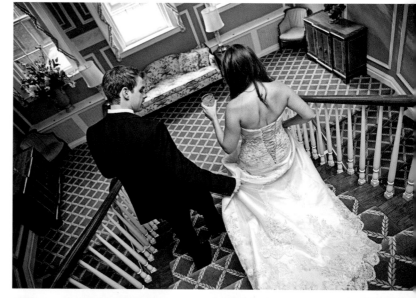

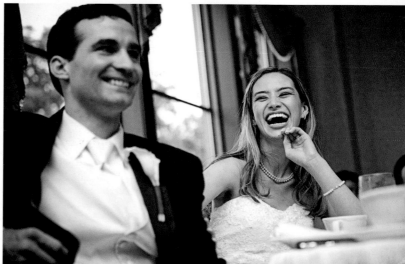

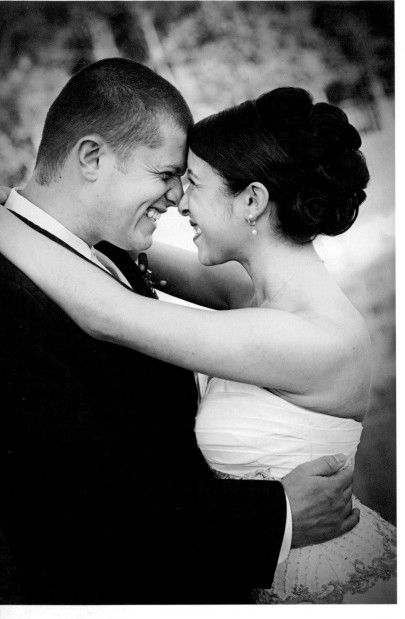

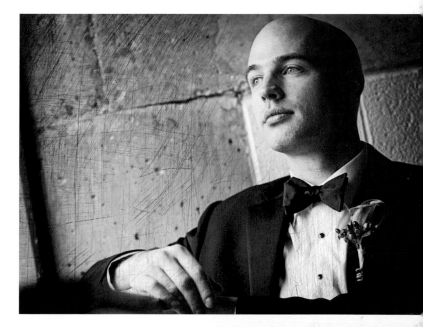

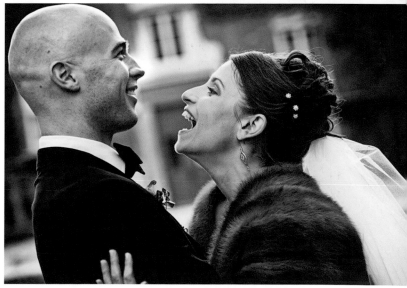

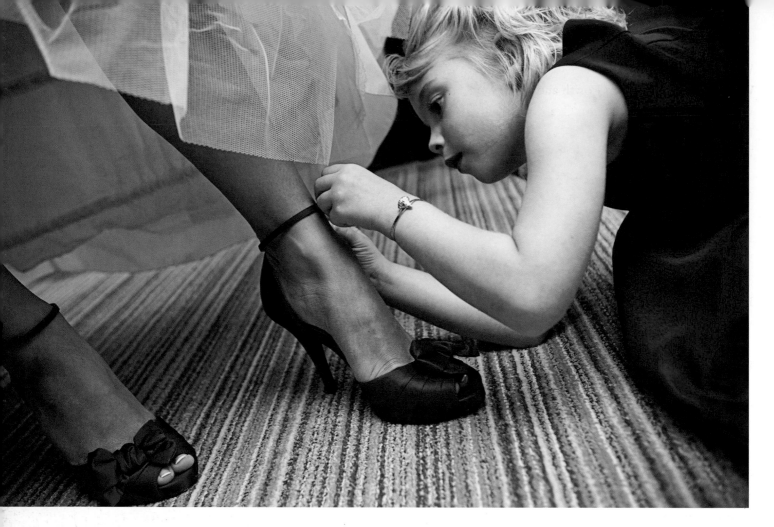

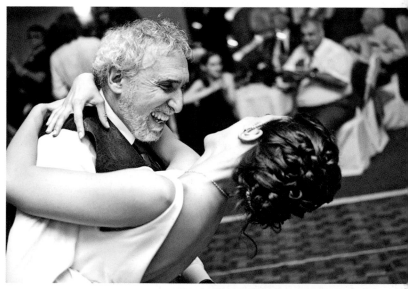

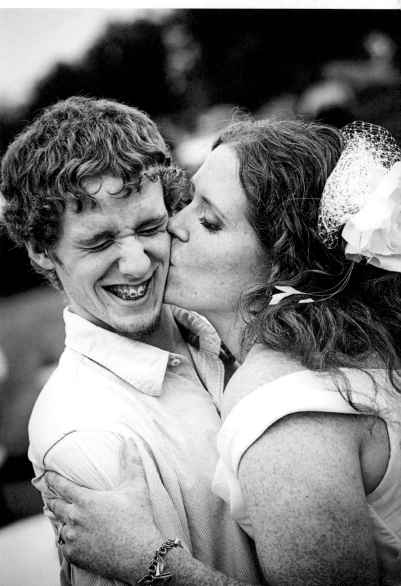

ABOUT THE AUTHOR

Paul D. Van Hoy II began his business at the age of sixteen in his Midwestern hometown of Evansville, IN. A native Hoosier, Van Hoy relocated his business to Western New York in 2005, after being accepted into the prestigious graduate program at the Rochester Institute of Technology, where, in 2007, he earned his MFA in Fine Art Photography.

In the same year, Van Hoy received worldwide recognition as Microsoft's "Photographer of the Year." Twelve months later, in 2008, *Creative Quarterly* magazine awarded him the accolade of "Photographer of The Year."

Van Hoy's award-winning wedding photojournalism has been featured in popular magazines such as *Brides and Bridal, Wedding Style, InStyle Wedding, Modern Bride,* and *Martha Stewart Weddings.* His poignant and compelling fine-art photography has appeared in publications such as *PDN, Digital Photo Pro, AfterCapture, Professional Photographer, CMYK, Camera Arts,* and *Communication Arts.* Some of his former and current clients include *Forbes, Health and Wellness, Men's Health, Food & Wine, Better Homes and Gardens, Country Living,* Adidas, Barilla, DKNY, Jones New York, and Fossil Inc.

Presently, Van Hoy resides in Rochester, NY, where his destination wedding photography business, Fotoimpressions, is based. He documents approximately thirty to forty weddings annually, working throughout the U.S., and shoots editorial, documentary, stock, and travel photography during his off-season. AGE Fotostock in Barcelona, Spain, currently represents Van Hoy's work.

A NOTE FROM THE AUTHOR

Coupled with my desire to teach others how to succeed as professional wedding photojournalists and to advance their artistry, one of the most compelling reasons why I've written this book is to reveal what has been understated and omitted by so many previously written texts on the topic of professional wedding photography.

I'm not alluding to conspiracies or classified information but to the topic of business strategy for professional wedding photographers, which is largely overlooked in most publications for the industry. As an artist and entrepreneur who braved shark-infested waters and began his business at the age of sixteen, I will not only share the principles of image-making and business practices, but also the headaches and heartbreaks that can clutter and inconvenience the road to achieving success within this profession.

By writing this book, I seek to provide aspiring and experienced professionals with a relevant and resourceful text that speaks directly to their passions, interests, and experiences. Above all, I hope to guide and encourage others who possess a similarly ambitious and entrepreneurial spirit to achieve their goals of becoming professional wedding photojournalists.

I seek to provide aspiring and experienced professionals with a relevant and resourceful text . . .

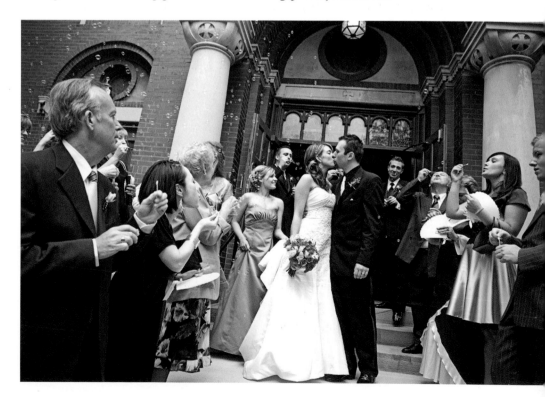

1. HISTORY AND PHILOSOPHY

Before we get into the nuts and bolts of devising a business plan for your emerging or existing wedding photography business, I'd like to briefly discuss wedding photojournalism. In order to define this term, I believe that we must first examine the inception, agenda, canons, and aesthetics of classic photojournalism.

A BRIEF HISTORY OF PHOTOJOURNALISM

If we accept that all images serve a purpose, significant or not, to document or provide some semblance of a story, then photojournalism actually began with the very first fixed images—with the advent of the daguerreotype by Louis Jacques Daguerre, circa 1836.

The demand for lighter, more portable cameras was necessitated by the rise of media and the growing public demand for war reportage. So, in 1925, the German camera manufacturer Leica issued the Leica I, the world's very first

The rise of more portable gear was a critical factor in the rise of wedding photojournalism.

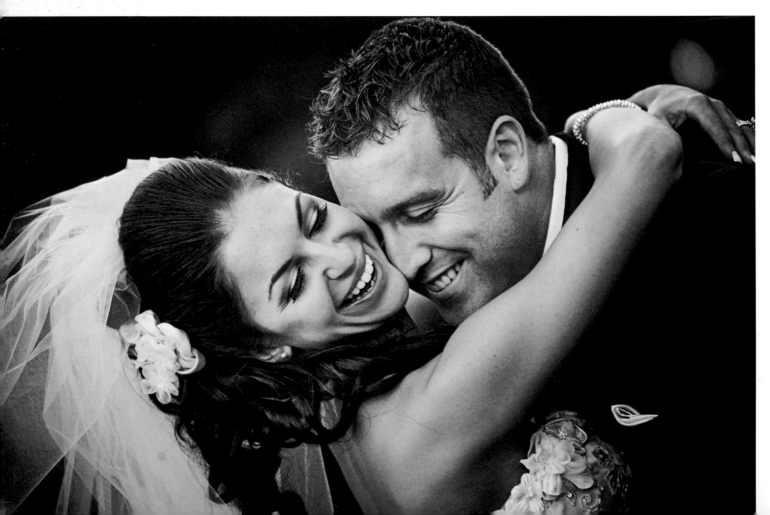

practical 35mm rangefinder camera. This technological breakthrough enabled photojournalists to advance from the fringes of war to the front line. No longer was the photographer restricted by cumbersome equipment and long exposure requirements. He or she could instantaneously record events while they occurred, capturing the action itself rather than war's aftermath.

The 35mm camera quickly became the industry standard, a mainstay among photojournalists and news correspondents. For the masses, it became the coveted and customary method used to document families and events. Even traditional wedding photographers reluctantly began to retire their beloved medium-format Hasselblads and employ the 35mm in response to the rising demand for documentary wedding photography. For that revolution, we have wedding photojournalists such as Denis Reggie to thank. By challenging the long-standing conventions of traditional wedding photography they broke ground on a new and exciting frontier where many of you are (or will be) building your lives and livelihoods.

THE PHILOSOPHIES BEHIND PHOTOJOURNALISM

In all disciplines of art, there exist conflicting (and subsequently segregated) schools of thought—binding principles that establish one as a member of this group or that. Within the field of photography, photojournalism is a categorization fraught with controversy; one is either loyal and abiding or alien and excluded. It is a discipline of photography governed by strict rules, codes, and ethics.

Entering the discipline of photojournalism is a process of indoctrination. The photojournalist, if formally educated, is taught to believe that news can be reported without bias; objectivity and detachment are the photojournalist's core values. Subjectivity is entirely antithetical to the aims of the photojournalist; for the photojournalist, news is not subjective—nor should it be. Those who are fundamentalists and purists vehemently believe that a single photograph or series of photographs can represent the objective and unadulterated truth.

Photography possesses an inherent evidential quality that, for many, can substantiate the truth—or, rather, is tantamount to truth. No other medium possesses such

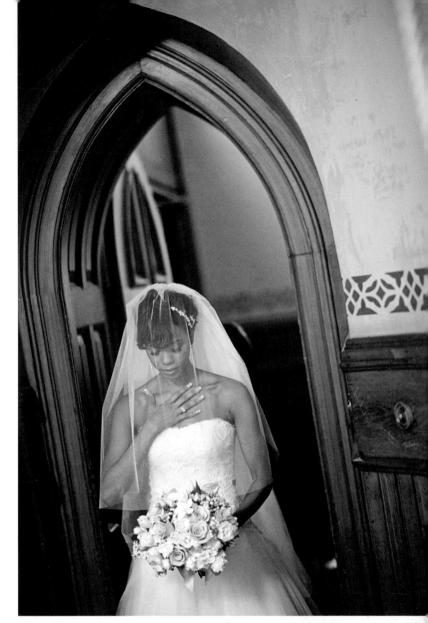

Pioneers who challenged the conventions of traditional wedding photography opened up a new frontier on which many of us have built our livelihoods.

accuracy and descriptiveness, or shares such closeness with the concept of impartiality. However, if you own a digital camera, have manipulated an image in Photoshop, or have ever thumbed through the pages of a fashion magazine, you know that photographs can easily misrepresent and deceive.

Although many still hold firmly to the ideologies that define the photojournalistic image as authentic and unlike any other form of photography, I think it important for artists to question their beliefs with regard to their medium. For example, if the objective of photojournalism is to tell the absolute "truth," then why do we make im-

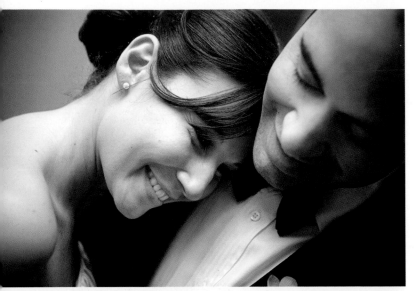

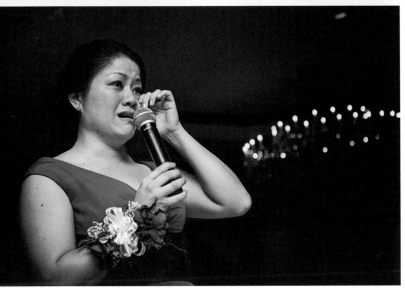

The advent of digital photography has freed wedding photojournalists to shoot more creatively and artistically—without the need to consider the per-frame cost, as with film.

ages with cameras that observe and record monocularly? Unless you're a Cyclops, don't most of us see the world with two eyes? Should we stop shooting monochromatic film—unless our readership is predominantly color blind? Should we abandon our wide-angle and telephoto lenses in favor of 60mm lenses—the focal length that most closely resembles the human perspective?

The list could go on and on, but you get the point. As wedding photojournalists, we must have awareness of and respect for the philosophies upon which photojournalism was founded, but we must also be critical of our own beliefs and not let the "codes" and ethics of a discipline—one with an altogether different agenda—stifle our creative vision and unique perspectives. Like the photojournalist, we have a story to tell; unlike the photojournalist, we also have a story to sell.

THE IMPACT OF DIGITAL ON WEDDING PHOTOGRAPHY

The inception of digital photography incited a virtual renaissance within the wedding photography industry. Prior to the digital age, each and every frame of film had to be accounted for. As a result, wedding photographers were tethered to shot lists that might include as many as a hundred different posed shots (depending on the permutations of the groupings). For the film wedding photographer, shooting a "candid" portrait meant having the subjects within a composed scene look away from the camera.

Digital photography, in no uncertain terms, emancipated wedding photographers from their former static role as mere technicians and production workers, allowing them to pursue more creative and artistic avenues. Suddenly, the rule book went out the window and our artistic license was reinstated. We went from shooting nouns to verbs, from making documents to creating works of art.

For most, the transition to digital was almost seamless. However, many of the die-hard traditionalists weren't so convinced or eager to embrace digital—and many who did, whether out of habit or protest, remained loyal to their formal philosophies and approaches to wedding photography . . . but not without consequence. I can recall, in my own hometown, the slow, steady disappearance of long-established portrait studios whose primary enterprise was wedding photography. One by one, they would replace their easels and framed storefront photographs with for-sale signs, until Sears and Walmart were the only "studios" that remained.

The public's interest also began to shift as digital photography gave rise to a new aesthetic called "wedding photojournalism," where the grit and grain of unscripted life suddenly became glamorous. Within wedding photography, no longer were formal, posed, evenly lit, soft-focused, and star-filtered images all the rage. Digital tech-

nology enabled wedding photographers to move up to the front line—to work in tight, confined, poorly lit spaces, and capture candid moments of raw emotion and real life.

For the very first time, brides and grooms were seeing themselves in ways they had never previously been represented in photographs. Sure, anyone who had leafed through the pages of *Time, Life,* or *National Geographic* was familiar with captured moments of raw and compelling human emotion. But, for the first time, *wedding photography* was revealing something more than just presences; it was revealing the very essence and humanity of its subjects.

This is not to suggest that the aesthetics of wedding photojournalism are owed entirely to digital photography; that would be untrue. Even today, there are those rare and marginal few who exclusively shoot film or implement film in their process—and I applaud them. However, for the majority, we have severed our relationship with film and bid adieu to the nostalgia of an era that has ended. It's even safe to say that many who are reading this have never exposed an image on film or dipped their hand into a tray of developer.

THE DIGITAL REVOLUTION

Digital photography is an incredibly powerful creative tool. It allows us instant feedback and the ability to see the results of our choices in real time. With film, the only comparable situation was with the use of Polaroid backs—but then there was the exorbitant expense of materials and wait time required for development.

As a film-based wedding photographer, I would make approximately 300–400 photographs per wedding event. Half of those images were duplicates that had been bracketed for exposure or were lost due to blinking or a distracted subject. Today, I make approximately 2000–2500 image captures throughout the course of a wedding event, which usually ranges from ten to fourteen hours. When shooting with film, I would pass up numerous photo opportunities because I was always painfully aware of how many frames I had

Digital technology enabled wedding photographers to move up to the front line

Wedding photojournalism reveals something more than just presences; it reveals the very essence and humanity of its subjects.

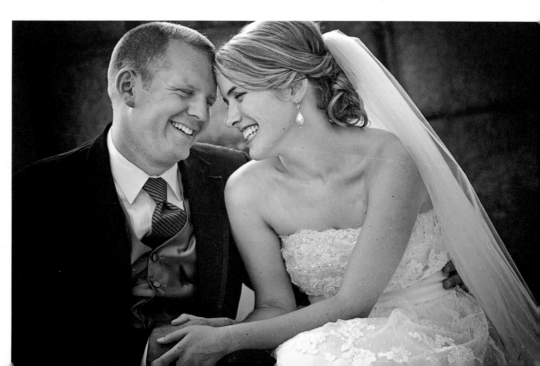

remaining. Quite simply, photographing moments that weren't predetermined or "set up," entailed huge risks. Since I couldn't just delete an unwanted or poorly exposed image, I literally paid for every image I made.

Accordingly, spontaneity and improvisation are two of the most valuable tools that digital photography has accorded to me. I am able to work intuitively and impulsively; if I see a subject or scene that holds even the slightest interest for me, there is never hesitation on my part. The only risk these days is not going with your gut and not taking the shot.

The quickness and responsiveness of today's professional digital single reflex cameras (DSLRs) also allow me to make critical adjustments on the fly. I can immediately review my work, or dial in my desired ISO and adapt to any lighting situation. And with the copious storage space and impressively fast write speeds of today's memory cards, I can shoot an almost infinite stream of successive images. All of these factors combine to give me a confidence never before known. In fact, I attribute my most successful wedding images to the sense of sureness that digital photography has provided me.

DEBUNKING THE MYTH OF THE "DECISIVE MOMENT"
Among many of those outside of or new to the profession of wedding photojournalism, there is a tendency to revere the veteran wedding photojournalist as a visionary—a clairvoyant of sorts, endowed with the gift of precognition. Continually, the photographs and philosophies of Henri Cartier-Bresson are conjured to substantiate such claims and to perpetuate what I refer to as the myth of the "decisive moment." Poor translations, and a general tendency to exaggerate and idealize the artistic processes of influential artists, have resulted in misinterpretations of this concept.

Considered a forefather and pioneer of photojournalism, Henri Cartier-Bresson's "decisive moments" exist not only as poignant reflections of the human condition, but as icons of evanescence. Bresson's gift was one of astute observation and awareness; he possessed not only a keen and discerning eye for subject matter and composition, but also an ability to discern the very moment when (in his words) the eye, mind, and heart came into alignment. Bresson recognized and defined this elusive occasion as the "decisive moment."

Aspiring photojournalists and admirers of Cartier-Bresson's work have exalted the significance of this "decisive moment" beyond its original and intended meaning. As a result, many students—and even colleagues—have intimated to me that a *truly* talented wedding photojournalist needs only to shoot or expose a handful of frames for each image they exhibit or place into their portfolio. They assert that the "true" wedding photojournalist can predict and anticipate a photo-worthy moment before it transpires. When I ask about the basis of this belief, the citation is always the same: Henri Cartier-Bresson's "decisive moment."

For Bresson, the decisive moment was about recognition, not precognition. In a 2001 interview, featured in the film *L'Amour Tour Court,* Bresson admitted to missing numerous photo opportunities because he was unprepared or simply unlucky. In Cartier-Bresson's words:

> My passion has never been for photography in itself, but for the possibility—through forgetting yourself, of recording in a fraction of second the emotion of a subject, and the beauty of the form. You see . . . you feel, and the surprised eye responds. Taking pictures means holding your breath with all your faculties concentrated on capturing a fleeting reality. You either get it or you don't.

For me, artistic intuition is an intricate and enigmatic science—something that does not come with experience or scholarship. I believe it to be inborn; you simply have it or you don't. Aesthetics and formalism can be learned by anyone; intuition, when it comes to photography, is an art unto itself. It's a sense you acquire from a life spent looking—because, even though it might be painful or inconvenient, you simply cannot stop. It's an innate preoccupation and obsession with the visual.

Though wedding photojournalists may not possess psychic powers, they can channel their intuition, utilizing

Sometimes, the apprehension

of the decisive moment

occurs post-capture . . .

what they have learned through the process of observation and discernment to give them an advantage—an awareness signaling the approach of a decisive moment. Hopefully, at that instant, they will also have their camera at eye level and their finger on the shutter release. The rest is history.

It must also be said that some decisive moments escape us . . . literally—as in, we miss the shot. Others, however, are not discovered until the editing process commences. Sometimes, the apprehension of the decisive moment occurs post-capture as part of a process of recovery and retrieval during which you pluck a single image from a batch of hundreds (and, in some cases, thousands) of photographs. In fact, my advice is not to worry over the decisive moment; shoot excessively, then select the best moment from the collection.

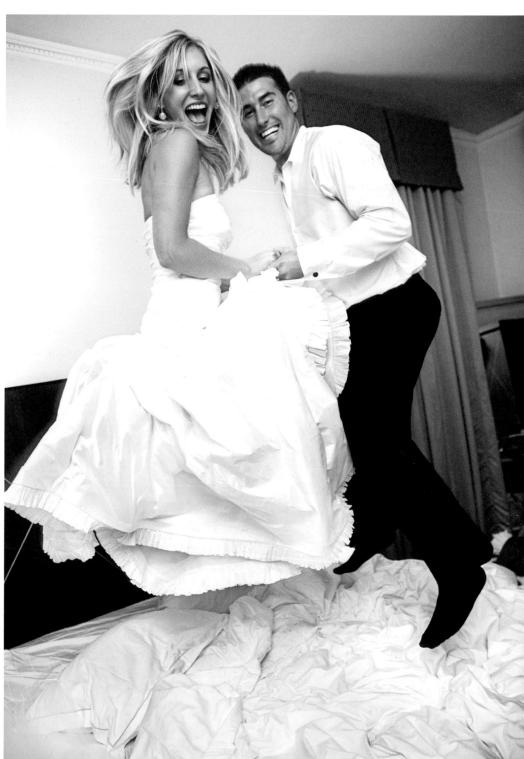

Though wedding photojournalists may not possess psychic powers, they can use their intuition, powers of observation, and discernment to give them an advantage.

2. GETTING REAL ABOUT WEDDING PHOTOJOURNALISM

I started shooting weddings almost fifteen years ago, beginning my business at the age of sixteen. Since then, I have photographed approximately 500 weddings (and after this year, that number will be closer to 550). This experience has taught me that wedding photojournalism is a career that can offer tremendous reward, but that it also entails significant challenges.

STRESS

I can tell you that being a wedding photojournalist is, first and foremost, a highly stressful career. You will be tested—mentally, physically, and emotionally. You will be pushed to your limits as an artist and as a professional. At the end of each wedding, I go home feeling beat-up and defeated—feeling like I missed all the great moments. Self-flagellation is very common among wedding photojournalists; most of us spend more time criticizing ourselves and pushing toward improvement than congratulating ourselves and finding contentment in the status quo.

AVOIDING COMPLACENCY

Complacency can kill your career in any creative field. In wedding photography, it's imperative to keep one eye level with the viewfinder and the other eye fixed on the horizon of popular consumer trends. I can't stress how impor-

> You will be pushed to your limits as an artist and as a professional.

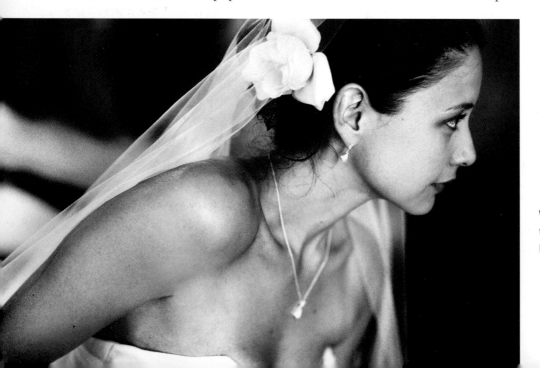

Wedding photojournalism is a career that can offer tremendous reward, but it also entails significant challenges.

tant it is to know your audience—this is fundamental for the wedding photojournalist. Alternatively, I would never advise against pushing the envelope or risking a new approach; there is much to be said for those brave enough to swim upstream. After all, it was a refusal to accept and perpetuate convention that led to the establishment and popularization of wedding photojournalism.

EMOTION

If you've ever attended or participated in a wedding, you know that they are a bit like controlled brush fires—and have the tendency to escalate into full-blown wildfires, complete with stampeding beasts and bewildered bystanders. From hung-over bridesmaids who miss their hair appointments to mismatched and poorly tailored tuxedos, from uninvited ex-amours to toppled and ruined cakes, weddings can be virtual cornucopias of chaos and pressure cookers of intense, pent-up emotion. Say "cheese!"

There's no question that weddings elicit raw emotion—after all, that's why we're there—but this is not always the case and can even prove to be the exception throughout the course of some wedding seasons. Not every wedding is a "good" wedding. Occasionally, colleagues and clients inquire to me about my "bad" weddings—and, to their surprise, it's not the rainy outdoor wedding, or the wedding where the rings were left behind at the hotel, or even the wedding where the limo delivered the bride to the wrong church. The "bad" weddings are the ones where the displays of emotion and affection are so scarce you begin to wonder if you're at a real-estate convention. I have literally had nightmares where I go flailing out of bed in a cold, panicked sweat, narrowly escaping the awkwardness of such weddings. As selective as I try to be about my clientele, you never know how interpersonal dynamics will play out until the actual day of the wedding.

Prospective clients searching on the Internet for wedding photojournalists arrive at my web site and see a portfolio filled with images of brides and grooms flirting and frolicking, friends and families swelling with tears and anticipation, guests toasting to happy and hopeful futures—page after page of compelling emotional crescendos that

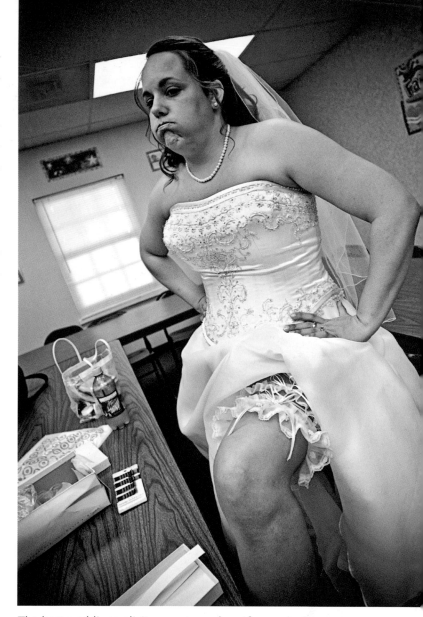

The best weddings elicit a great number of raw emotions.

win the hearts and favor of those seeking the same portrayal and commemoration for their weddings. However, a wedding photojournalist's presence doesn't guarantee that these moments will occur. It only promises that, if and when they do, the moments will be captured.

These unspoken, and sometimes unrealistic, expectations from clients can place a great deal of stress upon you—especially at those times when you find yourself documenting weddings that lack an emotional pulse. In such situations, the most valuable asset at your disposal is not hung around your neck or tucked away somewhere inside your camera bag; this is when your interpersonal skills and ability to interact with subjects will allow you to shine and save the day—photographically speaking. You

can either cling to your ethics and record what is present (and painfully absent), or you can abandon the "code" and be bold, making images that score points and sell.

This is the time to be assertive and directive—to help build confidence and to inspire interplay among your subjects. As photographers, we are very familiar with what we do; observing and recording the moments of others' lives seems routine and ordinary to us. However, most of our clients have never had their lives dissected by the camera's discerning eye. They have never been the center of such scrutinizing attention, and the experience can be alienating, almost terrifying. Michael Kimmelman's 1999 book *Portraits: Talking with Artists at the Met, The Modern, The Louvre and Elsewhere*, Cartier-Bresson had this to say about portraiture, "There is something appalling about photographing people. It is certainly some sort of violation; so, if sensitivity is lacking, there can be something barbaric about it."

If you visit any search engine and perform a keyword search for "wedding photojournalism" you will find that nine out of ten photographers' web sites tout a similar claim: "We offer an unobtrusive approach to photography, discreetly capturing your day as it truly happens and providing you with real, unscripted images." Proposals such as this ring with interest and appeal to prospective clients—which is why they've become staple selling points for wedding photojournalists. Ideally, this is how the wedding photojournalist wishes to operate, but the reality is quite contrary and rarely correlates with this concept.

THE CLIENT'S PERSPECTIVE

Although wedding photojournalism is the approach sought by most modern couples, our clients and subjects still possess a traditional attitude toward photography. The presence of a photographer and a camera is still very much the elephant in the room. So, even if you graduated top of your class at the ninja academy, it's unlikely that you've acquired enough stealth to move about and make your photographs unnoticed.

From the time were are children, we are conditioned to respond in a certain way to our picture being taken. At each wedding I photograph, there's a child engaged in play or at pause—oblivious to everything and everyone, including me. Then, just as I'm about to capture a candid moment, an adult jolts the child from their state of play and forces them to mug for the camera. I have lost countless photographs to mothers and fathers who force their children to stand up straight and produce fake smiles for the camera. By the time we reach adulthood, this behavior has become ingrained in us. Occasionally, we may even catch ourselves prompting a similar response in others.

Much like the uncanny feeling that makes us glance up when we suspect we're being watched, the camera's presence imparts a sense of unease—but one that is even

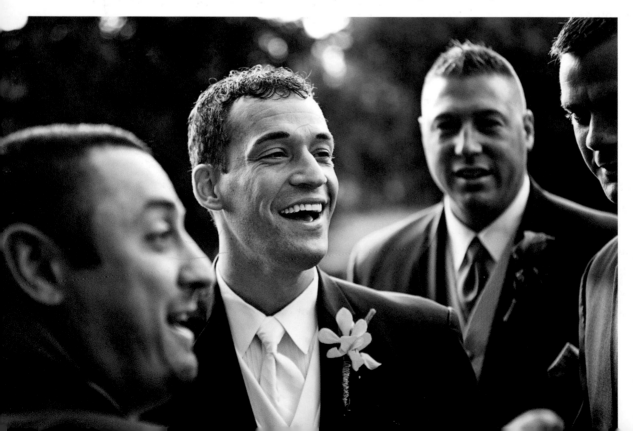

Encouraging your wedding subjects to connect openly can result in more meaningful images.

more amplified. Suddenly, our childhood conditioning kicks in and our natural state of repose is replaced with a Lurch-like stiffness and a terrified smile. Let's face it: as wedding photojournalists, we are actually the *cause* of our subjects' awkwardness and discomfort. Being able to capture candid moments is really an agreement, an unspoken collaboration of sorts. Your presence never becomes fully imperceptible to your subjects; rather, you establish a rapport with your subjects and in return they allow you to capture their image.

Like a street photographer, the wedding photojournalist hunts for forms, faces, and expressions. Personally, I am most interested in vulnerability and discontinuity, defining moments that materialize and disintegrate almost simultaneously. For me, this is what photojournalism is all about. Interaction with strangers through an image-capture device changes the dynamic of an already ambivalent relationship. It is crucial that the photographer be improvisational not only on a technical level but also in terms of the persuasions necessary to gain the momentary trust of a desired subject.

However, unlike street photography, where photographers share only a moment with their subjects, wedding photojournalism provides us with opportunity to establish much more meaningful relationships with our clients/subjects. It is during the consultation session—as well as the engagement session—that we can connect on a personal level and preemptively allay our clients' "camera shyness."

THE WEDDING PHOTOGRAPHER STEREOTYPE

Beyond the barriers and roadblocks of camera-weary subjects lies yet another obstacle to overcome—one that often requires tremendous restraint and tactful redirection. During the course of my career, I've begrudgingly accepted that there is a stereotype associated with the label "wedding photographer." Among many, we are perceived as flippant, fickle, and eccentric—and, in extreme cases of prejudice, uneducated, uncultured, and untrustworthy.

I blame the few bad apples who have abused their clients' trust and, in some cases, abandoned their clients altogether, leaving them with nothing but a sick, empty

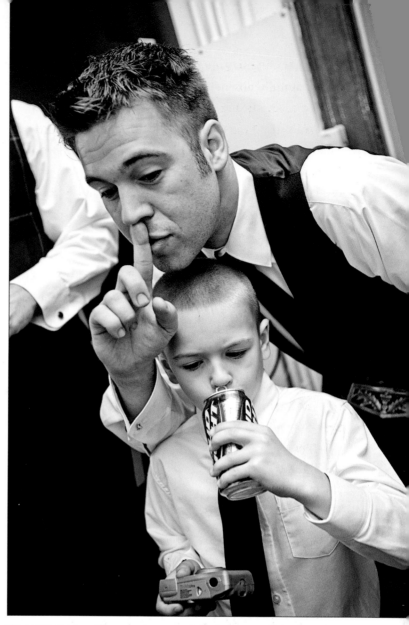

Your presence will never become fully imperceptible, but developing a good rapport with your subjects will help put them at ease in front of your camera.

feeling and the question of "who's going to document my wedding now?" Those are the infamous photographers who sometimes show up on the local news, shielding their eyes as they dodge questions about defrauding their clients.

The media and motion picture industry are largely to blame for perpetuating the stereotype of the starving artist. Photographers are commonly represented as itinerant paupers, holed up in their one-room studio apartments, surrounded by contact sheets and shut-off notices. The bottom line is that the general public has, at best, a vague understanding of our profession—and much of that un-

derstanding has been influenced by the outrage of the unfortunate few who have tasted the bitter fruit of those bad apples.

Occasionally, as I host prospective clients at my studio—a sumptuously decorated industrial loft space, adorned with canvas wraps and large framed photographs of my work, degrees, awards, publications, etc.—they will actually ask me what I do for a living! Just this past year, I had a client ask me, in all earnestness, what guarantee I could offer them that I wouldn't skip town with their security deposit. (It's okay—go ahead and laugh. I did!)

Misjudgment exists at every level for the wedding photojournalist; no matter how accomplished we might become, we must always be prepared (and willing) to prove ourselves to each and every client who passes through our door. My advice is to practice prudence and disregard any discourteous questions. Rather than looking upon them as affronts to your character or credibility, seize on them as opportunities to promote the selling points of your business and to reinforce your reputation with continued professionalism.

To establish a more accurate and positive portrayal in the eyes of my clients, I urge them to share my web site with their wedding party and family. If possible, I also invite the parents and wedding party to participate in the consultation session. I believe that one of the many aspects of being a successful wedding photojournalist involves sharing your artistic philosophies with those you photograph and educating others on the practices involved in your profession. Portfolios and awards can attest to one's artistic and technical abilities, but clients often base their ultimate decision on the personal connection they make with their photographer—their "gut feeling."

THE PREREQUISITES

If you're new to wedding photojournalism, or have had limited experience, you can easily be blinded by beginner's optimism and misled by polished portrayals of what the profession entails. Even professional photographers are not immune to the illusion that images create. Looking at other photographers' blogs and web sites can be incredibly inspiring—but also incredibly deceiving. As an

Being a wedding photojournalist and being in the business of aesthetics requires a vast repertoire of skill and talent that extends beyond what one can acquire in a classroom or workshop.

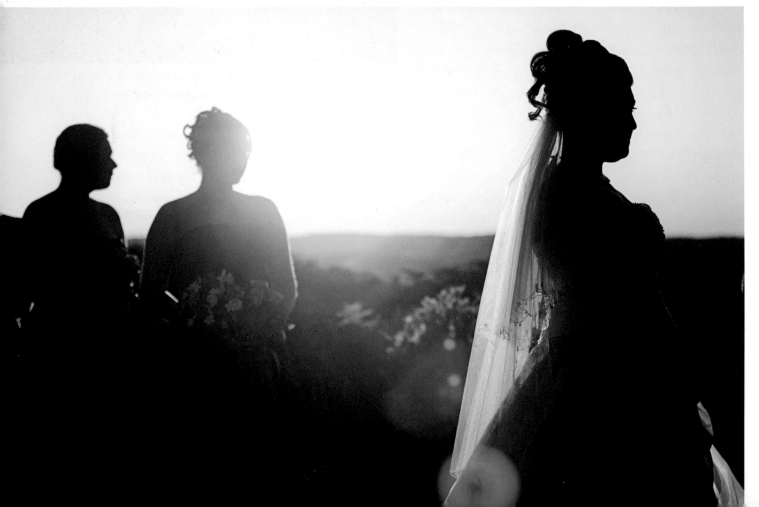

audience to others' work, even I have a tendency to focus only on the finished product and neglect to think about the many tedious and intensive processes likely involved in creating that collection of images. Being a wedding photojournalist and being in the business of aesthetics requires a vast repertoire of skill and talent that extends beyond what one can acquire in a classroom or workshop.

As a photographer, the ability to make strong, technically solid images is an essential "raw material" for building a successful business—but professionalism, sound business practices, and an ability to acclimate to any social situation are the most valuable tools of this trade. These are tools that have to be acquired and honed over time.

CONCLUSION

The idea that you can go unnoticed while animated and emotion-filled subjects arrange themselves in stunning compositions under a canopy of ideal weather and lighting conditions is pure fiction. However, many who write on the subject of wedding photography would like you to believe that fairy tale. After all, who wants to spook their readership?

My approach is altogether different; my reasons for writing this book are neither to glamorize wedding photography as a profession, nor to entice you to purchase additional products, nor to string you along. Rather, I want to prepare you for the road that lies ahead. By sharing this critical and comprehensive review of what the business of wedding photography entails, I hope to ensure not only your preparedness but also your success.

Professional wedding photography is a tough business to break into, especially with the changing economic tide. Average working-class clients are opting for more modest weddings, curbing much of their spending. This concession, in some cases, eliminates the professional wedding photographer from the equation altogether. Prospective clients are also more apt to bargain hunt and book with photographers who are willing to work for next to nothing—those who are hungry for work and have little to no overhead. This has opened the door to countless newcomers for whom wedding photojournalism has become an attractive employment alternative. I've watched the

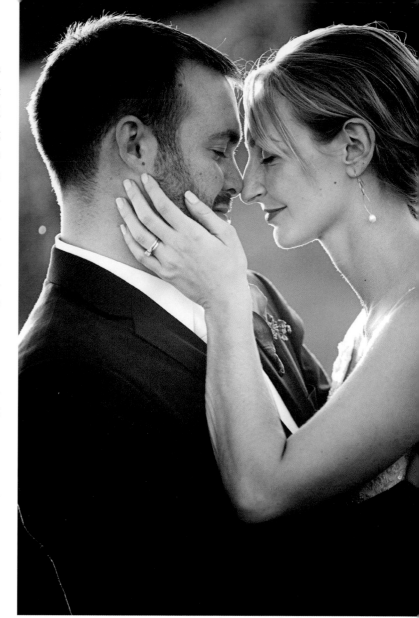

Being a successful wedding photojournalist involves sharing your artistic philosophies with those you photograph.

number of professional wedding photojournalists grow exponentially over the last couple of years and see no signs of that number slowing or shrinking in the near future. This means fewer leads for an ever-increasing number of practitioners in the field.

To survive, you must not only run a "lean" business by cutting unnecessary costs, you have to create a demand by drawing attention to yourself—by being the best at what you do. You must offer a service and a product that is unique to you but also speaks so compellingly and persuasively to your clients' interests and sensibilities that the thought of booking with anyone else burdens them with doubt and the possibility of regret.

3. MARKETING AND ADVERTISING

They say there's no better advertising than word-of-mouth advertising, and I agree. I would approximate that 75 percent of my yearly wedding bookings come by way of referral from previous clients. However, if you're just starting out and have only a dozen or so weddings to your credit, you're going to have to do some marketing and advertising. Before the brides start beating down your door, they have to know you exist. For most photographers today, this will begin with developing a solid web presence. Even for established businesses, refining your web presence can be a key element in enhancing your bottom line.

SEARCH ENGINE OPTIMIZATION (SEO)

Whether you're a new kid on the block, in the initial stages of building your business's web presence, or have owned and maintained a wedding photography web site for years and years, search engine optimization (SEO) is, in my

For most photographers today, developing a solid web presence is a key method for attracting clients.

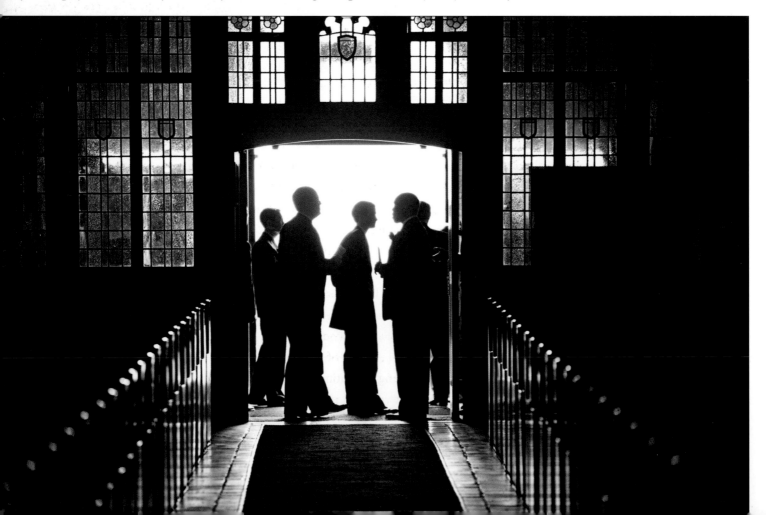

opinion, the most critical component in establishing your business's visibility and generating revenue.

According to SEO expert David Viney, author of *Get to the Top on Google*, search engines are the way in which 90 percent of people locate the resources they need. Additionally, 84 percent of searchers never make it beyond the bottom of page two of Google, so the importance of a solid SEO strategy, designed to increase your page rank and search engine placement, is self-evident. If your business doesn't appear on page one or two of Google or Yahoo's search engine's results, three-quarters of your prospective clientele will never know your business exists.

Before discussing why SEO is important to your wedding photography business and online presence, however, we should begin with this question: What *is* search engine optimization? An alarming number of professional wedding photographers respond to this question with a befuddled or confused gaze. We can probably attribute this lack of awareness to the rapid rate of the web's expansion coupled with the increasing sophistication with which search engines index information on the web.

Imagine the world wide web as one giant city with various stores and shops located throughout. Having your business's web site appear within the top ten results for your keyword criteria is like having your storefront situated at the entrance to the world's largest shopping district. Search engines, and the algorithms they use to index information on the web, determine your position within this pecking order. Search engine optimization is the most direct way to influence and effect your position within this hierarchy.

Simply stated, search engines (*i.e.,* Google, Yahoo, Bing, etc.) make it possible for anyone browsing the world wide web to find quality search results relative to their query or search criteria. Search engines provide answers to general questions ("Where can I find a wedding photographer?") as well as more specific ones ("Who offers destination wedding photography in Maui?"). Nested within these questions are what are commonly referred to as "keywords."

Keywords. Keywords are individual words that signify or correspond to the specific interest(s) of a searcher's

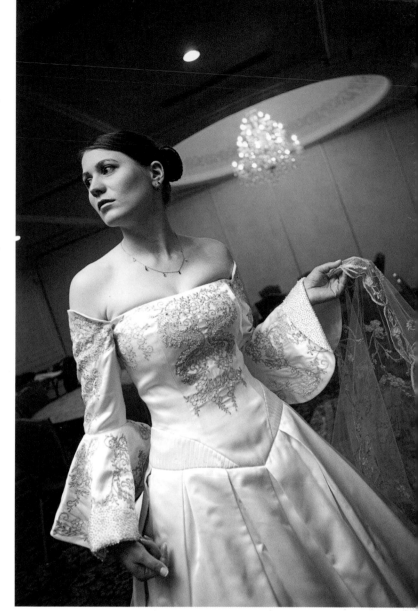

The vast majority of today's brides use the Internet to find the resources they need.

query. For example, if I'm interested in antique cameras, I might search for relevant web sites geared toward the interests of antique camera collectors by simply entering the words "antique cameras." If I wanted to narrow my search results for even more relevant content (let's say I'm partial to rangefinder cameras) I could fetch far better results by searching for "antique rangefinder cameras."

Individually, these words are referred to as keywords. When used in combination with other keywords they become "keyphrases." Keywords and keyphrases are the cornerstones of web indexing—and, subsequently, of search engine optimization. So, if the shortest distance between two fixed points is a straight line, then keywords would

signify that straight line between a searcher and his or her search results. Keywords and keyphrases are what make information—and, more importantly, your business—discoverable on the web.

A few examples of keywords/keyphrases relevant to wedding photography would be: "wedding photography", "professional wedding photography", "wedding photojournalism", "documentary wedding photography", "destination wedding photography", "travel wedding photography", etc. My advice for determining your optimal keywords is to study the keywords of your competitors. You can view any page's HTML source code by visiting that page and going to View > Source or View > Page Source in your browser's menu. To compile a list of keywords from each of your competitors' web sites, look at the lines that read:

<meta name="Description"> and <meta name="Keywords">

The HTML source code from my own site shows the keywords used.

```
<!DOCTYPE HTML PUBLIC "-//W3C//DTD HTML 4.01 Transitional//EN">
<html>
<head>
<link rel="shortcut icon" href="favicon.ico" >
<title>Rochester Wedding Photography Buffalo Wedding Photography NYC Wedding Photography</title>
<meta name="Keywords" content="Rochester Wedding Photography,Buffalo Wedding Photography,Destination Wedding
Photography,NYC Wedding Photography,Wedding Photography Blog">
<meta name="Description" content='Paul Van Hoy is Rochester NY Premiere Wedding Photographer acclaimed for his award
winning Wedding Photography in Rochester NY Rochester NY Wedding photography NYC Wedding Photography Destination
Wedding Photography'>
<meta name="Author" content="Fotoimpressions">
<meta name="Abstract" content="Rochester wedding photography,Rochester Wedding Photographer">
<meta name="Keyphrases" content="Rochester Wedding Photography">
<meta name="Copyright" content="2009 Fotoimpressions">
<meta name="Robots" content="index, follow">
<meta name="Googlebot" content="index,follow">
<meta name="Revisit-after" content="1 days">
<meta name="City" content="Rochester">
<meta name="Country" content="United States (USA)">
<meta name="State" content="New York">
<meta name="Zip code" content="14604">
<meta name="htdig-keywords" content="wedding photography,wedding photographers,wedding photography,New
York,Rochester NY,Syracuse NY,Buffalo NY">
<meta name="Classification" content="wedding photography,wedding photographers,wedding photography,Destination
Wedding Photography,Destination Wedding Photographer,New York,Rochester NY,Syracuse NY,Buffalo NY">
<meta name="abstract" content="Rochester wedding photography,wedding photographer Rochester">
<meta name="y_key" content="70919f45589f372d" >
<meta name="netinsert" content="0.0.1.1.2.5.2">
<meta http-equiv="Content-Type" content="text/html; charset=iso-8859-1">
<meta name="msvalidate.01" content="EA05342B6B2DEE939BCE4C424FC73A43" />
<script language="JavaScript" type="text/JavaScript">
<!--
function MM_swapImgRestore() { //v3.0
  var i,x,a=document.MM_sr; for(i=0;a&&i<a.length&&(x=a[i])&&x.oSrc;i++) x.src=x.oSrc;
}
```

Using Google Adwords Keyword Tool, you can get a complete list of keywords/keyphrases relating to your marketing campaign.

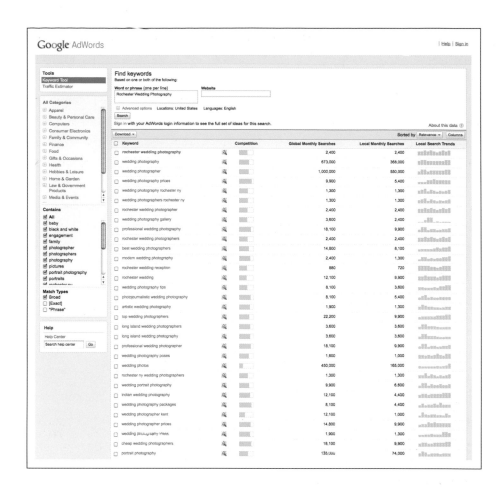

Keyword acquisition can be a simple or complex process depending on your services, niche, or geographical focus. Don't just "keep up with the Joneses" and directly copy your competitors' keywords. Ask friends, family, and coworkers about how they might locate a wedding photographer on the web. Ask them directly about the keywords and keyphrases they might use in their search query. There are many online keyword-generating tools and web sites that can also aid you. The one I often rely upon is Google's Adwords Keyword Tool (https://adwords.google.com/select/KeywordToolExternal). You simply type in the descriptive words or phrases relative to your marketing campaign and a list of keyword/keyphrase results will be returned.

After you've accrued a sizeable list of keywords and keyphrases, it's time to prioritize and pare down that list. Be realistic about the keywords and keyphrases you wish to optimize for and limit your focus to no more than four different keyphrases. For example, it would be extremely ambitious (starting out) to seek a page one or page two placement on Google's search engine results page (SERP) for the keyphrase "wedding photography."

If you are launching a new site, I suggest optimizing for local, geographical searches relative to your services and products. Let's say your business is located in Henderson, KY; in that case, you would try to achieve placement for keyphrases like "Henderson Wedding Photography", "Western Kentucky Wedding Photography", "Henderson Wedding Photojournalism", or "Wedding Photography Henderson". Though I'm sure you'll find competitors campaigning with the same keywords, the climb to a number-one position on Google or Yahoo won't be nearly as steep or insurmountable when you are campaigning with geographical keyphrases. (*Note:* Your goal should be to reach prospective clients who have never heard of you or your business. Therefore, since it will offer no SEO benefit, I discourage the use of your personal name or business name in your keyword campaign.)

Title Tags. The next step is keyword deployment. When, where, and with what frequency do you need to

deploy your keywords and keyphrases for maximum effectiveness? Let's begin with your web pages' title tags and metadata. (*Note:* Metadata is latent identifying information embedded within the HTML of a web page. This data is read and indexed by search engine spiders and crawlers, which scour the web collecting and organizing the vast expanse of information on the web so users can find relevant results for their search queries.)

Your web site's title tag is the most important element that can influence your page's placement in the search engines' SERPs. The title tag requires careful consideration; it not only serves as a summary of a page's content and online objective, but also comprises the clickable text/link served up in the search engine's SERP. Your title tag can also act as a call to action for users browsing the web—does it entice them to click *your* link over your competitor's link? Google places great importance on the title tag for all of these reasons, so give careful thought and consideration when writing your title tag. (*Note:* Personally, I use Adobe's Dreamweaver to create and append my web pages' metadata. However, if you do a Google keyword search for "web page software" you will see that there are numerous programs available that can assist you in writing or rewriting your pages' metadata.)

Theoretically, there is no limit to how long your title tag can be, but presently Google will only display 66 characters in the title tag heading for any single web page. The World Wide Web Consortium guidelines state that the length of the title tag should not exceed 64 characters. Yahoo truncates title tags at 120 characters, but most browsers won't display title tags that exceed 75 characters. I adhere to Google's 66 character maximum and begin my pages' title tags with my most relevant keywords.

Although very little is known about the highly guarded Google search-engine algorithm, enough evidence exists to support that one of the ways Google evaluates web pages is based on their keyword prominence, proximity, and density. This means that more weight is given to words appearing *first* in the page's titles, text, tags, and links. This is something you should be mindful of—especially when writing title tags and body copy for your web pages.

The title tag is where you want to implement your primary keywords. For instance, if your wedding photography business is specifically geared toward destination or travel wedding photography, then you want to optimize for those and other semantically similar keywords. An appropriate title for such a page might look like:

Destination Wedding Photography | International Wedding Photographer

This title contains seven words and 62 characters.

Let's say you're a wedding photojournalist and rely on engagement portraits to carry you through during the off-season. You would want to optimize for the keywords "Wedding Photojournalism" and "Engagement Portraiture." An effective keyword rich title might look like:

Detroit Wedding Photojournalism | Engagement Portraiture | Book us today!

This title contains ten words and 64 characters. It also contains a call to action and has geographic specificity. Eureka!

An example of a poorly optimized title tag might look like: "Welcome to John Doe's Online Wedding Photography Web Site." While this title does contain the keywords "wedding photography," the lack of prominence of those keywords undermines their presence. Additionally, titles such as these fail to capitalize on constrained space allotted for the title tag (66 characters). While it is a rather welcoming and friendly tag, it does very little to improve the visibility and placement of this particular page on the web—unless a user happens to be searching for the exact phrase "Online Wedding Photography Web Site" or for this particular "John Doe."

Penalties for Duplicate Content. It's important to note that Google penalizes web pages for duplicate content—meaning that for each new web page you publish, you will need to generate new metatags and copy specific to each individual page (*i.e.,* title tags, meta-description, and page text). Duplicate content, which is also referred to as "keyword stuffing," is regarded by the Google al-

gorithm as spam and will trigger a penalty; the pages in question may be relegated to the dreaded "supplemental index" (otherwise known as web page purgatory) or altogether removed from Google's index. Later in this chapter, I will discuss these penalties—as well as procedures for getting your pages out of the supplemental index and re-listed in the Google index.

Stop Words. You should also be aware of what are known as "stop words." These are common words that, according to Google, offer little user benefit in narrowing search results. Therefore, Google ignores these words when indexing pages on the web. These stop words include (but are not limited to): I, a, about, an, and, are, as, at, be, by, for, from, how, in, is, it, of, on, or, that, the, this, to, was, what, when, where, who, will, and with. I strongly advise that you *do not* use stop words in your primary page's title tags (*i.e.*, landing page, home page, about page, and contact page). Since we are restricted to 66 characters, no characters should be wasted on stop words.

Meta-Description Tags. Contrary to popular belief, the meta-description tag carries very little weight or SEO value, due to a history of abuses by spammers. However, let us not totally discount the importance of this particular tag. Though it may not directly impact your page's placement within the SERP, searchers rely heavily upon descriptions to guide and inform their search selections. After all, the text contained in this tag is displayed to users directly below the clickable title tag. Think of your web page's meta-description as a synopsis or abstract—similar to what you'd find on the back cover of a book.

Description tags can persuade a user to click your link over your competitor's, so it's important to write a catchy and concise description that reads easily and entices users. My advice on writing copy for this tag is to be honest—sell yourself and attract users without going overboard. A web page's meta-description can also be reviewed by selecting View > Source or View > Page Source from your browser's menu. The correct syntax is as follows:

<meta name= "description" content=
"place your description here."/>

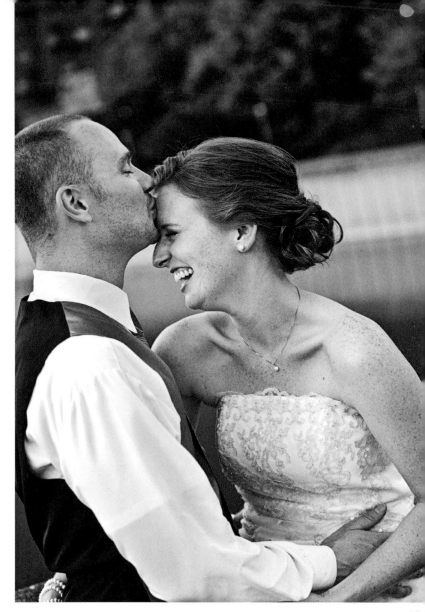

A call to action in your title tag can give bride's the incentive to click through to your site—rather than to your competition.

An example of a well-written meta-description tag reads as follows: "Established in 1902, Edward's Wedding Photography has over 100 years of experience in creating exceptional wedding photography." An example of a poorly written meta-description tag reads as follows: "Non-traditional wedding and senior photography serving the Lexington KY and Louisville Kentucky areas." While this description is honest and very straightforward, it doesn't pique my interest. With a few minor tweaks, this title could yield more interest and appeal—and subsequently more traffic.

Description tags are one instance of SEO where prominence, placement, and density of keywords are negligi-

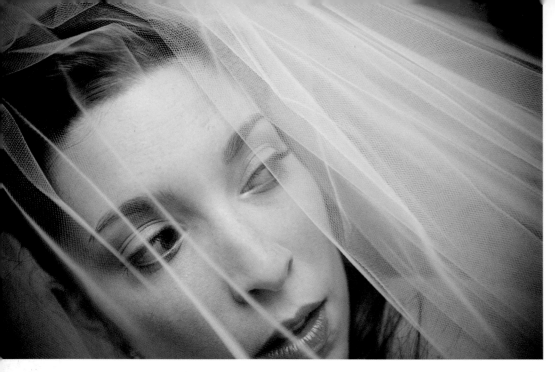

Tags that are geographically specific will help put your site in front of brides in your area.

ble, so concentrate on quality and readability. Presently, Google displays up to 160 characters for meta-description tags (including spaces). So, once again, you will want to choose wisely for this snippet of self-endorsement.

Meta-Keyword Tags. Due to abuse by spammers, Google now appears to disregard meta-keywords when determining the placement of a web page in search engine results—but they are still worth mentioning and pursuing. Meta-keywords can be viewed in the source code; they appear between the <head> tags in a page's HTML. The correct syntax is as follows:

```
<meta name= "keywords" content= "keyword 1,
          keyword 2,keyword 3"/>
```

I suggest that you try to limit your keywords to 30 words and place your most important keywords first. A good meta-keyword example would be:

```
<meta name="keywords" content="nyc wedding photography,
nyc wedding photography,nyc wedding photojournalism,nyc wedding
photojournalist,nyc documentary photography,nyc documentary wedding
      photographer,wedding,photography,photographer">
```

Be sure to use lowercase letters and separate the words with commas (no spaces). One final rule for your meta-keywords tag is to make sure that all of the keyphrases in your tag appear at least once in your on-page elements (*i.e.,* title tag, description tag, headings, alt tags, and body copy). If this cannot be achieved, I urge you not to include those words in your metakeyword tag.

Alt Tags. Alt tags are pretty straightforward; their intended purpose is to help the visually impaired "read" images on the web via screen-reader soft-

ware. Alt tags are a bit like meta-keywords insofar as they may not offer much SEO benefit, but they're worth utilizing on your web pages anywhere an image exists. Alt tags can be located in your HTML source code:

```
<img src="pix/wedding01.jpg" width=
"257" height="329" alt="Wedding Photograph
of Couple Kissing">
```

I encourage you to use keywords and keyphrases whenever possible, but caution you not to go overboard and stuff your tags with non-related keywords that could mislead those who rely on these tags.

Body Text. Copywriting is no easy feat—especially for photographers, who are usually more comfortable conveying ideas with images rather than words. Because the copy on your web pages is a highly critical component when it comes to search engine optimization and subsequent page placement within the SERPs, I strongly urge you to hire a copywriter if this is an area of weakness for you. Though a picture might be worth a thousand words, Google disagrees. Google's indexing algorithm relies solely on *text*. So it's imperative that we implement text/copy within the content of our web pages for optimal SEO benefit.

Shockwave/Flash. A growing number of wedding photography web sites employ Flash or Shockwave/Flash to present their portfolios to prospective clients. While Flash-based sites certainly have a reputation for their sleek visual impact and multimedia capabilities, they have a major downside: with few exceptions, Flash sites appear as blank pages to search engine spiders and web crawlers. They offer absolutely no SEO benefit; unless a user already knows your web address or is navigating to you from a link on another web site, they will never find you through an organic search on any search engine.

Now, before you start ripping your hair out and pulling pages off the web, let's talk about how Flash *can* be implemented without sacrificing rank and placement on the web. Personally, I love Flash and use a Flash template to present my portfolio. However, I only use Flash for two pages on my web site. Most importantly, my Flash

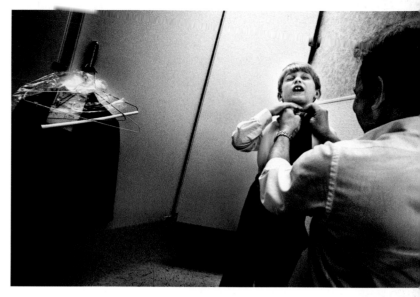

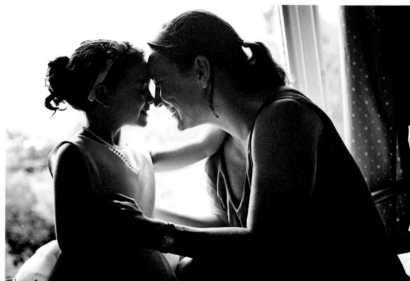

A picture might be worth a thousand words—but Google disagrees, so text is imperative on our web pages.

page is not my site's index page. Your index page (index. htm) is not only the first page a user arrives at when navigating to your site (your domain), it is also the first page that the Googlebot comes to when crawling the web. (*Note:* Index pages [depending on the site's structure] are commonly referred to as splash pages or landing pages. There's a lot of controversy and discussion over the utility of landing pages, but for wedding photography web sites, they make it possible for those of us with Flash portfolios to exist on the web.)

Personally, I use Bigfolio's templates to display my work on the Internet (www.bigfolio.com). I endorse

Bigfolio's web sites because they have an intuitive user interface, they're highly customizable, they present professionally, and they're reasonably priced—but above all, they implement coding that allows the site administrator to insert title tags, meta-descriptions, and keywords for SEO benefit. Even my Flash gallery pages rank well and place near the top on Google's SERP for my top four keyphrases! A few other great Flash photo template sites I'd recommend taking a look at are www.livebooks.com; www.clickbooq.com; www.sitewelder.com; www.qufoto. com; and www.evrium.com.

Site Architecture. Whether you employ Flash or not, I urge you to include the following pages in your site's architecture. Remember that each of these pages should be coded in HTML, and they should all have unique title tags, meta-descriptions, and body text. The only pages that should contain Flash are your portfolio pages.

Landing Page. Your landing page should serve as a map to the various sections of your site and contain no more than 500 words of copy. Most professional wedding photographers have a primary site (their wedding portfolio), a blog (their most current work), and a commercial or personal site (non-wedding related imagery). On most wedding photographers' web sites you will see a set of three to four images or icons accompanied by text that guides you from the landing page to your section of interest.

On my landing page, I offer three clickable choices: wedding, blog, and commercial. Toward the bottom of the page, I placed navigational links that allow access to my various other keyword-rich HTML pages. Between my upper (visual) and lower (text) link sections, I include roughly 400 words of keyword-rich copy. Each page's copy should contain descriptive information about your business's services and products, pertinent to the page on which the copy is placed. And before you get any ideas about saturating your copy with keywords and keyphrases, be aware that exceeding a density of more than 3 percent for any single keyword or keyphrase will likely be picked up on Google's radar as spam and trigger a penalty. A useful tool for checking keyword density is http://tools. seobook.com/general/keyword-density/.

A well-phrased snippet of self-endorsement in your description tags can pique clients' interest.

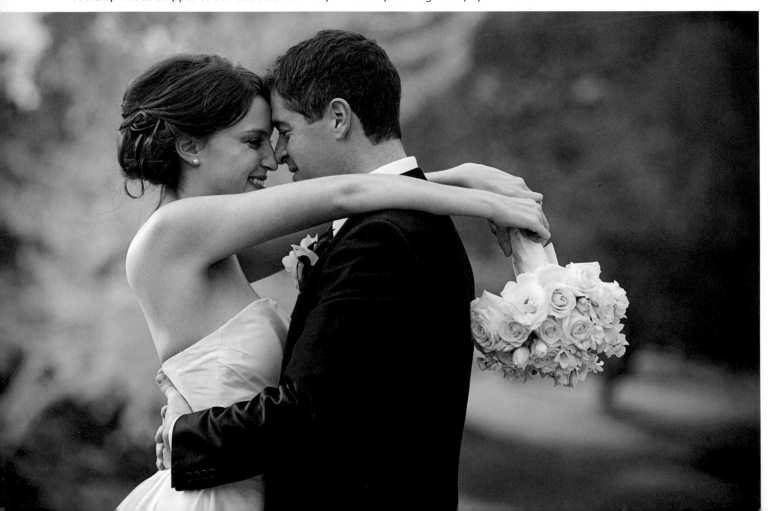

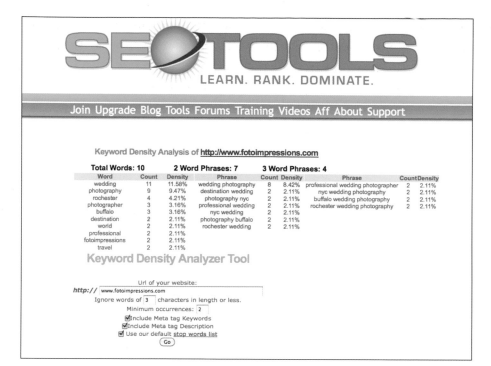

A useful tool for checking keyword density is: http://tools.seobook.com/general/keyword-density/.

Products and Packages Page. Here, you can utilize many of your keywords and keyphrases to describe your layout designs, albums, and your printing and proofing services. Your products and packages page should contain a few embedded images of the products and materials discussed. Make sure to clearly outline what each package includes, in terms of time and coverage. You can choose to list the prices along with your packages or refrain from making your pricing public and request that the user inquire directly to you via e-mail to receive your pricing information.

Raves and Reviews. This is one of my favorite pages; not only do you get to dote on yourself, you are freed from the task of copywriting, since you will be using client feedback. If you're just establishing or starting your business, don't worry—you'll soon have praiseful reviews pouring in from your clients. And if you're itching to fill this space, you can always ask your mother for a review! Be sure to include a few images on this page as well.

FAQ (Frequently Asked Questions). This is a vital page to have on your web site. I can't tell you how many couples have complimented me on my FAQ page and noted how influential it was in their decision-making process. Instead of discussing what should go on your FAQ page, I have listed mine for you to reference:

- I shoot 100 percent digital with the most current Canon DSLR equipment on the market.
- I use professional-series Canon EOS 1D Mark IV Cameras and EF lenses.
- I bring backup equipment to every wedding.
- Although I shoot with natural and available light as much as possible, I also bring studio lighting and flash equipment with me to every wedding I shoot.
- I would describe my style as a mixture of many photographic styles, ranging from fashion and editorial photography to fine art and photojournalism.
- Aside from wedding photography, I am also a working fine-art, travel, and stock photographer. If you're interested in seeing what I do in my free time, check out www.fotoimpressions.com.
- Clients receive images in color and also a fair amount of black & white, sepia, and artistically rendered color.
- All clients receive a DVD of "digital masters" of *all* the images shot on the wedding day, including edited image files.
- Your online proofs will be ready four to six weeks after your wedding.

- Custom-designed albums require 180 days for delivery once an order has been submitted.
- I never photograph more than one wedding a day.
- I have been shooting weddings professionally for twelve years.
- I hold a Master of Fine Arts (MFA) in Photography from the Rochester Institute of Technology (RIT).
- I book one to two years in advance for dates of high interest and shoot approximately forty weddings annually. Wedding photography is not only my career, it is my foremost passion.
- Travel fees are applicable to any wedding event in excess of ninety miles from my studio location. Travel rates fluctuate on a number of variables, including time of year.
- I maintain a current passport and am available for travel within the U.S. and abroad.

About. I'd wager that, at some point in your life, you have been asked by a potential employer, "Why should I hire you?" On the spot, that can be an intimidating question—but unclench your jaw, lower your shoulders, and relax; for your web site, you have as much time as you need to write an enchanting biography that highlights your photographic education, skills, affiliations, awards, and publications. If you don't possess all of the aforementioned qualifications, don't fret; place more emphasis on your passion, enthusiasm, and commitment to customer service. Last but not least, your "about" page should contain a portrait of you (and, if you have one, your assistant).

Contact. The contact section should be fairly cut and dry. I like to use it to summarize my services and reiterate the selling points of my business. This is a great page on which to include an anchor link to your Google or Yahoo maps if you have a listing or intend to secure one. The page should include your business's address, phone, fax, e-mail, and hours of operation. I would also include a mention about client consultation sessions (*e.g.,* "Consultations are available by appointment only and are usually scheduled Monday through Friday between the hours of 1:00 and 4:00PM," or something to that effect).

Links and Partners Page. This is a page for outbound links to wedding-related vendors and photographers—as well as reciprocal links you exchange with other web masters. If you're launching a brand new web site and haven't yet established any reciprocal links, start off by placing your outbound links in this section. I'll be discussing reciprocal and outbound links later in this chapter.

Hosting and Domains. If you don't already own a domain or web site, there are some factors to consider before you begin breaking ground on the web (bearing in mind the importance of a solid SEO strategy). Two fundamental decisions that will affect your search-engine rank and placement are choosing a host and choosing a domain name.

Choosing a Host. It is critical to choose a host with a reputation for speed and reliability. Slow hosts often time out—and the result is that your site won't be fully "crawled" or indexed by search engine spiders. Google's search engine algorithm takes into account a variable called "timedout-queries total," which suggests that the number of time-outs (resulting from a slow host) can impact your page rank and search engine placement. Of course, a speed-driven host will come at a cost. Like anything else, quality and reliability means more money. Ultimately, you'll want to choose a host that has minimal down time, high bandwidth, Linux for hosting, and a sterling reputation for customer support. Take a look at www.dreamhost.com; www.mediatemple.net; www.hostgator.com; and www.pair.com.

Choosing a Domain Name. Choosing a keyword-rich domain name is one of the most powerful SEO tools you have at your disposal—so use it! Consider this: after you and all of your competitors have used every optimization technique available, this is the one area of SEO where you can't be copied—because you'll own exclusive rights. Also, many of your competitors have had their sites and domains for years and years and won't be willing to replace their present domain name for a keyword rich domain. A few examples of keyword rich domains are www.nycweddingphotography.com; www.miamiweddingphotographers.com; www.seattleweddingphotojournalism.com; and www.weddingphotographydenver.com.

It will usually take about six to twelve months for your site to rank and place well within the search engines' SERPs. Use this time to research your competitors' web sites and plot your takeover.

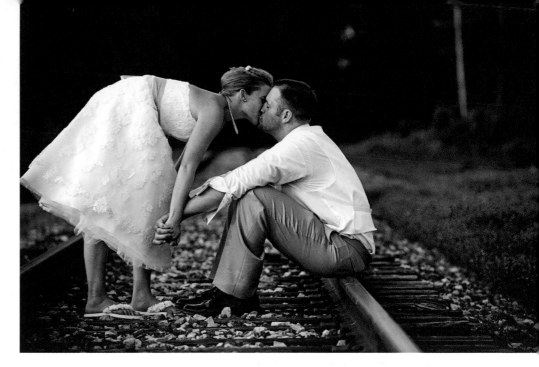

Better with Age. You've heard that good things come to those who wait and that great relationships take time to build. Well, this is another Google truism. As we've learned so far, Google evaluates every web page based on your site's metadata and page elements, but one additional way Google determines the rank and placement of your site is based on its age. This ageist criterion is referred to as Google's "age-deflation factor" and was established to foil spammers from setting up a thousand web sites overnight and cluttering the search engine results pages with sexual enhancers and weight-loss wonder drugs.

As a result, it will usually take about six to twelve months before your site starts to rank and place well within the search engines' SERPs. Don't let this probationary period discourage you; use this time to research your competitors' web sites and plot your takeover. During this time, you should be writing titles, tags, and copy—as well as building links, which are the heavy artillery of SEO.

Adding Links. Up until now we have been discussing on-page SEO. Essentially, we have primed your site with metadata, keywords, and relevant text that will help your rank and placement within the major search engines' SERPs. Now we need to talk about off-page SEO. This entails a process of research and outreach to other webmasters who host sites with related products and services. This means you will be looking to land incoming links to your web site from any site whose primary enterprise is wedding-related (*i.e.,* other wedding photographers, wedding vendor directories, bridal shops, tuxedo shops, wedding florists, etc.).

Ideally, you will want to choose web sites that not only offer related services, but those that have good page rankings, placement, and age. You can find out the ownership and age of any domain on the Internet by looking it up

> Use this time to research your competitors' web sites and plot your takeover.

in the WHOIS Database (www.whois.net). Once you've determined whom to contact, here is an example of what a link-request e-mail should look like:

Dear Sir/Madam,

My name is [*your name*]. I am the webmaster of [*http://www.yoursitehere.com*]. I recently visited your site and found it to contain rich, informative content. It is relevant within our industry and I feel that exchanging links would be beneficial for both of us in order to get better rankings in SERP and increase our traffic.

If you are interested, you can add our link on your web site links page.

Link Details:
URL: [*http://www.yoursitehere.com*]
Anchor text: [*your keyphrase here*]

I assure you that this would be a long-term business relationship and look forward to hearing from you.

Kind regards,
[*your name*]

PageRank. To find the Google ranking of any site on the Internet, simply download and install Google's Toolbar (http://www.google.com/toolbar/ff/index.html).

After downloading this browser plug-in, you will be asked to restart your browser before the tool bar's features take effect. Once you have quit and restarted your browser, click the wrench icon at the far right side of the toolbar to access the toolbar's settings. The first check box you will see says PageRank. Click the check box to activate this feature. Now, you will be able to see the rank of any page you visit on the web by simply clicking (or hovering over) the icon now visible in your toolbar.

PageRank is the very basis of the Google algorithm—and a key factor in determining the placement of a web

Selecting the PageRank feature for Google's Toolbar.

Viewing the rank of the page you are currently visiting.

page within Google's SERPs. To Google, a link from a relevant, reputable web site acts as a vote in favor of the site being linked to. Think of it as an online voting system; each link is a ballot cast in your favor.

Or is it? The truth is, not all votes are counted equally or carry the same weight. Linking to (or receiving links from) sites that have been penalized by Google for suspected spamming could actually have a negative impact on your web site's rank. Before linking to any site on the web, make sure to visit it and thoroughly review the content and navigation. If the site doesn't load or respond quickly, contains numerous broken links, or if its design looks like a psycho killer's scrapbook, keep searching.

Types of Links. There are a variety of link types, each carrying different weight when determining the Page Rank. According to Internet marketing consultant Neil Lemons (www.neillemons.com), here's the scoop:

- **Main Links.** These are links to the index page of your web site—or, in your case, your site's land-

ing page (*i.e.,* www.fotoimpressions.com).

- **Deep Links.** These are links to pages within your web site (*i.e.,* your blog, raves and reviews, FAQ, about, or contact pages). These links possess greater SEO value than main links.
- **Inbound Links.** These are links from other pages on the web that link directly to you. These links can be either main or deep.
- **Outbound Links.** These are links from your site's pages to other sites and pages on the web. Believe it or not, there is some SEO benefit to your web site's outbound links. However, you should only link to relevant, high-quality sites that carry a PageRank of at least five. Starting off, I would suggest linking to any of the following: www.theweddingchannel.com; www.theknot.com; www.brides.com; and/or www.marthastewartweddings.com
- **Reciprocal Links.** These are links that are usually established on a conditional basis between webmasters—that basis being "I will link to your site if you agree to link back to my site." ("I'll scratch your back if you scratch mine.")
- **Internal Links.** Internal navigational links not only help users navigate through the sections of your web site, they also help search engine spiders and crawlers move more efficiently through your site during indexing. For instance, if your web site design implements cascading tile sheets, your main navigation might include a link for a section named "Galleries"—and, when hovered over, this link would reveal a dropdown menu of links to specific categories within that section (such as: "Preparations," "Ceremony," "Portraits," "Details," "Reception," etc.). These are all examples of internal links. A light bulb should be going off over your head right about now, as you realize that this is another opportunity for you to employ your keywords and keyphrases for added SEO benefit.
- **In-Context Links.** In-context links are similar to internal links, but rather than appearing in your site's navigation, they usually appear within the copy of your pages. Using anchor text, you can turn any keywords or keyphrases within your page text into an in-context link that directs users to the page or pages relevant to that keyword or keyphrase. For instance, within the copy of your FAQ page, you may mention custom albums or prints. You can easily select the text "custom albums and prints" and turn that text into an in-context link that navigates users to your products and packaging page. I suggest that you use in-context links frequently—but not so much that users are overwhelmed by redundant links.
- **Anchor Links.** These are links that use anchor text to define the link. As noted above, these are commonly used to link to pages internally within your own web site (*i.e.,* as internal and in-context links) so users can navigate quickly through your site. The proper HTML code for creating an anchor link is:

```
<a herf="http://www.yourpage.com">place your
keyword-rich anchor text here</a>
```

I use anchor links whenever possible because they allow you to employ keywords and keyphrases. Consider the navigational links on your web site; I'm willing to bet they're literal to the pages they link to (i.e., Home, About, Bio, Gallery, Contact, etc.). Instead, let's consider a keyword-rich anchor text alternative for "Gallery." By changing the anchor text from "Gallery" to "Wedding Photography Gallery," you've just added additional keyword-rich content to your page. For your "Bio" link, you could change the anchor to "Wedding Photographer Bio." Be creative and see what other alternatives you can come up with—but don't stray too far. Don't misrepresent any of your page's content or confuse your users.

Building Links. As I mentioned earlier in this section, building links to your site from other similarly themed sites is a process of appealing to other webmasters and seeking their endorsement. Usually, a link exchange between webmasters is an agreement made on *quid pro quo*

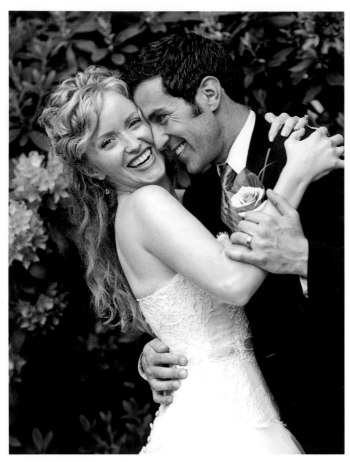

My advice is to be highly discriminating and only link up with sites that offer similar services and products.

basis (which is what I referred to earlier as a reciprocal link exchange).

Starting out, you may find few webmasters willing to sponsor your site, even with a reciprocal exchange agreement. The reason for this is that they are seeking maximum benefit from link exchanges as well, which means they may not be interested in an inbound link from a rookie web site that has little or no rank. It's a bit of a catch-22, but there are some webmasters, such as myself, who are generous and willing to help those who are in the beginning phases of building their business's web presence. I like to think of such links as long-term investments—especially if the site is built around high-quality content.

Additionally, there are other link-building alternatives—such as reciprocal-link exchange communities. Most of these are paid membership sites, but some do offer free memberships with limited resources. I would sug-

gest taking a look at www.linkmetro.com, www.links-pal.com, www.linkmarket.net, and www.linkexchanged.com.

My advice is to be highly discriminating and only link up with sites that offer related services and products. You will likely receive many unsuitable link requests, so be prepared to turn away a number of unqualified links. Investigate every web site you consider linking up with. Once again, pay close attention to its Google ranking, the overall quality of the site's content, any broken links, the load time, as well as design consistency and compatibility with other browsers. Don't link to a site that you wouldn't refer a friend to visit.

Be sure that anyone who agrees to link up with you doesn't just place your link on their links page as "www.[*yourdomainname*].com". Provide them with the anchor link code, and make sure to employ your top keywords and keyphrases for your link's anchor text. Finally, if you're going to begin exchanging reciprocal links with other webmasters, make sure to build a link partners page on your own web site—and never exceed fifty links per page. A page exceeding this limit will not be indexed by Google and can trigger a penalty.

Sitemap. A sitemap is an HTML or XML page containing an ordered list of the pages on your web site. Sitemaps can expedite the search engine placement process by helping spiders and web crawlers locate all existing pages on your site. Sitemaps also allow web masters to assign a numbered value to each page that helps spiders and crawlers identify your site's most prominent and important pages to be indexed.

Most hosting providers offer utilities within the administrative area to create your sitemap for you. However, if your hosting provider doesn't offer this feature, please visit www.xml-sitemaps.com. This web site offers a free service that will create an HTML and XML version of your site's sitemap. Usually, sitemap(s) are placed on your web site's server in a folder titled "resources." To help spiders and crawlers locate it, I would also strongly advise placing a link to your sitemap on your landing page.

If you don't already have a Google account, I highly suggest that you sign up for one and start taking advantage of Google's Webmaster Tools. Once you've set up

your account and logged in, you click "settings" in the upper right hand corner and then select "Google account settings" from the drop-down menu. From there, you will follow a link, listed under "My products," to the Webmaster Tools. There is a quick verification process necessary, which will require you to add a snippet of metatag information into your site's index page. Google will provide you with your unique code. Once your site has been verified, you can then add your sitemap URL by clicking the "add site" button.

Yahoo allows you to submit your sitemap by following a similar procedure, except they require webmasters to upload a verification key to their site's root directory, which takes about 24 hours for validation.

Microsoft's search engine Bing has really simplified this process. If your sitemap presently exists in your "resources" folder, make sure to place a copy in your root directory as well. Your root directory is the top-most directory in your site's hierarchy (*i.e.,* www.fotoimpressions.com/sitemap.xml) or the very first directory accessed by your FTP client. Then type the following into your browser's address bar and replace "yourwebaddress.com" with your own web site address. Press Return and you're all done!

http://www.bing.com/webmaster/ping aspx?sitemap= www.yourwebaddress.com/sitemap.xml

Google's Local Business Center Listing. You can garner a great deal of SEO benefit by submitting your business to Google's Local Business Center. While searching on Google, you've probably noticed the local business results that appear with a convenient little map and a lettered listing at or near the top of your search results page. Appearing within these results can generate a lot of traffic to your web site. According to Internet marketing specialist Neil Lemons, in order to rank within the business center's top results, you should include the following in your business listing profile:

Photos. Google has only recently allowed this. Add as many photos as you can—and a company logo.

Reviews. It's important that these be from real customers. You cannot have too many. Don't fake them either; it's easy to see. Just as with Amazon, people trust products with lots reviews that have kept above three stars.

Keywords in Company Description. They offer an area where the business representative can describe what the company offers.

Keywords in Company Name. Don't be deceptive by changing your company name, but if your keywords are in the extended business name or LLC, make sure this is the name with which you register.

Coupon. Google allows printable coupons to be added by your listing.

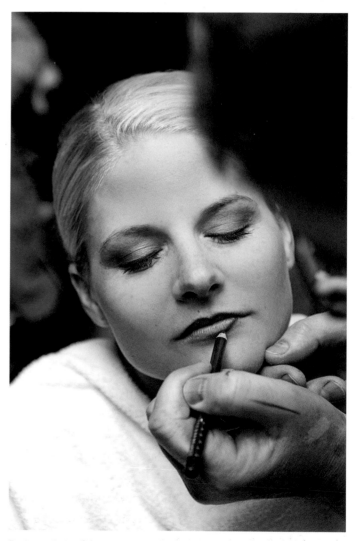

Rave reviews from your customers are powerful marketing tools. People trust businesses with lots of great reviews.

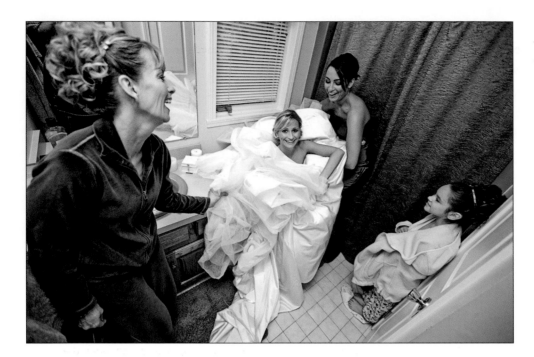

Photos can now be added to your Google Local Business Center listing.

Add these elements to your Google Local Business Center listing and you are sure to be in the top ten.

Links to the Listing. Add a link from your homepage to the listing and encourage current customers or web site visitors to review your company.

Videos. If your company already has videos on YouTube, you can place them right there on the page.

Submitting to Directories. You can submit your link to myriad of directories on the web. There are three primary types: paid directories, reciprocal directories, and free directories. I won't go into much depth about paid directories, since most of you won't have a surplus of cash to spend on advertising right out of the gate—but be sure to consider them for future link building.

Most directories that offer free link submission have a long queue. It typically requires anywhere from 30 to 120 days for them to review your submission and place your link within their directory. The reason for this is that (as you might suspect) many webmasters before you have submitted their link(s) for consideration, as well. Since online directories are mostly human-maintained, the process of review and placement is considerably slower than search engines that use spiders and crawlers to automate this process.

You will want to prepare for directory submission by writing two summaries of your web site services and products. The first one should be 60 to 70 words; the second one should be more concise—30 to 40 words in length. Be sure to prominently place your most important keywords and keyphrases toward the front of your descriptions. I save mine in a word-processing document and store it on my desktop for quick and easy access.

There are numerous sites on the web that compile listings of human-edited web directories with free site submissions. Simply perform a Google search for "list of free online directories" and you will find page after page of results. Once again, be selective about which directories you list your site with. As a rule of thumb, I don't list with any directory that isn't at least three years old. You will want to be sure to place your link within the most relevant section/category available on the directory. Usually, you will find wedding photography site listings under Shopping>Weddings>Photography.

The top two (free) directories you should submit your site to are www.aboutus.org and www.photolinks.com.

At aboutus.org you can sign up for a free account. One you have completed your new user registration, simply type your web site's address into their search bar and

hit Return. In just a few short seconds, they will retrieve information about your site (based on your site's metadata) and build a page for you within their directory. Now you will be allowed to edit information provided in your listing, including the company name, description, logo, contact, and related web sites. Take advantage of the related web-sites feature; here, you will be able to provide deep links (using anchor text) to pages within your web site, such as your blog and gallery page(s). Aboutus.org receives a PageRank of six from Google and will garner many great SEO benefits for your site.

After navigating to the photolinks.com web site, click the "add link" tab located at the top left section of the page. They offer free link submissions if you agree to give them a reciprocal link on your site. Click this option and fill in the provided fields with your contact information, web site address, and keyword-rich site description (limited to 255 characters). Photolinks.com also receives a Page-Rank of six and has strong relevance since it is wedding-photography related.

Other photo directory sites I recommend submitting your site link to are www.photographyhomepages.com; www.photographysites.com; www.topphotographers. com; and www.photodir.net. For a listing of 150 online directories that accept deep-link submissions for free, visit www.best-web-directories.com/free-deep-link-directories.htm.

Black Hat SEO. Often referred to as the "dark side" of search engine optimization, "black hat SEO" is a term used for unethical SEO strategies that attempt to subvert the established system of building presence on the web. In short, these are techniques that attempt to scam the search engines. Remember those unscrupulous spammers I mentioned before who wanted to turn the Internet into a muddled mess of male enhancers and tooth whiteners? Well, those are the types who commonly try to cheat the system. However, black hat SEO can hold its appeal for newcomers, as well—those looking for a shortcut or quick fix, and especially those who feel entitled to a top placement.

Hidden Page Text. Hidden page text is when a webmaster saturates or "stuffs" a web page with hidden key-words and keyphrases. These are invisible to human users because the text is either the same color as the page's background or placed in an external style sheet. In fact, you may be guilty of doing this—not for nefarious reasons, but for the sake of your site's visual design. During my undergraduate years as a graphic design student (when almost nothing was known about SEO), we were taught to hide unsightly text using this technique.

Purchased Links. Purchasing links is also considered an unethical SEO practice (ironic, since selling links is a major part of Google's enterprise [*i.e.*, Google Adwords]). I suppose it's a matter of "do as I say, not as I do," so we have to abide or face subsequent penalties. Unlike recip-

Today's modern bride relies on the web. Having your business place within the Google's top results can mean the difference between having a career or just moonlighting as a photojournalist.

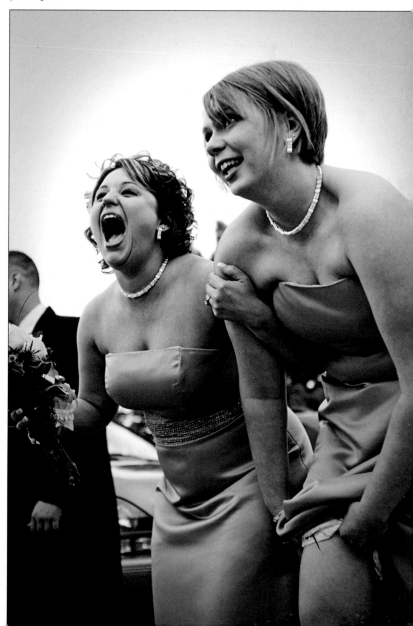

rocal link building, purchased links are one-directional; they are inbound links from top-ranking sites. Although, it is very difficult for Google to patrol and police every link on the web, I would strongly advise against purchasing links unless you're willing to risk a de-listing from Google's index altogether.

If your site is issued a penalty or de-listed from Google's index, you will likely receive a message in your Google Webmaster Console, followed by an e-mail informing you that your site has been de-listed. Indicators of a de-listing are fairly obvious; you will not be able to find your listing with the SERPs or you will notice a significant drop in the number of Google-recorded backlinks to your site.

If you want the most bang for your buck when it comes to generating sales for your business, there is no quicker or more cost-effective way than getting your business to the top of Google's SERPs.

Additionally, your site will likely experience far less frequent visits from the Googlebot search engine crawler. If such a penalty befalls you, immediately correct any of the issues that could have triggered the penalty and request reinclusion via the reinclusion link in Google's Webmaster Tools.

To keep things in check, ask yourself, "Would I be willing to have my web site audited by any of the major search engines?" If you feel any apprehension when putting this question to yourself, you should probably clean up your act. If you're concerned that you may be inadvertently doing something that may trigger a penalty from Google, analyze your page(s) by going to: http://tool.motoricerca.info/spam-detector/.

The SEO Wrap-Up. Today's bride relies most heavily upon resources provided to her via the web, and having your business place within the Google's top results can mean the difference between having a career in photojournalism versus moonlighting as a photojournalist. Google will always make revisions and refinements to its algorithm. Google may even, one day, devise an entirely new system for establishing pecking order on the web.

However, until that day arrives, we owe it to ourselves to stay informed and up to date on the topic of SEO. It used to be that you'd hang your sign, place an ad in the Yellow Pages, and rely solely on satisfying the customer and building your business's reputation solely through word of mouth, but the digital revolution has changed more than just the way we capture and view images.

The world's population is growing at an exponential rate, along with the technologies necessary to support our consumer spending. These days, business transactions take place on laptops and cell phones, from coffee shops and WiFi hotspots in airports and hotels. To be competitive in this market, you not only need to be good at what you do, you must be also be good at getting noticed amid the cacophonous crowd of your growing competition.

Sure, I could have written extensively on print media campaigns or radio and television spots, but I've also been in this business long enough to know what works most effectively. That's not to say that other forms of advertising are obsolete. But if you want the most bang for your

Tired of shooting at the same old venues? SEO can help you break into new cities—or even international wedding photography.

buck, there is no quicker or more cost-effective way than getting your business to the top of Google's SERPs. So, the next time you receive a call from some fast-talking telemarketer trying to sell you top search engine placement for your business, you can gladly say "No thanks, I can do that for myself."

BOOKING DESTINATION WEDDINGS WITH SEO

In 2001, I had been shooting weddings for five years and work was finally starting to feel like "Ugh—work!" Essentially, I was shooting the same wedding every weekend, just with different couples. I found myself returning, time after time, to the same hotels, churches, parks, points of interest, country clubs, etc. I was starting to burn out.

I realized that I was no longer being challenged and my work had become static and formulaic. I no longer felt like an artist, but rather an automaton. I was ready for a change; I still wanted to be a wedding photographer, but I needed to spice it up!

I decided to expand my marketing horizons seek out leads for destination weddings. To do this, I selected a few of my best images for promotion and began advertising in magazines and web sites that catered specifically to the more affluent, eclectic, and jet-setting clientele I was seeking. Here's the short list: www.ispwp.com; www.wpja.com; www.photographik.org; www.

destinationweddingmag.com; www.destinationidomag.com; www.theknot.com; www.offbeatbride.com; www.weddingchicks.com; www.swsmag.net; and www.weddingstylemagazine.com

I spent over $5,000 that year for print and web ads that subsequently landed me sixteen destination wedding bookings. The second year, that number grew to twenty-seven bookings with the same amount spent on advertising. By the third year, I began questioning: how I could get my name and my portfolio in front of destination brides without paying so much for advertising? The answer was obvious, but one that I had been overlooking: organic search engine results placement. Basically, the answer was Google!

I began to research something called search engine optimization—to me at that time, this was a cryptic language that left permanent creases in my brow. Within a few months, however, I had ripped through almost every book, article, and blog entry that existed on the subject. I was ready to take that top spot for "Destination Wedding Photography," pack my bags, and get my passport stamped!

So, while it's important to have a presence within your local market, you should also consider buying keyword-rich domains and developing web sites in other market/regions—especially if you're interested in traveling and booking destination weddings.

I suggest you start by picking the three nearest big cities or destination spots where you'd like to start booking weddings. Once you've got your destinations selected, begin by search-engine optimizing those individual sites so

Begin by search-engine optimizing those individual sites so that they will receive a decent rank . . .

To be competitive in this market, you not only need to be good at what you do, you must be also be good at getting noticed amid the cacophonous crowd of your growing competition.

that they will receive a decent rank and placement within the major search engines. Also, try optimizing your placement by increasing your site's keyword density for keyphrases that are geographically focused (*i.e.,* "Your Chosen City + Wedding + Photography"),

You should also consider optimizing your site for popular venues (hotels and resorts) that host destination weddings in your chosen cities. You would be surprised by how many brides find their photographers by searching their desired venue plus "photography" or "photographer" in their searches. Page one or two of Google is what you should be shooting for—but this may take a considerable amount of time and link-building to achieve dream destination cities (*i.e.,* Paris or Venice).

Just put this plan into action and you'll be writing postcards before you know it!

BLOGS

Blogs are veritable hotbeds of opportunity; if you don't already have one, you need to get one. As if consulting with prospective clients, documenting weddings, editing images, designing albums, and making sure our clients receive their wedding photos in a timely fashion wasn't enough, it's also incumbent upon us to make our most current work available to those seeking our services. Blogs not only make sense for their tremendous SEO value, but they provide us with a convenient way to connect with clients we haven't yet met.

My blog (www.fotoimpressions.com/blog/) presently generates enough incoming traffic to keep me (and four other photographers) booked solid throughout the wedding season. Brides love blogs. How do I know this? Because they tell me. Not only can they can view your most current work and establish a sense of who you are through what you've written and what others have written about you (readers' comments), but they can also borrow ideas from other brides featured on your blog.

I can't tell you how many brides I have booked who reveal to me that they had been following my blog for months before they were even engaged! What is most attractive about blogs is that they're not static. If you're a diligent webmaster, you're consistently adding new content to your blog and building interest in your work and a rapport with your clients. This entices brides to return and eventually book their weddings with you. A well-built blog that is frequently updated with fresh content will literally sell your work for you—but don't forget: users still have to find you!

Ideally, I recommend that you own both a primary site and a blog, but if you're just in the beginning phases of starting your business and you're working with a budget, I suggest starting a blog first. Blogs are fast, easy, and free! Typically, blogs can be set up within an hour—and many of today's popular blog platforms implement intuitive user interfaces that don't require professional assistance for setup or maintenance. In most cases, setting up your blog is as easy as creating an account profile on Facebook.

Blogware Programs. Three free popular blogware platforms are Wordpress, Blogger, and Typepad. Each platform offers bloggers distinct advantages, so I recommend that you research each of them before deciding which one is right for you. Currently, I use Wordpress for my wedding photography blog—but I first began blogging using Blogger, since it required very little initial setup. With Blogger, you don't have to purchase a domain name or web-hosting, since your blog resides on the Blogger servers.

This is actually one of the primary reasons why I switched from Blogger to Wordpress; although Wordpress requires that you have a domain-name and web-hosting, your database resides on your server. In the event that your blog crashes, this means you can restore any of your lost content directly from your blog's database. Since Blogger uses its own database to host your blog, you have no way to recover lost content in the event of a crash. Additionally, having a background in graphic design, I felt a little restricted when using Blogger's platform; many blogs created with Blogger share a similar look. Wordpress, on the other hand, is an incredibly customizable platform with over a thousand free themes and over seven-thousand plug-ins available to its users.

Wordpress is also compatible with many third-party theme developers such as www.prophotoblogs.com and www.photocrati.com. To locate more third-party themes,

Brides love blogs. How do I know this? Because they tell me.

simply Google "Wordpress themes for professional photographers." Wordpress theme development for professional photographers is a rapidly evolving enterprise, so spend a few hours researching what's new on the market. Premium third-party themes can range anywhere from $20 to $300 (for some of the more custom themes that include setup and hosting).

SEO Benefits. The SEO benefits of blogs are astounding, and once you begin to familiarize yourself with blogs (their construction and design) you'll understand why blogs can be your best friends when it comes to having your business discovered on the web. According to Lee Odden, CEO of TopRank Online Marketing (www.

toprankmarketing.com), the top eight SEO advantages of having a blog are:

1. **Structured Content.** Blog software with category features allows the aggregation of content according to themes. This makes it easier to algorithmically categorize content. If you can make it easier for search engines to understand your content, you have a much better chance of ranking well on those topics.

2. **Crawlable URLs.** Most blog software offers uncomplicated URL structure, making it fairly easy for search engine spiders to find and crawl blog content.

3. **Internal Links.** Blogs that post product- or service-related information can deep link anchor text to product information or purchase pages deep within the web site.

4. **Inbound Link Magnet.** One of the biggest benefits is that blogs link freely to each other—much more than web sites do. Blogs are also a significant source of many posts to social news and social media web sites. Text, audio and video are all easily supported for syndication by blogs. The more media is available, the more likely it will attract incoming links. Additionally, there are many widgets and plugins that make it easy to share blog content, thus encouraging links and traffic.

5. **Link to RSS Feed.** Links to RSS feed URLs that use the blog domain name will assist in building link popularity. When RSS content is syndicated or cited by other blogs, any embedded links will also assist in sending traffic.

6. **Fresh Content.** Both readers and search engines reward fresh content with repeat visits. From a search engine perspective, that means your site can be crawled more frequently, allowing your new content to become searchable more quickly. Fresh content is also indicative of a more authoritative web site.

7. **Active Community.** Comments and trackback features in blog software encourage interaction.

An active blog community creates the kinds of citations or signals from other sites (annotated and contextually relevant links) that search engines tend to reward in the rankings. Loyal blog readers can boost a site's visibility through advocacy on other blogs, in forums, offline at conferences, as well as on their own blogs and within the comments of your blog.

8. **Non-Search Traffic.** I think the greatest benefit of having an active blog has little to do with improving your search engine rankings, though. The best thing about blogs is that they allow you to generate substantial amounts of traffic via RSS and links that have *nothing* to do with search engines. My recommendation to marketers is to pursue traffic alternatives to search engines as aggressively as their budgets and marketing programs will allow. The result will be incremental increases in site traffic with search engine referred traffic an added bonus, if not correspondingly enhanced.

Here's a bonus benefit: With a blog and corresponding RSS feed(s), your site can benefit from visibility within blog and RSS search engines. Web sites without feeds (your competition, maybe?) are not included in these kinds of directories and search engines.

PAY PER CLICK (PPC) ADVERTISING

Before I learned about search engine optimization—when only three of my web pages appeared in Google's index on page 17 of the SERPs for my regional keyphrases—I realized that if I wanted to get my name out in front the 90 percent of brides who shop for their wedding photographers online, I was going to have to invest in PPC, pay per click advertising.

I began using Google AdWords PPC service in 2003 and paid $.25–1.25 per click, with a daily spending limit of $25. I won't tell you that AdWords will give you the greatest return on your investment—but, while you're waiting for all those newly implemented SEO strategies to take you to the top of Google's SERPs, give AdWords a go and see if it's right for you!

I can't tell you how many brides I have booked who reveal to me that they had been following my blog for months before they were even engaged!

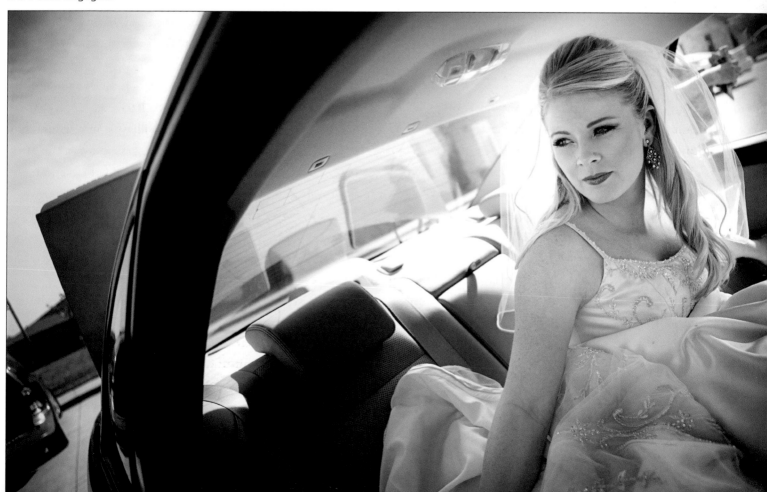

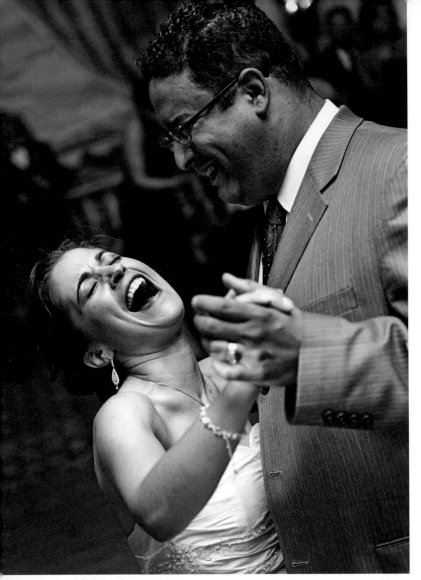

If you're a diligent webmaster, you're consistently adding new content to your blog and building interest in your work and a rapport with your clients.

Your objective should be getting your business name before a broad audience—even if the investment is $5,000 and the return is only $5,500. Ultimately, you're trying to build a brand and anchor your business's name in the minds of a brand-conscious clientele.

BUSINESS CARDS

I know—everyone and their brother has a business card these days. So should you fork over a few hundred dollars to join the card-droppers club? Absolutely. But you have to be creative, not just with your design, but also with how you implement your business card campaign.

For example, before every wedding, I create personalized business cards designed with a portrait of the couple on one side (from their engagement session) and the site address for their (future) online wedding gallery on the reverse side. I also strategically place a promotional code beneath the URL; if a visitor enters the code, they receive 20 percent off their first order. Unlike an e-mail that receives only momentary attention, these personalized business cards provide a permanent visual reference. They are more likely to linger in one's consciousness than a hyperlink. Implementing a promotional code will also allow you to keep track of your campaign's effectiveness.

Effectiveness is also determined by etiquette when disseminating your business cards. *Never* walk around and pass out business cards to guests at a wedding and *never* place a stack of cards beside the guest book. Most brides are more than happy to include their personalized cards in their thank-you cards. The only time I hand out a card at a wedding is when I am asked for one.

I pay roughly $20–40 for a hundred business cards. Of those one-hundred cards, I average twenty-five visitors who redeem their code. When it comes to business cards, I've always been able to recover my investment. They certainly won't make or break your business, but you're sure to book a few more weddings by adding them to your advertising arsenal.

When shopping for business cards, there are few sites I'd suggest looking at: www.4by6.com; www.modern-postcard.com; and www.moo.com.

ONLINE WEDDING VENDOR DIRECTORIES

Wedding vendor directories are comprehensive wedding planning communities that cater specifically to the interests of couples. They include a host of resources ranging from reception decor, wedding attire, flowers, rings, and cakes, to—of course—wedding photography. Some of the better ones, like theknot.com, make it possible for any bride to undertake the task of planning her own wedding like a pro—and brides literally flock to these sites!

Many of the directories offer some sort of free listing for vendors; other will only grant you a link if you purchase a paid listing. If you opt for a paid listing, I would strongly advise you to make sure that you're listing your business in one of the top-rated directories, such as www.

theknot.com or www.brides.com. Also, be sure to target your local region(s) and implement your keyphrases when creating your business profile. Most importantly, use links with keyword-rich anchor text whenever possible.

A few paid directories I would suggest listing with are www.theknot.com; www.brides.com; and www.once-wed.com. A few free directories I would recommend are www.mywedding.com; www.projectwedding.com; www.weddingwire.com; www.onewed.com; www.wedj.com; and www.partypop.com

BRIDAL SHOWS

Bridal shows are like job-fair conventions in reverse; those seeking employment remain stationary while potential employers mill about and mingle with qualified applicants. Bridal shows can be a boon if you're looking to book a few weddings in a day's time—but be sure to do your homework first! Inquire about the show's attendance record and speak with exhibitors from previous years' events to ask about their experience.

When it comes to bridal shows, networking opportunities are endless. Chances are you'll be busy consulting with brides, so have your assistant take a lap around and collect business cards from all the exhibiting vendors. (Many of my reciprocal web site partners are fellow vendors I networked with while attending bridal shows.)

I don't recommend bridal shows for those of you just beginning your business, as they require quite a bit of print collateral (*i.e.,* albums, books, canvas wraps, prints, brochures, etc.) in addition to your booth rental fee. On average, I invest $3,000–4,000 to outfit my booth and see a return of $15,000–25,000.

If you plan on renting space at a bridal show, select a booth located away from the DJs and entertainers. Most bridal events host runway fashion shows that are quite clamorous—and screaming at your client is no way to start a relationship.

MAGAZINE ADS

Over the past decade, print media has been in a steady state of decline, which means there has never been a more auspicious time to take advantage of publishers who are willing to pare down prices. In fact, I've seen prices for premium ad spots so that were so low I literally had to call their ad department—because I mistook the price for a typo!

Most everyone is familiar with *Martha Stewart Weddings* and *Wedding Style*, but ironically the return on investment (ROI) for ad spots in these publications isn't quite as favorable as ad spots run in regional publications (*San Francisco Brides, Atlanta Weddings, Chicago Bride, New York Weddings,* etc.). To find out if your region, city,

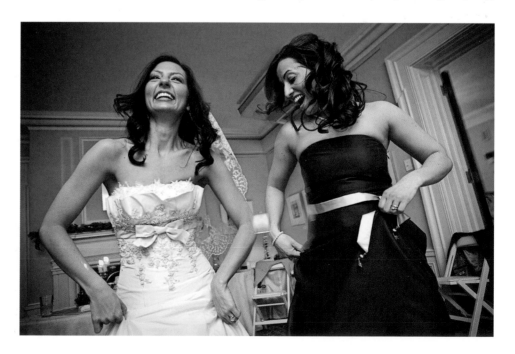

Bridal shows can be a boon if you're looking to book a few weddings in a day's time—but be sure to do your homework first!

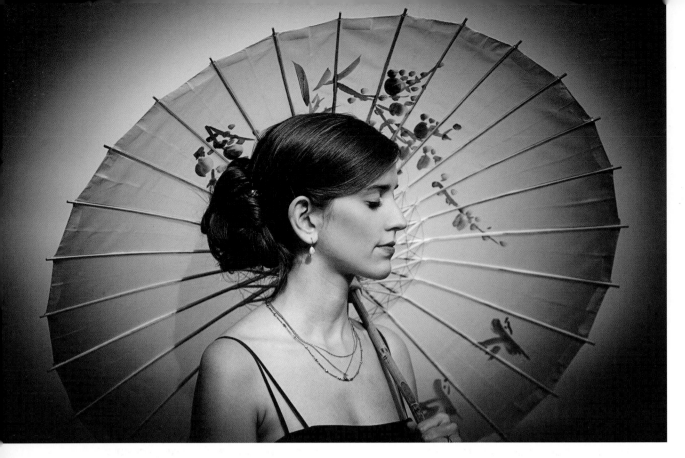

Brides are persuaded by pictures and design, not by logos and copy.

or state has its own bridal publication, simply Google "[your region, city, or state] + bridal magazine".

If you do decide to run a print media campaign, I advise you to purchase an ad space no smaller than half a page and no larger than two-thirds of a page. I've had over ten years experience placing ads in print media and have found that two-thirds- and half-page ads garner almost as much return as full-page ads, which are much pricier.

Aside from finding your target market and negotiating a killer price, the most critical part of your campaign is your ad's layout and design. Brides are persuaded by pictures and design, not by logos and copy. Put your best foot forward and use your most poignant wedding image with minimal text. Some of the most effective ads I've seen rely on one strong image and offer only a phone number, web site URL, or an e-mail.

Don't rack your brain for a catchy title or slogan; clean and simple is the solution. If you've never designed an ad before and don't feel comfortable creating your own, bring in a designer to do it for you. Trust me, it's worth the expense. The last thing you want is a poorly designed ad representing your business to prospective brides.

PRESS RELEASES

Press releases are common in the field of public relations. They are newsworthy statements or announcements written for the sole purpose of garnering media attention. Objectively written in third person, a press release should describe your business, products, and services in clear, concise language that doesn't read like a sales pitch; it should read like an announcement, not an advertisement. Releases should be fairly short; I suggest writing no more than 300 words.

A press release is a highly effective way to announce your new business, and it's absolutely free. Contact your city or town's local newspaper(s) office and inquire about their submission guidelines. While most newspapers accept digital press releases, there are still those remaining few who will require you to send in a hard copy of your release.

The best way to guarantee that your release will be published is to add an element of newsworthiness. For example, if your wedding photography business is "going green" and uses recycled materials for prints or albums, or if perhaps your business is donating proceeds from this season's bookings to a reputable charity, you're a shoe-in.

Don't be surprised if they ask to send a reporter to do a feature on your business. For more information on press releases, go to www.samplepressrelease.info.

BLOG PREVIEWS AND TURNAROUND TIME

Offering blog previews and a quick turnaround time are perhaps two of my most effective marketing strategies. The majority of wedding photographers take anywhere from eight weeks to six months to deliver images to their clients. Not only does this fail to capitalize on the lingering elation of newlyweds, it creates a climate of discord. I can't tell you how many times a member of the bridal party has made disparaging remarks to me about his or her own wedding photographer specifically for this reason.

Immediately following each wedding event (after I have downloaded all of my memory cards and backed up all my image files), I edit three to five photographs from my bride and groom's day and upload these "sneak peeks" to my blog. Then, I send an e-mail containing the blog link to the couple and kindly thank them for sharing their special day with me. What this accomplishes is threefold:

1. It alleviates any concern that I might have crashed my car or been abducted by aliens. Sending a few of my best captures reassures the couple that the beauty and emotion their day has been preserved.

2. It conveys to my clients that I am excited about their images. Aware that I have put in a full day documenting their wedding, couples are flattered and impressed by my continued commitment to providing them with peace of mind.

3. It drives traffic to my web site. It's not unusual for my site's traffic to spike by 200–300 additional visitors on the Sunday following a wedding. In addition to sending out a mass e-mail, most brides are members of Facebook or other online communities where they will post your blog link to share with others.

After each wedding, I edit a few photographs from my bride and groom's day and upload these "sneak peeks" to my blog.

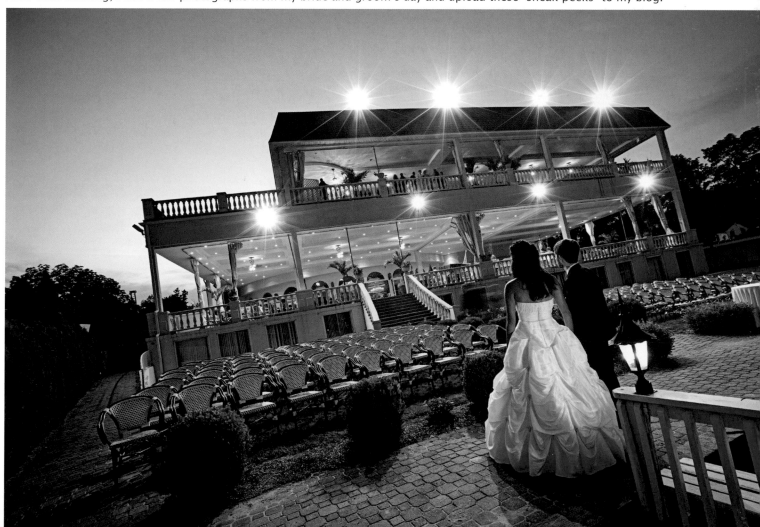

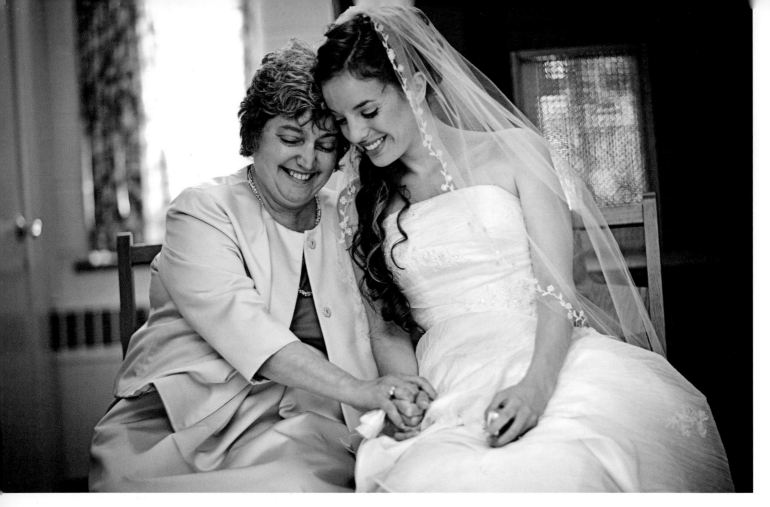

Over the years, I have learned that by turning around images in a timely fashion, my business flourishes. I finish editing each wedding I shoot within a week (or prior to my next wedding, whichever comes first). Although my client's gallery may already be completed and published to the web, I don't release that link until four weeks have passed.

When your work is received is critical to *how* your work is received. Waiting too long to deliver client images can be detrimental to your business, but delivering images too soon can stifle suspense. When creating proof galleries or slide shows of your clients' images, be sure to either host the presentation on your site or include links back to your site. I would estimate that I receive one- to two-hundred referrals a year from visitors to my clients' web galleries.

Devise a plan prior to each wedding season and budget enough time for yourself so you can guarantee quick turnaround for your clients' images. The last thing you want is for a good client relationship to go bad because you let yourself get caught behind the eight ball. Brides talk about their wedding photographers for many years following their weddings. Make sure that you give them only positive things to say about you and your business.

It's important to devise a plan prior to each wedding season and budget enough time for yourself so you can guarantee quick turnaround for your clients' images.

COMMUNITY SERVICE

No, this doesn't mean it's time to put on an orange vest and hit the highways. Community service is about reaching out to local businesses and organizations,

offering your services for free. This networking strategy is perhaps the most effective way to develop long-standing relationships and referral programs with other businesses in your community.

I'm assuming that the majority of readers photograph more than just weddings. Personally, I enjoy shooting city stock photography: skylines, major attractions, historic landmarks, architecture, parks, and commercial, residential, and lifestyle photography. Every town, regardless of its size, has a visitor's center or a chamber of commerce, both of which generate lots of printed materials for informational and promotional purposes. These are your two biggest networking allies.

The number of businesses that need updated photos for their web sites and annual reports would astound you. Approach the advertising departments of the businesses you photograph and inform them that you are establishing a new photography business and would like to simply donate a few free images on the condition that they consider your services when and if there is a future need for photography.

This strategy works well with non-profit organizations and as well as with other wedding vendors (*i.e.*, florists, entertainers, bridal shops, limousine and car service companies, etc.). I have relied on this practice for many years (in all of the cities I've lived in), and many of those businesses are still clients of mine today. If you believe in Karma, then build your reputation not just as the photographer who makes outstanding photographs, but also as the photographer who does good deeds.

PROFESSIONAL WEDDING PHOTOGRAPHY COMMUNITIES AND AFFILIATIONS

I want to stress the importance of community when it comes to professional wedding photography—especially for those of you just beginning your businesses. Being a professional wedding photographer is more than just a full-time job; it is, essentially, a lifestyle. Our job description encompasses many roles; most of us are our own business's CEO, marketing and advertising specialist, accountant, public relations officer, consultant, customer service rep, art director, graphic designer, digital archivist, webmaster, and shipping clerk. Needless to say, we need all the assistance and resources we can muster to manage our businesses, to stay educated and informed, and to ensure the best quality services and products for our clients.

I grew up in a small community whose memories were entrusted to a small, elite group of well-known and established photographers—none of whom were interested in sharing their wisdom with me. I had to learn the old-fashioned way, by taking my lumps and paying my dues. Relying solely on trial and error, I made many mistakes and discovered what didn't work, many times over, before finding my way.

I didn't have a mentor and the Internet was a vast, unfamiliar frontier at that time. Fortunately, newcomers no longer have to navigate without a compass; there are scores of web sites and online resource communities dedicated to helping aspiring wedding photographers achieve their goals.

PPA. The Professional Photographers of America (PPA) is the world's largest non-profit trade organization for professional photographers with over 22,000 members worldwide. The cost for an annual Active Professional Membership is only $323 or $24/month. Some of their membership benefits are listed below. To review all of the PPA member benefits, please visit www.ppa.com.

Discounts. Members receive discounts on Adobe and Apple products, data recovery services, and FedEx shipping, copy, and printing services.

Insurance. Members have access to business liability insurance, equipment insurance, malpractice insurance, and more.

Copyright Assistance. The PPA is the only photographic association that provides a full-time copyright and government affairs staff.

Merit and Degree Program. Members earn merits for service, instruction, competition, etc. until they achieve a PPA degree recognizing their achievements.

***Professional Photographer* Magazine.** The PPA's monthly magazine delivers information on the latest products and technologies, guidance on

running a successful studio, and profiles of inspiring photographers.

WPPI. The Wedding and Portrait Photography International was founded in 1978 to meet the rising demand for an organization committed to providing educational and business related resources specifically for wedding photographers. The cost for a basic membership is only $99 annually. Some of their benefits are listed below. To review all of the WPPI member benefits, please visit www.wppionline.com.

Rangefinder **Magazine.** Membership includes a twelve-month subscription to *Rangefinder* magazine, offering product reviews, profiles of successful professional photographers, and articles about the business and creative aspects of professional wedding photography.

WPPI Convention and Trade Show. Discounted registration for the WPPI Convention and Trade Show, featuring presentations from top wedding, portrait, commercial, lifestyle, and fine-art photographers—as well as the largest trade show in professional photography.

Print and Album Competitions. Discounted rates for the AWARDS of Excellence 16x20 print and album competitions, offering prizes and equipment worth thousands of dollars.

Discounts. Members receive discounts from a variety of providers in the industry, including Drive-Savers, AlienSkin, Graphic Authority, and more.

WPPI Referral Network. WPPI's photographer database can bring you added photography assignments by allowing prospective clients to search by a specific locale and link directly to your e-mail or web site address.

SPS. If you're presently attending college for a degree in photography, I highly recommend that you join the SPS. The Student Photographic Society was founded in 1999 to provide career building resources, networking opportunities, and information resources to photography students. The cost for an annual membership is only $29 and includes numerous benefits, as listed below. To review all of the SPS member benefits, please visit www.studentphoto.com.

Career Assistance. The assistant search engine at www.studentphoto.com allows members to post a resume and up to six images.

Free Equipment Insurance. Every student member receives $500 in free equipment insurance (with a $100 deductible).

Sample Forms. Sample contracts, model releases, and copyright registration forms are all available for free at www.studentphoto.com.

Copyright Assistance. Copyright assistance is available to assist you in preventing theft of your work and assist you in recovering compensation if your work is stolen.

Student Volunteer Program at Imaging USA. Student volunteers get free access to all programs, parties, a hands-on portfolio review by some of the best pros in the business, and free lodging at one of the host hotels.

WPJA. The Wedding Photojournalist Association represents some of the best talent in today's professional wedding photojournalism industry. It's important to note that not everyone who applies for a membership will be accepted. The WPJA upholds highly discriminating standards, which is what makes a membership to their organization so exclusive. In the introduction, I mentioned photojournalists who maintain a purist position on wedding photojournalism—well, the WPJA is an association built and regulated by those beliefs. Membership to the WPJA is $300 annually. To review their guidelines for membership, please visit www.wpja.com.

AGWPJA. If your work doesn't fit within WPJA's guidelines, don't be discouraged; they have sister site, the AGWPJA (the Artistic Guild of the Wedding Photojournalism Association). This association is no less discriminating when it comes to selecting its members. However,

the AGWPJA's guidelines differ with regard to post-processing of images; they allow members to implement toning, textures, and artistic color effects in their editing process—as opposed to raw, unadulterated documentation. Membership to the WPJA is $240 annually. To review their membership guidelines, visit www.agwpja.com.

Photographik.org. Photographik.org is a directory of highly talented and elite wedding photographers worldwide. Its primary purpose is to connect photographers with consumers, but also photographers with other photographers. It serves as a knowledge-sharing community for those seeking to network and expand their enterprises. Once again, membership to photographik.org is regulated by a set of strict guidelines. Whereas the WPJA is most concerned with what constitutes a truly "photojournalistic" image, photographik.org is mostly concerned with what constitutes a "quality" image. To review their guidelines for membership, please visit www.photographik.org.

WPW. The Wedding Photography Workshop is a free online resource and sharing community that provides tutorials, tips, and advice to aspiring professional wedding photographers. The WPW also hosts monthly contests and an annual year-in-review contest. The WPW's primary goal is to provide educational resources for wedding photographers who wish to improve their technical aptitude as well as their business skills. Membership to the site and forum is free and open to anyone seeking greater success with his or her wedding photography business. To visit the site, go to www.weddingphotographyworkshop.com.

Beyond the myriad of benefits and resources that accompany a membership in any of these organizations, having professional affiliation(s) also serves as a mark of distinction to prospective clientele—so be sure to place the logo of your affiliation prominently on your web site. This lets your clients know that you subscribe to standards of quality and excellence upheld by your affiliation(s).

Having professional affiliation(s) serves as a mark of distinction. Be sure to place the logo of your affiliation prominently on your web site.

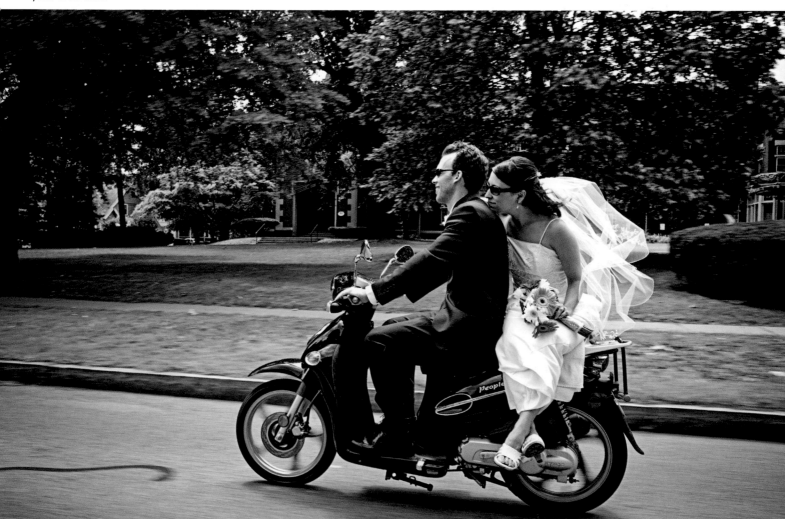

4. KNOW YOUR AUDIENCE

*E*ven if you're an established professional wedding photographer with a couple seasons to your credit, client consultations can still be hit and miss—which means you could be leaving a lot of money on the table. The best way to ensure your business's continued growth is by upping your consultation IQ and becoming a strong closer!

CONSULTING WITH CLIENTS

Consulting with prospective clients often proves to be a precarious game of cat and mouse. For beginning professionals, consultations are as nerve-racking as tightrope walking over a pit of angry alligators. No kidding—some of my first sessions were so awkward and uncomfortable that I seriously reconsidered whether wedding photography was the right profession for me.

Fourteen seasons later, I've concluded that the key to becoming an effective closer is control; you must know how to establish and maintain it at

What's your primary style? Posed and formal, relaxed, photojournalistic, creative, artistic, candid, traditional?

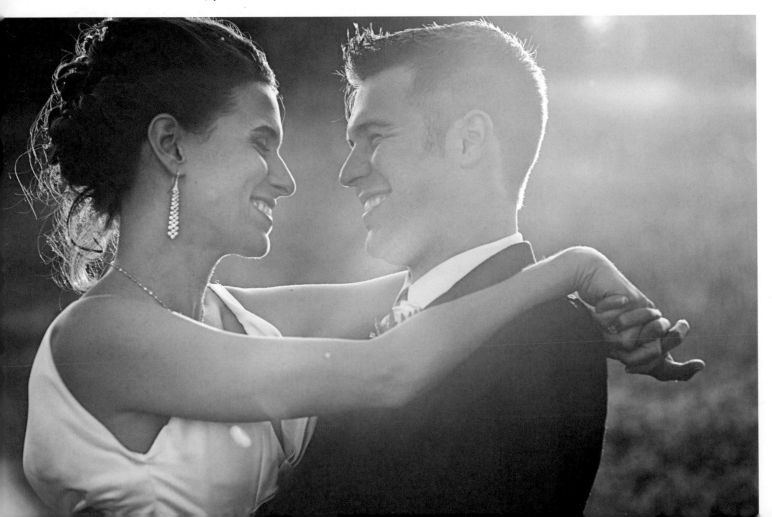

all times. When I say take control, I mean lead the pacing and progression of the consultation from start to finish. This doesn't mean that you should bully or browbeat your clients. Rather, you must be personable and charismatic—and above all, a good communicator.

Whether you're a wallflower or a social butterfly, I believe that everyone possesses the ability to be charming and engaging. The real challenge is being able to win over the many types of clients who might come through your door. This means that, beyond being personable and persuasive, you must also be able to accurately read your clients so that you can quickly "change up" your approach to suit a variety of interactive scenarios.

One way to build confidence and overall preparedness is to be preemptive; know what questions your clients are likely to ask you—and, more importantly, know which ones they're *unlikely* to ask. Be prepared for those curveballs. Having a well-practiced repertoire of rebuttals and redirections is essential to becoming an effective closer.

It's common for brides to come prepared with their bulging three-ring binders (I jokingly refer to them as "matrimony manifestos"), complete with a copy of "Questions To Ask Your Photographer." Here's a sample of some of the stock questions you may be asked:

- What's your primary style? Formal, relaxed, photojournalistic, creative, artistic, candid, traditional?
- Do you shoot in color or black & white? Or both? Do you shoot in a digital format that can create both color and black & white versions of the same picture?
- What kind of input can we have on the direction of the shots? Can we give you a shot list?
- Are you the wedding photographer who will actually take our pictures? If not, can we meet the person who will be?
- Can we meet any assistants who will also be taking our pictures?
- How many times have you worked as a wedding photographer? How many events were similar to the size and formality of our wedding?

- How many other events will you also photograph that weekend?
- What kind of equipment will you bring with you? How intrusive will lighting, tripods, other equipment or assistants be?

You should familiarize yourself with these questions so that you will be able to provide full, detailed answers upon request—but never let your client lead the session with their list of questions. An invaluable tip here is to be informative while remaining conversational; satisfy these questions before they're asked. This is a hallmark of a seasoned professional.

By providing a thorough and comprehensive breakdown of your services you will demonstrate to clients that you have a sincere interest in allaying their questions and concerns—and, more importantly, that you identify with them. I strive to go above and beyond just answering the cursory questions like, "Do you bring backup equipment to every wedding?" I make it a point to introduce new questions for my clients to ask of other photographers they might interview after their session with me. I inform them on a range of topics from the importance of shooting in RAW to why a legitimate professional wedding photographer should carry liability insurance.

As much as I would like to secure a signed contract and be the last photographer my couples meet with, I will actually urge them to consult with other professionals before making their final decision.

You might be scratching your head and thinking that this tactic completely undermines the desired outcome, but I've found it to be a highly effective psychological strategy. Attempting to close clients on the day of the consultation can be off-putting; it may seem pushy or desperate. Even if I feel that I've won the couple's favor, I grant them time to weigh their options. I tell them that I understand that selecting the right wedding photographer is a significant decision not to be made in haste, and that they should meet with others and give themselves ample time to determine which photographer is right for them. Last but not least, I alleviate assumed pressures and deadlines for issuing a decision by letting brides know

that, as a courtesy, I will tentatively hold their date until I receive a definite yes or no from them.

Playing it cool is a definite winning strategy for closing prospective clients; it conveys that you have a great deal of confidence and trust in your own work and professionalism, which inspires reciprocal confidence and trust from your clients.

Never regard clients as customers. Some photographers feel most comfortable getting down to business the very moment a couple passes through their door. For me, it's common to spend the first fifteen to thirty minutes engaging the clients on a personal level. I'm genuinely interested in learning about the lives of those who may potentially commission me to document their special day. Be sure to inquire about their careers, educational backgrounds, personal interests, passions, avocations, etc.— and don't forget to ask about how they met! The answers you receive to these questions will break the ice and open the door to discourse.

The more you know about your clients, the easier it will be to develop a personal connection. While professionalism, quality, and price are all determining factors, clients are far more likely to book with a photographer they like and feel a strong rapport with.

My best advice is to abandon premeditated sales pitches—and to stop relying on an encyclopedic set of albums to distract your clients and spare you from the awkwardness of making small-talk. Trust me, if a bride schedules a consultation session, she is already familiar with your photographs; she's interested in familiarizing herself with *you*, the photographer. Yes, she's interested in learning more about your packages and philosophies, but ultimately she wants to find out more about your personality. Will you contribute to the stress and chaos of the wedding day, or are you the calming type who has a knack for diffusing stressful situations? Are you likely to have positive interactions with her wedding party, family, and guests, or will you be the aloof type that avoids eye contact and incites awkwardness in others?

So, when it comes time for your next consultation, proceed as you would if you were casually meeting with old acquaintances to help them choose the best wedding photographer and demonstrate how you fit that profile. Be genuine and forthcoming; satisfy all their questions and concerns in a conversational context. Your goal should not be slam-dunking a pair of prospects, it should be to make new friends and share your profession—and your passion for it—with a captive audience.

DO YOU REALLY KNOW WHAT BRIDES WANT?

Do you know what the average bride, in your regional market, expects to pay for her wedding photographer? Do you know what inclusions and amenities she expects in a basic or premium wedding package? Do you know how your business model (*i.e.*, the services and products you offer as well as your pricing/packaging structure) is perceived by prospective clients?

Knowing your audience is one of the most critical, yet often overlooked, aspects of building a successful enterprise. Gaining awareness of what appeals to prospective clients can help you align your business model so that you can increase your yearly bookings and ramp up your yearly revenue. It can also help you get a leg up on your competition and take over that number-one spot within your local market.

I workshop with a lot of wedding photographers who understand technical aspects of image-making and the logistics of business. When it comes to relating to clients and their concerns, though, they often return a blank, confused look—much like your clients would if you tried to engage them on the topic of color space.

Simply stated, most wedding photographers understand the business relationship from the photographer to the client, but not the reverse—from the client to the photographer.

So, how does one gain access to the client's perspective and all the valuable insights they have to offer by way of critical and candid discourse? You simply ask.

During my consultation sessions, I always make it a point to ask, "Have you had an opportunity to speak with or meet any other local wedding photographers?" If they have, I follow up with, "What was your experience/interaction with that individual like?" Quite honestly, if they were head-over-heels for another photographer, they

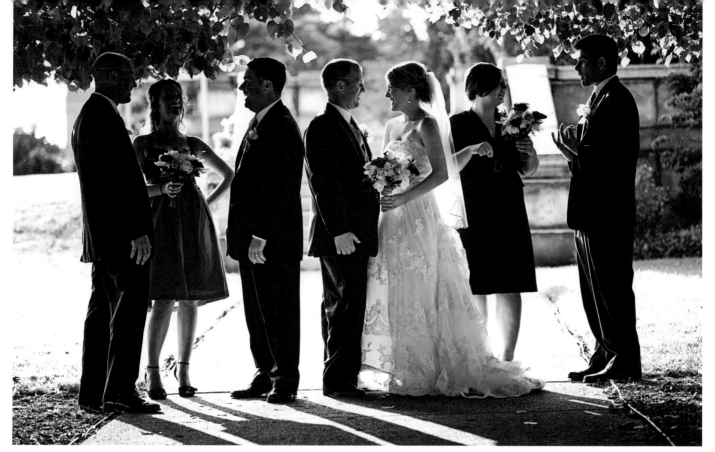

Do you know what the average bride, in your regional market, expects to pay for her wedding photographer? Do you know what inclusions and amenities she expects in a basic or premium wedding package?

wouldn't be sitting on my couch looking for something they had already found elsewhere.

If you're hesitant to ask these questions, fearing they might come across as prying or offensive, don't be. In my fourteen years of experience, I can't recall a single occasion when I offended a client by asking these questions. Some might feel more comfortable withholding the names of those they've met with, but generally clients will talk freely and openly about their interactions and experiences with other professionals.

The answers you receive will provide you with a more precise idea of the couple's decision-making criteria. Are they most concerned with price, product, or personality—the personal connection they feel toward their wedding photographer? The feedback you receive will help you focus on the topics most relevant to your client's list of concerns.

UNDERSTANDING THE COMPETITION

Equally important to gaining awareness of your audience is having understanding of your competition and how you

rank among it (in your own eyes). If you haven't already, you should acquaint yourself with the other professionals—their portfolios and business models—within two hundred miles of your studio/area of coverage.

If you can find out who you're up against and learn their strengths and weaknesses, you can even the playing field, so to speak, by emphasizing aspects of your business (shooting style, product quality, packaging, pricing structure, etc.) that might rank favorably over your competition and help persuade the client to select you.

CONCLUSION

The bottom line is this: although you may know the ins-and-outs of what you're selling, unless you know whom you're selling to, you may be fighting a frustrating and futile battle. (As my grandfather used to say, you might be trying to sell snow cones to Eskimos.) It's very easy to sell people what they want—and finding out what they want is as easy as paying attention to your audience and asking a few simple questions.

5. WORKFLOW: BEFORE AND AFTER THE WEDDING

For those of you who are new to the term "workflow," I like to describe it as the process by which we, as photographers, get from image capture to image delivery. Establishing a streamlined workflow is vital to your business's bottom line because, in short, the more time you spend creating your work, the less money you make.

BEFORE THE WEDDING

Traditionally, discussions of workflow focus on the image editing process (*i.e.*, processing images in Adobe Photoshop or Lightroom). However, for wedding photographers, our consideration of workflow should begin with how we prepare in the day(s) prior to each event. I started writing myself "to do" checklists many years ago; they're not only time-savers, they have—literally— saved me in instances where I might have otherwise forgotten a crucial piece of equipment or a detail about the wedding event I was to document.

Creating a checking a to-do list can help you ensure wedding-day success.

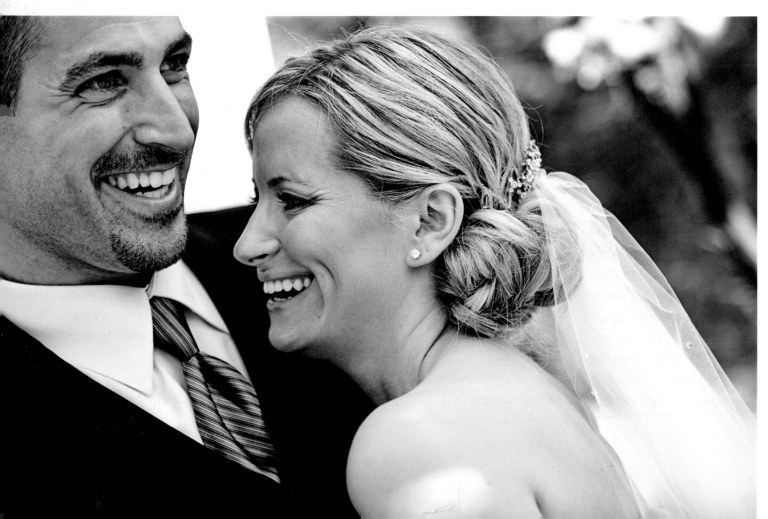

Equipment Check. My workflow regimen begins with a full equipment/diagnostics check four to five days prior to the wedding. This ensures that if any of my equipment is malfunctioning, I can quickly replace it with a rental while the damaged or broken item is being repaired. (An equipment rental house that is fast, reliable, and has award winning customer service is www.lensrentals.com.)

I also perform a walk-around inspection of my vehicle and make sure that it starts and has a full tank of gas. There is no feeling more harrowing than getting all of your gear loaded into your car only to spot a flat tire or find that the battery is dead from leaving your headlights on the night before.

Cleaning and Maintenance. After testing my camera bodies, lenses, flashes, and lighting kit(s), I clean my optics, as well as my camera's image senor. The idea of cleaning your camera's sensor might be intimidating if you've never done this before, but I promise it is a very simple routine maintenance procedure that anyone can do. Personally, I use the Senor Swab and Eclipse methanol cleaner. You can use the Senor Swab to clean your camera's mirror, as well. If you use canned air, be sure to invest in a Dust-Off Plus 360 Vector Valve so you don't risk getting any moisture into your camera body or lenses. (For more detailed information and tutorials on the various methods and products available to clean camera sensors, go to www.cleaningdigitalcameras.com.)

If you use a tripod-mounting plate, make sure it is fastened tightly and securely to the camera's base. I use Loctite's removable Threadlocker to prevent any possible loosening.

Batteries. Next, I make sure to charge all of my cameras' and flashes' battery units (including all backup batteries). If you don't presently use rechargeable batteries in your peripheral equipment, you need to go green and start using them. I'm a huge fan of Energizer's fifteen-minute quick charger, which uses AA NiMH batteries and comes with a power adapter for your car.

I use the NiMh rechargeables for a year (approximately forty charge cycles) and then replace them with a fresh set at the end of each season. I pack thirty-two rechargeables for every wedding I shoot, since I shoot with two flashes

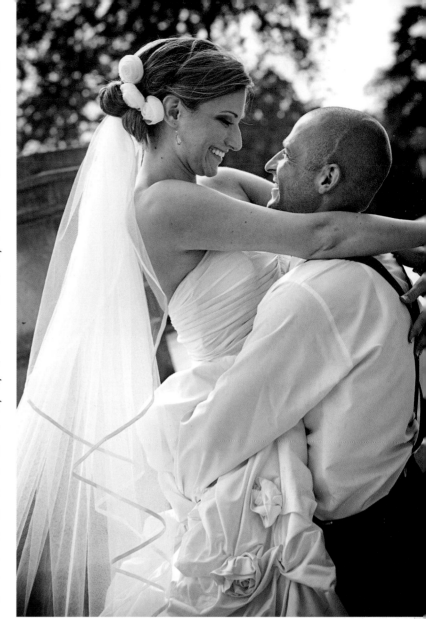

Comprehensive pre-wedding preparations let you remain more focused once you get to the event itself—and that sets the stage for better images.

that require four AAs each. These batteries can compete with—and even outlast—Energizer's Ultimate Lithium batteries, which tend to weaken because they're prone to overheating.

Memory Cards. I then format and erase all of my compact flash cards so I won't waste time when a card change is necessary. This also ensures that I won't begin recording images to a card that already contains images from my previous weekend's wedding. This would be a costly and regrettable mistake.

Camera Settings. After I've made sure my equipment is clean and functioning properly—and after I've charged

Dressing in solid, neutral-colored dress shirts and trousers ensures I blend in with the guests—making it easier to capture candid moments.

all of my batteries—I make sure my cameras' settings are how I want them. I capture in RAW, so I make sure that my image capture settings are set to RAW mode, and that my capture color space is set to Adobe 1998. (The RAW format and color space will be covered in greater detail later in the book.)

Finally, all pro DSLR camera bodies allow you to set the time and date, as well as the file-naming and numbering for the images you capture. Make sure to keep the time and date current on your camera and use a file naming and numbering convention that is simple and that will help you later when organizing and editing your work.

Clothing. It may seem obvious but it is often overlooked: we represent our business/professionalism not only in the way we interact with our clients, but also with how we present ourselves dress-wise. It's important to keep current with fashions. If you graduated high school in 1989, it's unlikely that what you wore to prom will work for your next wedding. You don't want to commit a fashion gaffe—or become a fashionista and have the focus fall to you. Remember, you're not going to a funeral; you're going to a wedding. Dress comfortably, sensibly, and professionally.

Having the right shoes is at the top of my list, since I'm usually on my feet for twelve to fourteen hours on the day of a wedding. I want a shoe that provides great support and breathability but doesn't look like a glorified sneaker or a dress shoe on steroids. After many years of switching shoes and trying out every Dr. Scholl's insert, I can confidently say that Clarks are the ideal shoe for what I do. They are well known for their Un.Sheridan rubber-soled shoes, which have a unique air intake and circulation system that cycles air throughout the shoe bed with each step. It's like having fans in your shoes. These sleek, attractive dress shoes are dressy enough for any formal occasion but perform like premium tennis shoes. Whatever shoes you choose, be sure to polish or clean them—and gentlemen, make sure your socks match!

I don't know about you, but I do a lot of bending and strange contorting during the wedding day and I owe my knees and elbows to Champion's neoprene knee and elbow supporters. Not only do they provide support, but they also provide cushioning when taking a knee or supporting yourself while resting on an elbow. They're so slim that you can wear them under dress pants/shirts without any unsightly seams or bulges.

I prefer to dress in only blacks and grays while documenting wedding events. Colors and patterns seem to draw too much unwanted attention; I'm more likely to blend in with the wedding party and guests when dressed in solid, neutral-colored dress shirts and trousers.

I strongly advise against wearing a tuxedo or a designer suit; overdressing for any occasion creates a conspicuous distraction and can cause discomfort—especially for the wedding photographer, since he/she will be bending, stretching, tucking, and folding like a human accordion all day. Make sure to tuck your shirt in, wear a nice belt or suspenders, and have your shirts and slacks cleaned and pressed prior to each wedding event. If you're going to wear a tie, use a tie clip and make sure you know how to tie a single Windsor—no clip-on ties!

Grooming your apparel is as essential as grooming your person. Make sure to invest in a lint roller—especially since you'll likely be wearing black. Cat hair and couch fuzz can foil even the swankiest ensemble. Just as I would never leave my studio without a backup camera, I never leave my home without backup attire. I can't

tell you how many times I've split a seam or just simply sweated through a shirt. Always be prepared!

I usually have my primary and backup ensemble professionally dry-cleaned and pressed three to five days prior to each wedding event. Make sure that you've picked up your dry-cleaning and inspect to see that there are no holes, split seams, stains, or unsightly wrinkles.

If you're going to accessorize, be minimal and avoid flashiness. I keep it simple—no earrings, cufflinks, necklaces, or nose-rings. I wear only a timepiece (a modest, black Timex watch). Do not wear cologne or perfume; none whatsoever! Finally, avoid bulging pockets by keeping your cell phone, Blackberry, wallet, billfold, and car keys in your camera bag.

Sleep. Working as a wedding photojournalist invariably means you'll be waking up early to document the day's preparations, whether it's a morning hair appointment with the girls or an early tee time with the guys. Most of your weddings will also include a bit of travel, which means you'll have to wake up even earlier! On average, I travel thirty to forty-five minutes in the morning to rendezvous with the wedding party for their morning preparations.

It's pretty common practice for me to wake up at 6:00 AM every Saturday morning during wedding season—even if I have a Saturday off. This keeps you in good practice, especially if your normal sleep schedule is that of a rock-star. I often have to reform my sleep schedule, since I'm night owl who finds that his most productive hours occur when the rest of the world is sleeping.

Aside from pulling an all-nighter and risking wild hallucinations, you can reformat your sleep schedule by shaving thirty minutes off your bedtime every night for a week. I like to use this method in conjunction with either a glass of wine or an over-the-counter sleeping aid—but never combine the two together or you could end up sleeping through the entire wedding season!

Unfortunately, we can't rely on caffeine to carry us through a twelve to fourteen hour day; without sufficient sleep, we can't perform optimally on the day of a wedding. I don't need to tell you that weddings are physically, mentally, and sometimes emotionally demanding. Would you consider shooting a wedding with only one camera battery that barely holds half a charge? No, of course not, as wedding photographers we do all that we can to put the odds and advantages in our favor, so don't overlook the importance of a good night's sleep.

AFTER THE WEDDING

A photographer's style determines whether or not his portfolio appeals to prospective clientele. However, we must not forget that wedding photography is a complex visual language brimming with subtexts, connotations, allusions, and subtleties that can seduce (or repel) one's audience. This is where editing comes into play; editing is how we articulate ourselves as image-makers.

Editing is a very intuitive and personal process for me, as it is often guided by what looks good to my eye. I believe we all possess a unique personal vision, which is why no two photographers will ever edit the same image alike. My editing style became more established as my proficiency with Photoshop improved. Even if you have an idea of how you want your images to look, you need to possess the tools and knowledge necessary to create that look. Once you've acquired those skills, you will begin to notice a consistency in the look of the images you create. This is when your style will really start to emerge.

Editing is a very intuitive and personal process for me, as it is often guided by what looks good to my eye.

Previsualization. Eventually you may begin to "previsualize," meaning that, while shooting and assessing scenes and subjects, you will be able to accurately envision the final post-processed product. Previsualization is a powerful tool that fully integrates the whole photographic process—from conception, to capture, to final output. You begin to see and interpret the visual world through the potentiality of your medium. This is the highest level of self-actualization for the photographer; once this level of awareness is achieved, the technical aspects of photography become secondary, allowing the photographer to concentrate more keenly on content.

My Digital Workflow. For each wedding I document, I capture two- to three-thousand images in RAW and edit approximately three- to four-hundred of those images when constructing the pictorial narrative of my client's wedding-day story. When it comes to post-processing, I edit 75 percent of those three-hundred wedding images individually and rely on presets, actions, and batch-processing for the remaining 25 percent. In fact, the presets and actions I use are ones I've made for myself based on my own personal workflow routine. Those actions are available at www.weddingphotographyworkshop.com.

After looking through some of my photographs, you can see that I like to create high-contrast monochromatic images and chromatic images with artistically rendered color effects, such as cross-processing and retro-vintage washes. I'm a full-frame shooter and love to exploit the camera sensor's entire surface area when composing and capturing my images, so cropping is rarely part of my editing process.

Editing begins with adjustments to the overall image exposure. I capture in RAW and edit in Adobe Camera Raw, so increasing or decreasing image exposure is not only quick and simple, it doesn't degrade the image's quality by introducing artifacts or noise. Highlight detail is very important to me, so I like to lower the exposure by one or two stops. I then introduce some fill light to restore the subtle shadows lost when lowering the image's exposure. Next, my concern shifts to the contrast. Rather than using the contrast adjustment slider, I create contrast by making slight adjustments to the image's tonal curve.

If I wish to make a black & white image, I simply subtract the color saturation and use the split-toning sliders to apply a bit of sepia or cyan to the image's highlight and shadow areas. To draw more attention toward the center of the scene, I like to add a slight vignette around the edge of my images. Then, my very last step is to import the images into Photoshop and apply sharpening, using the high-pass technique, before saving the files as TIFFs.

After selecting which images will make the final cut, and before I begin my editing process, I examine each individual image and determine the best way to proceed with editing it. Ultimately, I want to edit each image in a way that enhances the prominent visual features already present within the scene. As the saying goes, "You can't force a square peg into a round hole"; the same philosophy should apply to the way you edit your images.

I believe that each image comes with its own set of considerations. Be sure to give your images the individual attention they deserve and edit them in a way that accentuates their subject matter without making the editing technique itself the image's most salient subject matter. I invest a great deal of time and concern in my editing process. My style is the product of how I edit, but also the outcome of my work ethic; I edit images for my clients the same way I edit images for artistic exhibition.

The majority of our audience/clientele may be oblivious to these subtleties and nuances, but I've never been willing to gamble that the people who seek out my work—or those to whom my work appeals—are visually illiterate. I firmly believe that most people can discern "quality" when it comes to images, even if they possess no formal knowledge of photography or post-processing.

I believe the success of my work—and the distinct, captivating qualities inherent in the imagery that I produce—are the result of an ethic to which I have always abided. I always work to fulfill *my* expectations and to satisfy my own *personal* standards of quality and excellence. If I am able to meet those standards, then I invariably surpass the expectations of my audience/clientele. To me, this is the difference between a camera operator who is competent at his job and a true visual artist who is a master of his craft.

I firmly believe that most people can discern "quality" in images, even if they possess no formal knowledge of photography or post-processing.

Don't misunderstand what I'm saying; at the end of the day, this is still a business and we cannot abandon the bottom line. I'm simply saying that there's never a one-size-fits-all solution. We must work to find balance between being meticulous masters of our craft and being timely and profitably efficient at producing the final product.

Batch Processing: Presets and Actions. Whether you're looking to simulate the look of film or just want to apply some sharpening to your images, presets and actions can revolutionize your workflow by reducing the amount of time you spend editing and by adding artistic impact to your images.

Presets allow Adobe Lightroom and Camera Raw users to apply a set of previously recorded steps in order to produce a particular effect or aesthetic to either a single image or a group of images. These effects include color correction; contrast, sharpness, and saturation adjustments; black & white conversion; and creative color effects like cross-processing and split-toning.

Actions are exclusive to Adobe Photoshop, but function almost exactly as presets do. Actions are procedural steps prerecorded during the editing process; they're a bit like automated recipes for producing various photographic effects. Some actions produce subtle effects, like increasing contrast or color saturation; others can completely transform the look of your images.

Batch-processing allows Adobe Lightroom, Bridge, and Photoshop users to automate the entire post-processing phase. A user can select an entire folder of images and apply any number of steps they select to take the image from its raw, unedited state, to a finished or edited state. For example, I rely on batch processing to apply sharpening to my images and to convert my RAW files to JPEGs for client viewing.

Although I am big fan of presets and actions, I must caution you not to become dependent on actions and presets alone. It is vital that you learn how to successfully edit images individually *before* you batch process a thousand images and hit send. Relying solely upon automated processes can put even the best image-editor out of practice. Make sure to mix it up and get your hands dirty from time to time; that way you can keep your creative muscles toned and in shape.

Wedding Photography Workshop offers some of the most creative and cutting-edge presets and actions available on the market today. WPW's comprehensive collection of products have helped thousands of wedding photographers rev up their workflow and create distinct and recognizable photographs that sell. For more information on WPW's latest presets and actions, go to www.weddingphotographyworkshop.com.

My Basic Digital Workflow Breakdown. When I return home from documenting a wedding, the very first thing I do is restart my computer and download the memory cards to one primary folder on the internal working hard drive. Then, I transfer each memory card to its own subfolder within the primary folder. I end up with one main folder named after the couple (like "John_&_Jane_WED2010") and numerous subfolders named chronologically (like "SET1", "SET2", "SET3", etc.). Once all of the files are on my internal working drive, I backup the entire "John_&_Jane_WED2010" folder to an external hard drive.

The next day, I batch update the metadata through Adobe Bridge, Lightroom, or Photomechanic; I include my business name and copyright date, my contact information and all relevant keywords, like "preparation" or "ceremony."

I load all of the RAW files into Adobe Bridge and review each, assigning a numeric rating to the pictures. Every photo that interests me gets a four-star rating. Once all of the files have been rated from zero to four stars, I go back through the collection and designate the best of the best with a five-star rating. My goal is to end up with three- to four-hundred five-star rated files.

Next, all files with less than a five-star rating are deleted. (*Note:* There is still a backup set of these images on my external drive, just in case.) The five-star files are then moved to a new folder within "John_&_Jane_WED2010" entitled "Edits", which is where I prepare the images for the disc, online gallery, and album.

Now, I begin the actual editing process in Adobe Camera Raw. Using Camera Raw, I'm able to individually and batch adjust the color, exposure, contrast, fill light, clarity, and sharpness. After I've made my Camera Raw edits and saved the files as high-quality JPGs or TIFFs, I open each image in Photoshop and make additional selective edits, like cropping, setting the white and black point, dust removal, and light retouching with the patch, clone, and healing brush tools.

Using custom made Photoshop actions (available at www.weddingphotographyworkshop.com), I automatically sharpen each image using the high-pass layering technique, flatten the images, apply a border, and save each image to the "Edits" folder as a high-quality JPEG.

After editing all of my five-star rated images, I take one last look at them in Bridge and make slight alterations to their order to give the greatest visual impact. Next, I launch Adobe Lightroom and create an online gallery using the Simple View slide-show option. I save this gallery to the "John_&_Jane_WED2010" folder and also back it up on my external drive.

Now, I publish the collection of images online and send an e-mail to my clients containing their link and password. The next day, I burn a DVD of high-resolution JPEGs, which I mail to my client. Lastly, I delete all of the files from my computer's internal working hard drive and format my memory cards.

From start to finish, my editing workflow takes around six hours, starting with sorting about two-thousand RAW

Even while I'm capturing images, I'm thinking about how I will edit them. It has become a very organic and transparent process for me.

files and ending with delivery of three- to four-hundred perfectly edited files—including black & white, sepia, textured, and artistically rendered color images.

Speed. Speed and efficiency are skills that I've acquired over sixteen years of editing. Even while I'm capturing images, I'm thinking about how I will edit them. It has become a very organic and transparent process for me, knowing my strongest images and also knowing how to best edit them.

A useful tip that can speed up your workflow is to "edit in" when selecting your best images for album inclusion or client proofing. Editing "in" (as opposed to editing "out") means that you will be determining which images are *keepers* before you decide which ones to kick out. It's easy to lose a lot of time jumping around from folder to folder, image to image, reviewing your images many times before making your final cut. Don't let the selection process overwhelm you and place you in a perpetual state of doubt. Ultimately, this process should exceed no more than two stages:

Round One. Review all images in chronological order and place four stars beside every image that has interesting content and composition, is clearly focused, and holds the eye's interest.

Round Two. Re-evaluate only the four-star images and place five stars beside every image that has unique story-telling potential and aesthetic merit. Ultimately, you will want to narrow your five-star selections down to two- to three-hundred images for the final collection.

My computing system is set up for speed, as well. I use Macs with quad processors with at least 8GB of RAM and allocate the maximum allowable amount to Photoshop. I also use scratch disks to optimize performance and speed while handling large files and batch processes.

Aside from the tools (hardware and software), speed and consistency are products of repetition (*i.e.*, editing a quarter million images year after year). As the saying goes, practice makes perfect—but it also helps to speed up performance. Above all, I find that establishing a start-to-finish workflow and eliminating redundant steps is the best way to begin building speed and establishing an editing style that works efficiently.

6. SHOOTING

HOW MANY CAPTURES SHOULD I MAKE DURING A WEDDING DAY?

For me, my visual process of acquisition/capture is rapid. I literally cannot move or shoot fast enough to capture every angle, composition, and subject of interest I see. If I could, I would be shooting ten- to fifteen-thousand images per wedding. Because of the infinite and inexhaustible number of images I can capture with digital photography, I can react to my visual intuition and be a more improvisational and spontaneous shooter. With film, we literally paid for every unplanned photograph we made.

I don't think anyone can put a number on how many "good" photos could or should be taken at a wedding; I shoot *everything* I have an instinct or impulse to shoot. In fact, my strongest images are the result of instinctive and obsessive shooting—shots I would never have chanced when I was a film shooter. I presently shoot two- to three-thousand images per wedding (about fourteen hours) and deliver, on average, three- to four-hundred strong, edited images to my clients. I could easily increase that number to seven- to eight-hundred if I wanted to go blind editing for a few more days.

I think it's very common for crossover shooters (those who once shot weddings using film) to remain conservative and modest in their approach. It took me roughly two years of shooting digital before I really engaged the medium and capitalized on the creative liberation that digital delivered.

I encourage you to shoot everything that holds even the slightest visual interest or appeal. Be impulsive and implement a shooting style that is more like using a net than a spear. Visually speaking, there are some rare and phenomenal creatures swimming around us—at all times—that are too fine and fleeting to be angled any other way.

DIGITAL *VS*. FILM

I began my photography education four years before digital came on the scene. At first, I was adamantly opposed to digital and even color photography. I was a staunch formalist who shot only black & white and prided myself on mixing my own chemistry and laboring in the darkroom until my pupils practically popped. I thought anyone who didn't print his or her own work couldn't be considered an artist or taken seriously as a photographer.

> My strongest images are the result of instinctive and obsessive shooting . . .

Many of my philosophies and practices have since changed. I was very sentimental about film and indifferent toward other image-making mediums—especially digital. Looking back, I now consider myself fortunate to have entered into photography at such a critical stage in its history and reformation.

Process is not what makes us great photographers or artists; it is simply the technology we use to bring our concepts/ideas to fruition. It has taken me many years to let go of my elitist attitude and accept that even pedestrian images, shot with point-and-shoots and cell phones, are as relevant—and, in many cases, as intriguing and provocative—as any professionally made images or other visual works of art.

Whether an image was apprehended using a digital or film camera is of no consequence to me. Personally, I don't care who knows what about silver halides or push/pull processing. As far as I'm concerned, the medium is no more than a means to an end. That end is the image, and that's what matters most to me.

I simply cannot deny the overwhelming advantages that digital holds over film. If you wish to compete in this business, you must be willing to embrace digital photography and the technology that encompasses every phase of its process. Eventually, this may require digital wedding photographers to possess proficiency at HD video as well.

RAW *VS.* JPEG

Now that you've had time to explore all the features and custom settings on your new DSLR, you're finally ready to find out what RAW format is all about. The best way to introduce you to RAW is to discuss the logistics of each format.

RAW. RAW image files are uncompressed image files, which means that all of the information collected by your camera's sensor is preserved and stored within the RAW file. This produces large image files (*i.e.*, a 10-megapixel camera in RAW mode will produce a 10MB file). Depending on the camera, RAW images record 12, 14, or 16 bits of tonal information (JPEG files only record 8) and have a higher dynamic range, which gives them greater exposure latitude (*i.e.*, greater detail in highlight and shadow

I don't think anyone can put a number on how many "good" photos could or should be taken at a wedding; I shoot *everything* I have an instinct or impulse to shoot.

areas). The RAW format is not, however, a universally accessible image file format like JPEG and TIFF; this means RAW files require special software (like Adobe Camera Raw) in order for you to view and access them.

JPEG. JPEG is a universal format that can be read by virtually any software or open-source program capable of displaying images. Unfortunately, JPEGs record only 8 bits of tonal information, which means you're left with only half the tonal information that you would otherwise receive with a RAW file. Accordingly, JEPGs have a lower dynamic range, which means JPEGs preserve less detail in the highlights and shadows. Additionally, JPEGs are com-

pressed or "lossy" image files, which means that much of the original information captured by your camera's sensor has been truncated or "thrown away." This results, on the up side, in smaller files that require less memory and storage than RAW files. For example, a 10-megapixel camera will produce a JPEG that is 3–5MB in size.

Shooting in JPEG. Each time you capture an image in JPEG, you're allowing your camera to make critical decisions about how your image should look based on an algorithmic equation—a one-size-fits-all solution. Your camera's internal software (firmware) ultimately decides what part(s) of your image are worth keeping and what should be thrown away. Higher compression means more information will be discarded, which subsequently results in a greater reduction of JPEG quality.

If you presently shoot JPEGs, here's something else you may wish to consider: Each time you open a JPEG, make an adjustment in Photoshop (*i.e.,* levels, curves, color balance, etc.), and then re-save that image, you are losing *additional* data due to recompression. The resulting degradation is referred to as "artifacting." Compression artifacting occurs when a compressed image, such as a JPEG, is repeatedly compressed. Compression artifacts occur first within the fine detail of an over-compressed JPEG, appearing as misaligned blocks of muddled detail.

The two major advantages JPEG shooters have over RAW shooters is size and speed. While most mid-range DSLRs can keep up with the demands of the paparazzi and sports shooters who casually fire off a hundred frames in less than sixty seconds, most professional DSLRs cannot capture more than six to eight RAW images shot in continuous burst mode.

Shooting in RAW. Shooting in RAW allows photographers to be what they want to be: *in total control.* Rather than allowing your camera's fickle firmware to determine the fate of your images, shooting in RAW means that you will be in control of all editing decisions.

However, before you can fully appreciate the power of RAW, you will need a RAW editing software program. Personally, I use Adobe Bridge, along with Adobe Photoshop and Adobe Camera RAW, to access and edit my RAW image files. If you don't own Adobe Photoshop,

check with your camera's manufacturer; many produce their own RAW editing software.

I first open the folder(s) containing my images in Bridge and double click an image, which automatically opens it in Adobe Camera Raw. This is an incredibly powerful editing program that allows a user to make adjustments to color temperature, tint, exposure, brightness, highlight and shadow recovery, contrast, clarity, vibrance, and saturation. Virtually all of the adjustments you would normally make to a JPEG in Photoshop or Lightroom are available to you in the Camera Raw interface.

As noted above, RAW captures contain *all* of the original image data recorded by your camera's sensor. This accords the photographer a level of flexibility and control unknown to those who capture in JPEG. An example of this is blown-highlight recovery. Overexposed RAW images can often be recovered due to their uncompressed informational structure; with JPEGs, the information necessary to rebuild blown highlights has already been discarded and is irretrievable.

The Verdict. Whether we're discussing film or digital, the common denominator that determines image quality is the same: you want to capture and record as much information as possible. With film, you can produce a higher quality image by exposing a larger piece of film; with digital, the closest thing we can come to producing a "negative" is to capture in RAW.

If you're just starting your business and can't afford the cost of additional speed and memory for your computing system—or the idea of processing large RAW files is overwhelming—shoot JPEGs for now. However, I encourage you to eventually switch to RAW—or at the very least, experiment with it and compare a few images captured in JPEG against those captured in RAW.

As photographers, we all share in common a deep concern for our craft; we are connoisseurs of the visual. Personally, I have yet to encounter a photographer whose foremost concern isn't image quality. In fact, most of us are willing to risk bankruptcy just so we can afford the very best when it comes to equipment. So why would you not want the very best when it matters most—when it comes to the images you capture?

7. DO I REALLY NEED AN ASSISTANT OR A SECOND SHOOTER?

*S*o, you've just started your wedding photography business or you're amid the planning process, weighing the costs and benefits of hiring an assistant or a second shooter. You've researched all of your competitors' business models and discovered that the majority of them work with either or both.

Throughout my fifteen-year career as a professional wedding photographer I've photographed over four-hundred weddings. To the awe and astonishment of most of my competitors, I have photographed 75 percent of those weddings alone.

Like many of you, I had very little start-up capital when I conceived to photograph weddings professionally. I was young, uneducated, and inexperienced—which meant that I had to appeal to clients seeking economy. I priced myself so low that I barely broke even on my first twenty-five weddings, so incurring additional costs wasn't an option.

I'm sure you've heard the saying that one must "sink or swim." I had to improvise and adapt in order to hold my own and compete with two-shooter teams. This meant that I had to hustle and work twice as hard as those who had assistants and second shooters . . . or did it? By the time I could afford to hire a second shooter, I had already become self-sufficient and quite comfortable shooting alone. However, I remained curious what advantages there were to having an assistant or a second shooter. I began by pairing

By the time I could afford to hire a second shooter, I had already become self-sufficient and quite comfortable shooting alone.

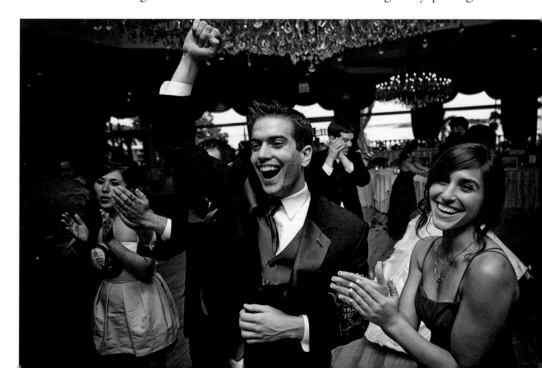

up with peers from my college photo program and other up-and-coming professional wedding photographers in my area.

Over the course of the following wedding season, I discovered that not all second shooters and assistants are created equal. I worked with a few who were rather remarkable, but they proved to be the exceptions to the rule. In the end, I felt like I was working harder for less money, as I was now responsible for managing someone else. Although there were some benefits, I began to wonder if having a second shooter was much more than just a selling point—an enticement for clients who simply believe that, when it comes to wedding photographers, two are always better than one. As I do with all important business decisions, I began to examine the pros and cons of hiring a second shooter.

THE CONS

Cost. Most second shooters and assistants expect to make $300 per wedding event—unless you're willing to hire a photo student from a local college, who may or may not have their own equipment or transportation. (And if this student fails to appear or perform poorly, you could end up losing more than the $300 you would have paid someone with sufficient experience.)

Time Investment. Having a second shooter means investing the time and money in locating and training competent prospects that can meet the necessary criteria for your business's professionalism and quality standards. This requires thorough interviews, portfolio reviews, as well as professional reference checks.

Paparazzi Effect. The paparazzi effect occurs when you put any two photographers together in the same room with the same subject(s). By nature, photographers are extremely competitive creatures; they're like gadflies when photo-ops arise. It is not uncommon for a "decisive moment" to be thwarted by the presence of two photographers moving in for the kill. Revealing moments shared between subjects are extremely delicate and can be easily derailed. I can't tell you how many times an overly ambitious second shooter has stifled what would have otherwise been a climactic emotional crescendo. Another issue

with second shooters is having them appear within your images. At times you'll swear they're conspiring against you, as they have an uncanny knack for finding their way into the backgrounds of your best shots.

Copycatting. Copycatting is a legitimate concern for anyone who reveals their business model to someone looking to establish a similar business for themselves. Like magicians guarding their secrets, professional photographers are highly protective of their "trade secrets," and rightly so. Don't get me wrong, taking a vow of silence is absurd and extreme, but I believe you should practice prudence regarding what you share about your business and with whom you share that information. If you're going to hire an assistant or a second shooter, proceed with caution and consider having your assistant or second shooter sign a regional, two- to three-year non-competition and non-solicitation agreement prepared and signed under the supervision of an attorney.

Babysitting. By default, most second shooters are young and inexperienced. Many will compensate by being overly aggressive or by becoming aloof when a situation calls for action. Overall, I find that most assistants and second shooters lack initiative and thus require a great deal of guidance and direction. As you can imagine, this can be very distracting and consequential to the continuity of the day's coverage.

THE PROS

Profit. On average, wedding photographers who operate in pairs book more lucrative weddings. Clients, in most cases, are willing to pay an extra $500–1000 for packages that include the services of a second shooter.

I have packages that can be tailored either way (single or second shooter) but find that most clients opt for the latter. Truth be told, second shooters rarely make significant contributions to what appears in your clients' albums, but they provide added assurance and incentive for most couples. When clients opt for packages that include a second shooter, they're purchasing peace of mind—because, let's face it, if your second shooter possessed the same level of experience as you, your prices would be double and they simply wouldn't be able to afford you.

Weight Loss. A second shooter will undoubtedly lighten your load and save you a trip to the chiropractor. If you're a photographer who likes to carry a variety of lenses and portable lighting equipment, let your assistant or second shooter do the schlepping—but make sure they're bending from the knees. Depending on your state's labor laws you may be held liable the occupational health of those you subcontract.

Gross Take. Having a second shooter allows you to produce more photos for your clients. Though the merit and content of their work won't always meet your criteria for album inclusion, having additional content provides you with an invaluable variety of options when it comes to constructing the narrative of your client's wedding day.

Ubiquity. For weddings that span multiple venues and weddings where timing constraints and location conflicts prohibit a single shooter from documenting the preparations of both the bride and groom, a second shooter is the only solution. Additionally, most clients desire to have front and back coverage of their wedding ceremonies. Given that many of today's nuptials run only ten to twenty minutes, not having a second shooter could easily result in lost photo ops at the altar for the sake of a rear wedding shot.

THE VERDICT

You should be aware of the pros and cons of working with a second shooter so you can make informed deci-

sions about when and why a second shooter may be necessary. As wedding photographers, we rely heavily upon our tools—but not all jobs require the same set of tools.

Second shooters can certainly give you a leg up, but they can also work to your disadvantage. Be highly selective about who assists or second shoots for you; they are representing your business before an impressionable audience of potential prospects.

Don't be afraid to fly solo. If you're just starting out, spare the expense of hiring a second shooter and go it alone. Shooting alone can be quite empowering and it forces you to develop skills that ultimately contribute to making you a more self-sufficient and effectual wedding photographer.

Alternatively, if you've only ever shot weddings alone, don't be afraid to pair up with another photographer. It may take a bit of time to find your second-shooter soulmate, but once you locate a reliable second shooter that you "click" with, you might just pop the question and promote them to a permanent position.

Shooting with or without a second shooter certainly isn't going to make or break your business, but sometimes the pros beat out the cons—and vice versa. The only way to know which option is right for you is to give each a fair trial. Each approach presents its own sets of challenges; patience and persistence will be your greatest allies when finding which option best suits you.

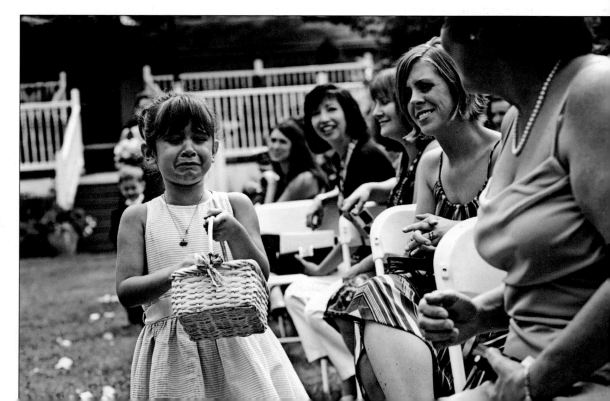

Shooting alone can be quite empowering and it forces you to develop skills that ultimately contribute to making you a more self-sufficient and effectual wedding photographer.

8. BECOMING A SECOND SHOOTER

*I*f you are in the preliminary stages of beginning your wedding photography businesses, you've probably assisted with a few weddings and now are considering a position as a second shooter. Working with a seasoned wedding photographer is the quickest and surest way to improve your skills and broaden your overall business sense.

As a veteran wedding photographer, I am highly selective when reviewing applicants for a second shooter position. Equally, I advise seconds never settle on the first wedding photographer willing to bring them on board; working alongside the wrong wedding photographer can be self-sabotaging. As I noted previously, not all second shooters are created equal—but this is equally true for primary wedding photographers.

FINDING THE RIGHT PHOTOGRAPHER

First of all, don't wait for a "help wanted" sign to be posted. Don't wait for an invitation at all; the best second shooter positions never get advertised. Com-

Most established wedding photographers are continually seeking new seconds and "fill-ins" for their presently employed seconds.

pile a list of local wedding photographers, then critically evaluate each photographer's work—the content, technical quality, and overall consistency of their coverage. Also, consider how well they interact with others. Did they come across as rude, impatient, or awkward when you spoke with them? A few important points to consider should be:

1. How long have they been shooting weddings?
2. Do they have any formal education or training in photography?
3. What professional wedding photography communities are they a member of or affiliated with?

Chances are, if they run their wedding photography business from a trailer in a used car lot, you might need to continue your search.

Don't be afraid to approach the best wedding photographers in your area. You might think they already have a surplus of second shooters or that they wouldn't be interested in someone with little or no experience. Wrong! Most established wedding photographers are continually seeking new seconds and "fill-ins" for their presently employed seconds.

Second shooter positions have tremendous turn-around; most are college students nearing the end of their programs or aspiring wedding photographers en route to starting their own businesses. On average, my seconds only stick with me through one or two seasons before heading back home or pursuing their own businesses.

WHAT PRIMARY SHOOTERS ARE LOOKING FOR

Personally, I look for someone who is just as passionate about photography as myself. I'm not interested in sharing the thing I love most in life with an opportunist. Besides, those who treat wedding photography as just a means to an end are usually the ones who have the weakest portfolios.

When an applicant walks into my studio, the first thing I pay attention is their personality and interpersonal skills—how well do they interact with me or my other photographers? Being a wedding photographer requires

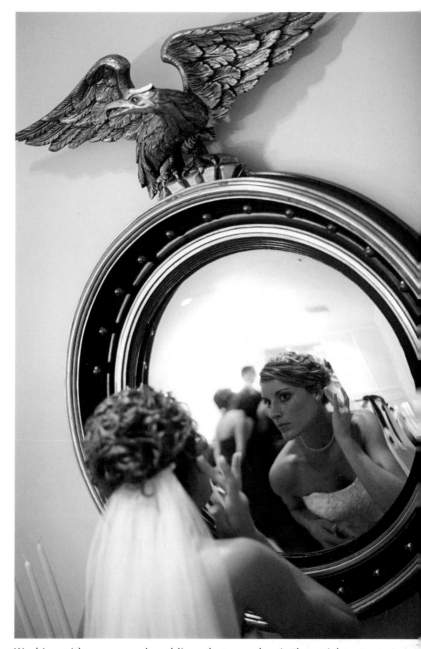

Working with a seasoned wedding photographer is the quickest and surest way to improve your skills and broaden your overall business sense.

a great deal of interaction with strangers; it requires outgoingness, assertiveness, tact, and a high tolerance for stress. Previous work experience in a customer service related field is a plus, but not a determining factor.

The rest of what I need to know is revealed in the applicant's portfolio and his or her portfolio presentation. If you show up to your interview in sneakers and a jean jacket, pulling loose prints from your backpack or purse, you probably won't get the job.

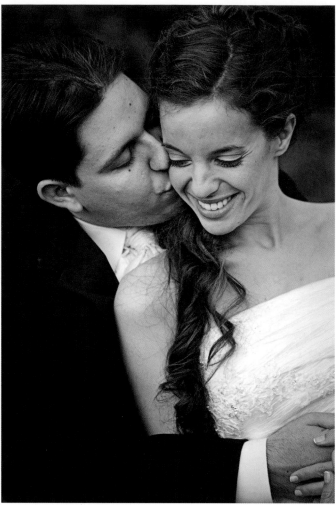

Even though I have a standard pay rate for all of my seconds, I like to ask applicants what their personal rate is.

RESUME AND PORTFOLIO

Submit both a digital and hard copy of your cover letter and resume. If you have a web site or work online, send the link—but don't show up at the interview without prints and expect the photographer to remember your work from a link you sent weeks ago. Although we live in the digital age and rely heavily upon computers for image previewing, it's important to have twenty to thirty of your best images printed, mounted, and sleeved in a portfolio.

If you choose to submit a digital portfolio or web site for review, be sure the program or slide show functions properly and can be viewed on both Mac and PC. Additionally, your web site link should be operational and easy to navigate. Personally, I would rather an applicant send me to their Flickr or Picasa account than a partially finished Flash site with poor navigation.

INCOME EXPECTATIONS

I have a standard pay rate for my seconds, but I like to ask applicants what their personal rate is. Some rattle off a figure before I complete the question, but many will stammer and search the sky for a floating figure before saying something like, "I dunno, I guess whatever you think I should make," or "Gosh, I've never really thought about it," or (my favorite), "I don't care, I'll work for free!"

Such responses indicate to me that the applicant may not think highly of themselves or their work, so I would suggest that you determine a value for your work and avoid making statements or speaking in a way that may seem self-deprecating. On the other hand, don't go into an interview with an arrogant or self-entitled attitude. I would much rather hire a shy or reserved second than some self-interested photo diva.

FINAL THOUGHTS

If you really want to make a strong, positive impression, do some research on your wedding photographer—it shouldn't be hard, since most photographers list their bios right on their web sites. If they have a blog (and they probably do), read through it and make mental notes about their most recent shoots or photo projects. Engage them about their work and ask them about their process!

Remember, this isn't a one-way interview here. Be sure to ask them relevant questions pertaining to your potential hiring. The most impressive candidates convey a strong, genuine interest and enthusiasm toward wedding photography. Talk about yourself and your work in a way that showcases your strengths, but also discuss your areas of weakness and areas where you'd like to improve. Ultimately, you want to communicate that you've carefully considered what you want and that you can contribute to this potential partnership.

If you don't have your own camera equipment or what you do own is sparse or outdated, don't worry. Most established wedding photographers have back-up or secondary equipment that they will gladly let you use. Also, it's okay if you don't have many wedding images in your portfolio. It's actually refreshing to see something different than wedding photos for a change.

9. THE ENGAGEMENT SESSION

The engagement session can provide the photographer and the couple with an opportunity to establish a more meaningful connection. Additionally, engagement sessions can aid a couple's understanding of the photographic process prior to the big event. Consulting sessions are usually when personal relationships with our clients begin; after all, they decided to book with you instead of your competition!

I am most interested in creating photographs that reveal personalities—the laughter, romance, and passion of my clients. To do this, I need to know about my subjects, so I supply my couples with a brief questionnaire prior to scheduling an engagement session. Here are some of the questions it includes:

- When you want to escape together, where do you go?
- What adjectives best describe your individual personalities?
- How would you describe your sense of humor?
- How do you make your fiancé(e) laugh?
- How do you display affection toward one another?
- Which of you is the more affectionate and outgoing?
- How would your friends and family describe you together to others?
- What is the cutest thing about your fiancé(e)?

I am most interested in creating photographs that reveal personalities—the laughter, romance, and passion of my clients.

- In what ways are you most similar to/different from one another?
- What accessories or props would make for fun between you?

The answers I receive help to inform critical decisions I may make regarding the couple's engagement session (*i.e.,* the environment to choose and the subject relationship to encourage). Additionally, this information allows me to interact on a more personal level with my subjects; I'm able to induce a myriad of moods and reactions using personal information I wouldn't otherwise be privy to.

LOCATION

Before making suggestions, allow your clients to choose their own location. Chances are there's a location of great sentiment they've already settled on. Unless my couple is coming in from out of town, I rarely select the venue for my engagement sessions. If you have to choose the location, select an environment in which you know your clients will be most comfortable. Some couples prefer a remote, quiet environment (a rural retreat or a park);

Props can kick start the session and enhance interaction.

others opt for a more public environment (a playground, amusement park, or arcade).

For all locations, research whether or not photography is permitted and that the location is not privately owned. Although being chased off by guard dogs or someone wielding a shotgun might make for some great candids, it's not worth the risk to your health or reputation.

TIME OF DAY

The time of day is an important consideration. First, not everyone peaks at the same time of day; some of us are running out of steam right when others are catching their second wind. Second, if your couple prefers privacy for their session, you'll want to select a day or time of day when pedestrian traffic is at a minimum. I would steer clear of public parks on weekends, for example. Last but not least, select a time of day that will lend itself to the ambiance you wish to establish. For my zany and playful couples, I really enjoy the early and mid-morning light; for my more modest couples, I find that the evening light can help incite and embolden affectionate displays.

CLOTHING

Clothing is a consideration that can easily be overlooked, but one that can bear tremendous impact to the outcome of an engagement session. Manufactured fibers (polyester, acrylic, and nylon) are less prone to wrinkling than fabrics made from natural fibers (cotton, hemp, and linen). Since your subjects will be in a variety of poses throughout the day, it's important that they not only wear clothes that make them look and feel good, but also clothes that can withstand two to three hours of playful frolicking.

Obviously, you will want to avoid clashing colors and patterns. I advise couples to bring two to three additional outfits so we can have some alternative choices at our disposal. Ultimately, you want your couple to make comfort their priority; a jeans-and-tee-shirt guy or gal won't feel relaxed (or photograph well) wearing a business suit.

PROPS

Props can help to kick start the session and enhance interaction. I'm not suggesting you go out and buy clown

Find topics you can all relate to and use what you learned about the couple from your questionnaire to help guide you.

shoes or an oversized tricycle, but be sure to ask your clients if there's anything additional they would like to incorporate in the engagement session. A lot of my couples have dogs and are *crazy* about them. If this is the case, you better overcome your fear of canines and keep a dog whistle within reach. A quick list of previously used props includes oversized sunglasses, pinwheels, balloons, tandem bicycles, wax lips, fake mustaches, and water pistols!

DIRECTION

Be sure to give guidance and direction to your couple; this is a big area of weakness for so many photographers. It's likely that your couple has never been professionally photographed together, so be prepared to contend with some camera shyness.

As a candid photographer, I want people to feel relaxed and do what feels natural for them, so I like to begin by giving only suggestions and slight direction. Ultimately, I want my subjects to feel that they have my full trust and confidence. I try to shower them with positive feedback and flattery.

My best advice is not to get preoccupied or overwhelmed with technical concerns. If you're obsessing about shutter speeds and f-stops, your head isn't in the right place. Your plan of attack should be to get really personal—not the creepy "I'm going to knit us all matching sweaters" type of personal, but you know what I mean.

I approach every engagement session with the same attitude as when I'm playing and making silly pictures with my closest friends. Laughter is my secret weapon when it comes to countering camera shyness. If you can get your couple to laugh, they'll be like putty in your hands.

Find topics you can all relate to and use what you learned about the couple from your questionnaire to help guide you. Usually, I will scout a location with my couple and spend fifteen to twenty minutes conversing with them about their day before the camera ever comes out.

I get excited when I shoot and I'm seeing something in the viewfinder that I like. I yell and whistle, hoot and holler—sometimes I even talk in tongues! I suppose that to an observer outside the situation, I might seem like a cheese-ball or a lunatic—but who cares? *I just made some killer images!* So share your excitement with your couple; it's not only contagious, it helps to build their confidence.

Alternatively, know that if you're tense or stressed, your clients will quickly pick up on your discontent and that will only exacerbate the problem. If the lighting isn't quite right or you're not getting good interaction out of your couple, just remain patient and positive until the magic happens.

10. SHOOTING STYLE

*E*ver watch other photographers work? Last year, I got to attend some weddings as a guest. While all my friends and family were focused on the bride and groom, I was scoping out the competition. It was an eye opener. Quite frankly, I was dumbfounded by what I saw—or, rather, *didn't* see! The photographers were never looking through their cameras! At times, I questioned whether or not they were even taking pictures, since I so rarely saw them with their camera at eye level. I thought to myself, "Maybe they're shooting from the hip . . . or perhaps they're just the assistant or second shooter?" After spying the shooting styles of a few wedding photographers, I realized that we often forget or just simply overlook the fundamentals of how we shoot. When I'm documenting a wedding, from the moment I arrive at the salon, until the last dance is over, my camera rarely leaves my eye. (Come to think of it, maybe that's why the prescription for my right eye keeps getting stronger?)

ALWAYS BE PREPARED

When I was about six years old my father took me on my very first fishing trip. Before letting me throw out my first cast, he said to me in that serious business-dad voice, "Don't ever take your eyes off your pole." I must say it was sound advice—but advice I was only willing to take after I learned the hard way and watched my beloved Snoopy rod-and-reel combo shoot

Quite frankly, I was dumbfounded by what I saw— or, rather, *didn't* see!

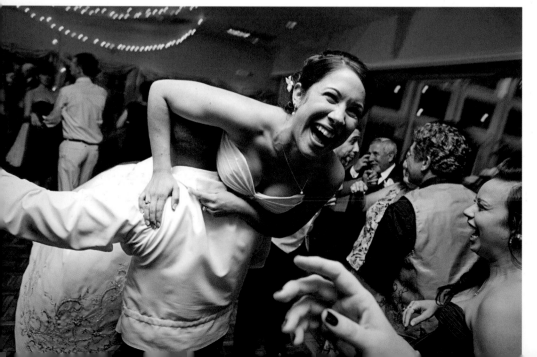

When I'm documenting a wedding, from the moment I arrive at the salon, until the last dance is over, my camera rarely leaves my eye.

off the pier and into the lake. I recalled that lesson of preparedness during my first year of shooting weddings. I noticed how a great moment always seemed to present itself at precisely the same moment I lowered my camera or looked the other way. I missed so many opportunities that it literally kept me awake at night with regret, and I vowed to never miss another great shot on the account of being "unprepared."

SELF-AWARENESS

When I'm workshopping with wedding photographers, the first thing I inquire about is their shooting style. How do they approach subjects, anticipate shots, and maneuver while shooting? Most reply with a blank look, because it's something we don't really think about—we just do it.

The wedding photojournalist's subject matter is momentary and highly unpredictable, so it's important to become aware of how you ready yourself for those decisive moments. In some regards, it's like shooting clay pigeons; one must have quick reflexes and be prepared.

I tell photographers to treat their cameras like video cameras, meaning that they should observe each scene without ever lowering the camera from their eye. For example, I notice a lot of photographers lower their cameras when speaking with subjects or being spoken to by their subjects. This is a bad habit you must break.

TALKING THROUGH IT

I'm not sure what strange phenomenon takes place when I'm shooting, but I often find myself struggling to form recognizable words or any sense at all when I speak. I think it's the arresting effect of having all of your faculties focused on what's in the viewfinder.

It has taken me many years to perfect the feat of being able to converse with subjects while shooting them—and unlike riding a bike, it requires practice, practice, practice. Personally, I like talking to my subjects and some of my best photographs have been taken during my discourse with clients.

Subjects will resume a more natural demeanor when the camera comes away from your eye. My strategy is to not give in, knowing that they will eventually retire their

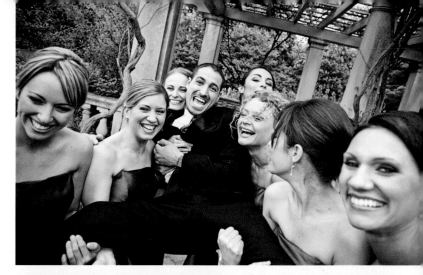

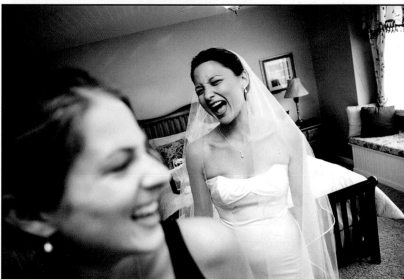

The wedding photojournalist's subject matter is momentary and highly unpredictable.

inhibitions, relax, and return to a more natural state in front of the camera. It reminds me of children who protest their parents by holding their breath. Eventually, they just have to give in, and they do—always!

CAPTURING EMOTION: LAUGHTER

Looking through my photographs, it's obvious that I love to capture climactic moments of raw, candid emotion. Above all, I've found that I have a knack for capturing one expression in particular: laughter! Fellow photographers and brides alike often ask me, "What do you do to elicit laughter from your subjects?" The fact of the matter is that I don't tell jokes or perform slapstick skits—I don't carry a bottle of seltzer or smash pies in people's faces. I don't do anything but document the moments as they naturally occur.

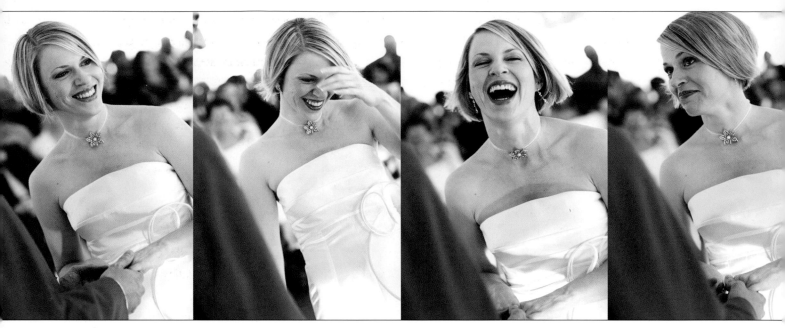

When hunting hijinks and bouts of hysterical laughter, I rely mainly on my sense of hearing.

Earlier in this book, I wrote a section called "Debunking the Myth of the 'Decisive Moment'," in which I addressed a common misapprehension among less-experienced photographers, who often assume that veteran shooters can predict when and where these moments will transpire. While I maintain that capturing a decisive moment is really just a crapshoot of chance and circumstance, prediction and anticipation do play a role in apprehending moments of emotional climax.

I rely heavily upon my sense of sight to locate a photo-worthy subject or scene. However, when hunting hijinks and bouts of hysterical laughter, I rely mainly on my sense of hearing. When I'm mingling among guests during cocktail hour events or receptions, or when I'm photographing guests as they assemble and are seated in the church, I simply listen for laughter.

Laughter and levity is definitely contagious—but it's also persistent and irrepressible once it begins. Anytime I hear loud, boisterous laughter, I make a beeline for the source of the action. Knowing that more laughter will likely ensue, I delicately approach the scene/subjects and carefully compose the scene. Then I wait.

I'm not sure how many of you have ever tried to photograph lightning without using bulb mode and a tripod, but I will tell you that the odds of you having a quick enough response time (and trigger finger) to capture a strike are lower than your chances of winning the lottery. Just like capturing lightning, you must be poised and prepared to capture genuine laughter/smiles. I will train my camera on a subject or group of subjects until the payoff comes— and nine out ten times, lightning strikes again and again.

Laughter and levity is contagious—but it's also persistent and irrepressible once it begins.

It's common for photographers to lower their camera once they've been "caught" by their subject(s), but big payoffs don't come without persistence and, above all, patience. Don't think that just because your cover has been blown that the potential for a decisive moment to arise has been foiled. Simply stand your ground and recompose. Allow your subjects a moment or two to ease back into their anecdotal exchanges. With your scene already composed and your focus locked, the rest is history—you've just captured lightning in a bottle!

CHIMPING

If you've never heard of "chimping" before, it's a pretty funny colloquialism that describes a compulsive behavior known only to digital photographers. When a photographer chimps, her or she is simply checking the camera's LCD display.

A lot of digital photographers who haven't worked with film, or haven't learned about proper exposure, rely on the image preview to determine what their exposure should be. Personally, I don't have a problem with this, but it's crucial for digital shooters to establish confidence in their technical abilities so they can advance beyond this phase where they feel it's necessary to check their camera's LCD window after every three or four captures.

If you're a photographer who finds yourself "chimping" after every three or four shots, try putting some gaffer's tape over your LCD and shooting for half an hour to an hour, until you can build the confidence necessary to break this habit. Remember, you'll have all the time in the world to review your images when the wedding is over—so get back to work!

CONFRONTATION

Confrontation is the term I use when referring to subjects that engage the camera head on and in some cases proceed to stare you down. The camera's presence just simply doesn't sit well with some; it makes people feel self-conscious, alienated, obtruded upon, and even harassed. Usually, these subjects will look the other way or avoid you altogether. However, some—usually males—will try to use their telekinetic powers to implode your skull.

Confrontation doesn't just apply to staring matches with alpha males; it can be as simple and innocent as being caught by a subject who suddenly becomes aware of your presence or their role as an unwitting subject in your photograph. Usually, they will wield an expression of surprise or perform a double-take and replace their natural gaze with an artificial one—but most startled subjects will recover quickly and resume whatever interaction elicited your original interest.

My advice here is to pursue your shot and stand your ground. It's important to never let an awkward subject make you feel unsure or as though your presence is unwanted or intrusive. Sometimes, I'll quickly shift my head to one side and send them a quick wink or just smile while shooting them; this almost always lightens the mood. But no matter what you do, *do not lower your camera* or walk away with your tail between your legs.

CONCLUSION

I'm sure you can all relate to these topics; the regret of missed moments doesn't leave us overnight. To some extent, we are all guilty of at least one or more of these behaviors—but all behavior is learned and can just as easily be unlearned.

In my experience, the relationship you have with your camera can seriously affect your subject's awareness and reception of you. For example, if you seem tentative about taking a shot and tiptoe around the subjects, they'll be even more likely notice you. Furthermore, nervous photographers make their subjects nervous; you can easily spoil a shot with ambivalent body language.

We are in the business of photographing the fleeting and unforeseen. That's the biggest payoff of being a wedding photojournalist—capturing those elusive moments of expression and intimate interaction. But even the photographer with the fastest lens can't compete with the speed at which a decisive moment dematerializes, so keep those cameras up and be ready for anything!

11. CRITICAL WEDDING-DAY PHOTOS

1. THE GRANDPARENTS

Some of our fondest childhood memories are linked to our grandparents. They are the dear and distinguished elders who enrich our lives with their love, wisdom, and remembrance. Photographs of the grandparents are especially important given the momentous nature of the day's event coupled with concerns surrounding their health and longevity. In fact, it's not uncommon for me to receive an e-mail or a phone call from a bride whose grandparent fell ill and passed away in the weeks or months following the wedding. As you can imagine, photographs of a recently deceased grandparent hold tremendous value to the family in mourning.

Grandparents are a bit elusive and among the most difficult subjects to capture candidly; they are from an era when proper protocol for picture-taking meant standing up straight and confronting the camera with a stoic gaze. Usually, the best time to photograph them is right before guests are scheduled to arrive. Grandparents tend to be punctual and often arrive at the church earlier than others. If you miss this opportunity, there's always the cocktail hour and reception—but bear in mind that they will likely depart immediately following dinner service.

> Grandparents are a bit elusive and among the most difficult subjects to capture candidly

The best time to photograph them is right before guests are scheduled to arrive.

2. THE CAKE-CUTTING

First of all, who can deny the awesomeness of cake?! The cake-cutting is definitely one of my favorite wedding-day photo-ops. While guests are scrambling to grab their cell phones and point-and-shoots, the suspense begins to build; will the couple play nice and gently feed cake to each other or will an all-out wedding cake war ensue?

My strategy for capturing this photo is fairly simple. I like to take a knee and situate myself directly in front of the cake table. I prefer to shoot this scene horizontally so I can include the cake somewhere in the foreground. You'll want to be sure that the batteries in your flash are fresh, as cake-cuttings often involves action and you won't want to miss the moment of truth—or its aftermath.

Don't forget to photograph the guests and their reactions, as well. This will be easy to do, since you will be positioned right in front of them. However, the bride and groom should be your primary concern. Don't chance a guest-reaction shot until after you've nailed the couple's cake exchange.

Will the couple play nice and gently feed cake to each other or will an all-out wedding cake war ensue?

3. THE BRIDE AND HER FATHER: PRE-CEREMONY

In those few remaining moments before a bride walks down the aisle and is given away by her father for marriage, a very tender and emotional farewell takes place. Sometimes, this rite of passage plays out in very subtle expressions, but more commonly it incites a strong stir of emotions.

I've seen my fair share of fathers and daughters burst into tears while waiting for the processional doors to open. It usually happens suddenly and without warning; one will turn their gaze toward the other, or a simple affectionate gesture like the clutching of a hand will provoke an outpouring.

Sometimes, fathers and daughters will stand apart, knowing that the closer they are to one another, the more likely an emotional sequence will result. In such situations, I will not hesitate to ask a bride or her father to lock arms with each other. This almost guarantees that a poignant interaction will unfold and allows me to make a photograph of them together, engaging and reacting to one another.

I've seen my fair share of fathers and daughters burst into tears while waiting for the processional doors to open.

This is a critical moment to capture—but unless you're shooting with an assistant or second shooter, make sure you're in position at the front of the church *before* the father and bride begin their walk down the aisle. If you are shooting alone, the church's wedding coordinator can help you time your departure to ensure that you're not stuck behind the pair as they make their entrance.

4. THE GROOM'S FIRST GLIMPSE OF THE BRIDE

Every bride wants a photograph of her husband's first reaction when he sees her walking down the aisle. Most brides aren't bashful and will remind you, many times, just how badly they want this moment captured.

While everyone is leaning out into the aisle to snap a quick picture of the bride, a very special and significant moment is taking place at the altar. The reaction varies

with each groom. Some stare blankly onward as if lost in thought or frozen with fear; others literally fall apart. It's not uncommon for the best man or church officiant to put a hand on the groom's shoulder and whisper a few encouraging words in his ear.

For this particular shot, I usually stand at the end of the aisle, in front of the first pew on the left side (where the groom and groomsmen are commonly positioned). This ensures that I will get a clear shot of the father and bride as they proceed down the aisle, but also a shot of the groom's reaction. There is no margin for error here, so if you're covering the ceremony by yourself, seize this moment either immediately after the processional doors have opened or after the father and bride have advanced three-quarters of the way down the aisle.

5. THE MOTHER OF THE BRIDE
HELPING WITH DRESS PREPARATIONS

This can be a tricky shot for reasons similar to the pre-ceremony photo of the father and bride; each may try to avoid seeing the other in an attempt to avert an emotional meltdown. If this is happens, simply ask the mother to partake in the bridal preparations or have the bride summon her mother. However, you may wish to confer with your bride prior to inviting the mother into the room; some brides specifically request that their mothers are not present during this time.

If the mother isn't already involved in the action, have her stand beside or facing the bride so she can help steady the bride while she's being laced up or while she's slipping into her shoes. Also, it is common to have the mother apply jewelry items such as pins, bracelets and necklaces, or other bridal heirlooms (often shawls, handkerchiefs, or rosary beads). After getting them together in the same room, I try to keep my distance and allow their interaction to proceed without further interference.

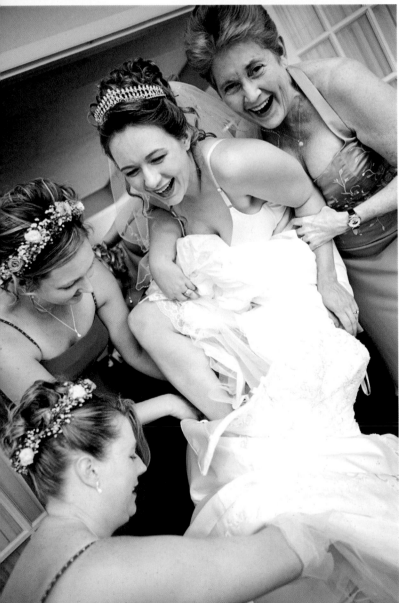

TOP—Every bride wants a photograph of her husband's first reaction when he sees her walking down the aisle.

LEFT—If the mother isn't already involved in the action, have her stand beside or facing the bride so she can help steady the bride.

I suggest photographing the dress preparations with a fixed wide-angle lens or a wide-zoom (such as a 24–70mm). Capture a collection of angles taken at various focal lengths, switching back and forth between vertical and horizontal compositions. Unless the dressing room has something dynamic to lend to the photograph, I try to shoot a sequence of tight shots, concentrating on action, hands, details, and expressions most of all. Be sure to take a few wide environmental shots to cover your bases, but make sure you're tight on your subjects when the emotions kick in.

6. THE BRIDE AND GROOM'S FIRST DANCE

The first dance usually takes place immediately after the bride and groom make their entrance into the reception hall. However, not all couples follow this format, so upon your arrival at the reception venue be sure to check with the DJ to get a rundown of the evening's events.

Wedding-day schedules don't always run according to plan, of course. This may result in a sacrifice for both the photographer and the wedding couple, since the portrait session with the bride and groom is often the first scheduled item to get dropped from the itinerary. If this happens, the first dance can provide you with a shot or two at redemption.

This is a critical shot because it's usually the first opportunity for the bride and groom to really engage one another, retire their worries, and take in all the joy, union, and meaning of their day. They will be lost in their own little world, embracing, kissing, and gazing into one another's eyes while their parents, bridal party, and guests look upon them with loving approval.

You will have approximately three to four minutes to make some really strong images of this interaction. I suggest getting close to your couple; don't be shy about getting out onto the dance floor with them if it means getting the shot. Shoot tight, but also shoot wide. You

will want a mixture of closely cropped verticals and horizontals, but also some wide shots that provide a view of the ballroom and observing guests in the background.

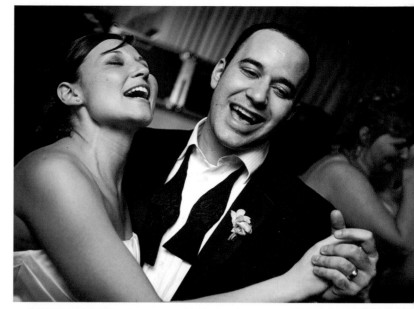

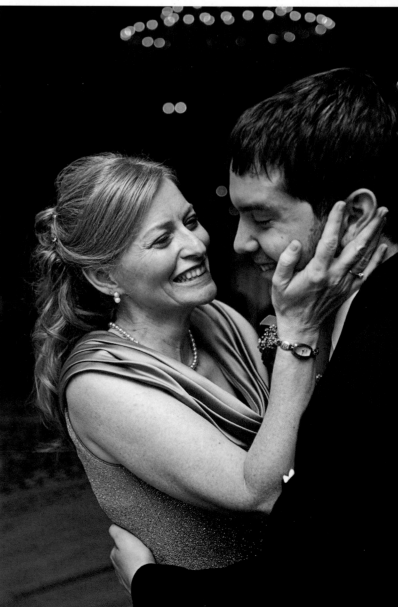

TOP—The first dance usually takes place immediately after the bride and groom make their entrance into the reception hall.

RIGHT—It's very common for the mother and son to either reminisce while dancing or sing to one another.

I usually shoot the first dance using a wide aperture while slightly dragging the camera's shutter (i.e., f/2.8 at $\frac{1}{50}$ or $\frac{1}{25}$ second while shooting at an ISO of 800, or sometimes 1600 depending on the intensity of the ambient light). Whether you're up close to your couple or on the fringes of the dance floor, never take a stationary position for more than a few seconds or you may risk losing favor among the guests by blocking their view of the newlyweds. If you're working with an assistant or a second shooter, have them capture some reaction shots of the parents while you concentrate on the couple.

7. THE MOTHER AND SON DANCE

This photograph comes in as a runner-up to the father and daughter dance, but is still a highly critical shot to capture. For the overwhelming majority of weddings, the attention and focus falls most heavily on the bride and the bride's family—that's just how it is. That said, there are few opportunities to capture intimate moments of interaction between the groom and his parents—especially with the groom's mother.

Mothers are very emotional about losing their sons, so this interaction can be a fairly dramatic one. It's precisely for this reason that making a great shot of both the mother and son together can prove difficult. Often, if a mother is crying or grimacing with emotion, she will pull tightly into her son and hide her face. So, in addition to the likelihood of a height discrepancy, you may have to contend with subjects shying away from the camera. The only way to remedy this is with patience and persistence. If there is crying, it won't last throughout the entire dance. Eventually, one of them will pull back a little and smile at the other, and this is when you should make your shot.

It's also very common for the mother and son to either reminisce while dancing or sing to one another. Talking and singing subjects are difficult to photograph, but just remain patient; they're building toward a laugh, I promise you. Definitely capture the tearful moments, as well— and don't let shy subjects dissuade you from getting close. If you're shooting with an assistant or a second, their lens should be trained on the bride and her family during this dance.

8. THE FATHER AND DAUGHTER DANCE

If the father of the bride has maintained his composure throughout the day's preceding events, this is one event where he will likely fold and express both joyful and grievous emotions over losing his little girl. Most fathers and daughters dance very tightly together; the bride crying into the father's shoulder or lapel and the father reciprocating with his head down and his eyes closed.

Once again, interactions vary from wedding to wedding and you can never fully know what to expect. Some fathers really strut their stuff on the dance floor, twirling their daughters like tops and fox trotting like there's no tomorrow. If this happens to be the format for your father daughter dance, you may have an even bigger challenge.

Whichever happens be the case, just remain patient and keep pursuing the shot. Wait for that moment when

Most fathers and daughters dance very tightly together.

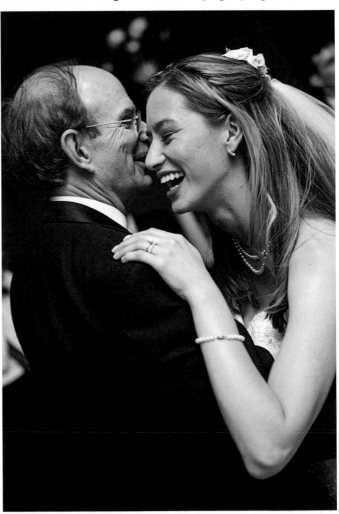

they pull back and engage one another; this will be the moment to photograph. Moments between tearful and embracing subjects can be quite powerful, but I always strive to make at least one strong image of my subjects confronting one another.

Fast-moving subjects in the low light of the reception can provide focusing and compositional challenges. If you've never photographed action under dim lighting conditions, you may want to practice it a few times to find out what equipment and technique works best for you.

A piece of equipment I've come to rely on for receptions is a hotshoe wireless slave transmitter. Slave transmitters emit a much stronger infrared AF assist beam than your speedlight, which means faster and more accurate focusing. Since your hotshoe will be occupied, use your flash bracket so you can continue to utilize your flash. In some cases, I will just hold my flash in my free hand and bounce it off the ceiling.

Shoot tight and wide using both vertical and horizontal compositions to frame your subjects. Drag your shutter; I suggest using a shutter speed of $\frac{1}{50}$ or $\frac{1}{25}$ second at f/2.8 so you can include a little ambient light and some subtle motion. Once again, your assistant or second shooter should have the camera turned toward the groom and his parents during this dance.

9. THE FIRST KISS

Perhaps the most critical and iconic wedding-day photograph is the first kiss. This is a shot you definitely want to be prepared for, so be sure to acquaint yourself with your clients' ceremonial schedule and bear in mind that most first kisses take place soon after the exchanging of rings.

I suggest shooting this scene vertically, but depending on your location and the couple's position, you may want to compose this scene horizontally. I try to place myself halfway up the center aisle, shooting with a 70–200 f/2.8 lens at a high enough ISO that I can achieve a shutter speed of at least $\frac{1}{100}$ second.

You can never really know what kind of kiss to expect; it depends on the couple. Most first kisses are short and sweet especially at Catholic weddings. However, some can be pretty passionate and awkwardly excessive in length. I

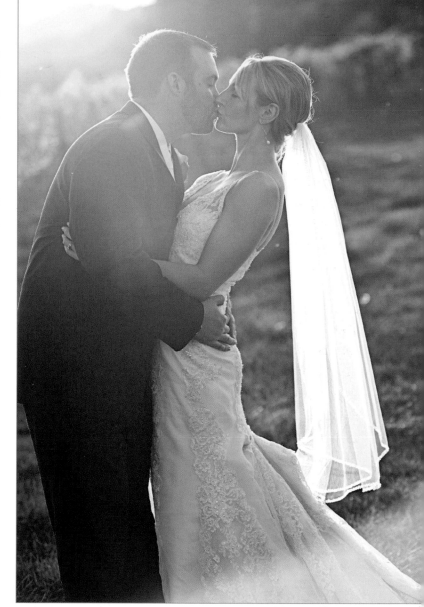

Perhaps the most critical and iconic wedding-day photograph is the first kiss.

prefer the latter since they provide longer opportunities to not only get the shot, but also to photograph the reactions from the guests and even the officiant.

If for some reason you miss the kiss, don't panic—I repeat: *do not panic*. I have missed many first kisses throughout my career, and what I am about to tell you can really help you recover the lost shot if you find yourself in this predicament. Immediately after the couple has left the altar and the guests have exited, have the couple quickly return to the altar.

I usually tell them that I need to grab a few quick shots before the decorations are taken away. *Do not* tell them that you missed their kiss. Resuming my position, halfway

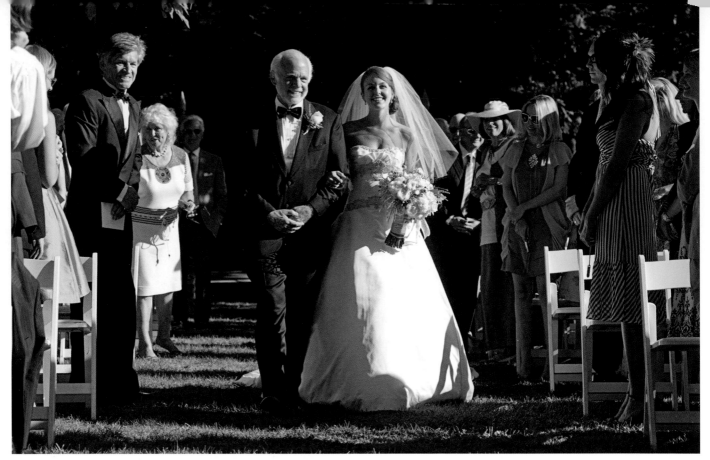

According to most of my brides, having their father walk them down the aisle is the number-one most defining wedding-day moment—the one they have spent their whole lives envisioning.

down the aisle, I'll ask them to face one another and kiss. Voilà! You now have your first kiss photo—but you must never reveal to a client that you missed such a critical shot or that you replaced it with a posed one.

10. THE FATHER WALKING THE BRIDE DOWN THE AISLE

According to most of my brides, this is the number-one most defining wedding-day moment that they have spent their whole lives envisioning. If you miss this shot, you may want to relocate to another country—no pressure, right? This is not only a highly critical and anticipated shot, but can also be among one of the most challenging to make.

Most churches have a central aisle that is quite long and will allow you to take numerous shots as the father and bride make their way to the altar. However, the combination of low light and the advancing movement of the father and bride can result in soft images as either a result of motion blur or back focusing issues.

Most popular DSLRs come equipped with a predictive auto-focusing mode (*i.e.,* AI Servo [Canon], Con-

tinuous Autofocus Servo [Nikon], and Focus Tracking [Olympus]). Under normal shooting conditions, most photographers have their camera's focusing mode set to AF-S or "single area autofocus," which is most useful when shooting stationary subjects, such as still-lifes and portraits. I find that switching to AI Servo on my Canon is the best way to make a crisp image of my approaching subjects. Also, I make sure to change my shooting mode from single to continuous mode, which allows me to fire quick bursts (up to ten frames per second) in hopes that the focus will fall sharply on my subjects' faces in at least one of those images.

Switching to continuous mode also ensures that any sudden or unexpected gesture to a guest will be captured. If your bride is old school and wearing a blusher veil, you will want to be prepared to capture a shot of the father unveiling the bride immediately following their approach. Lastly, if you're shooting with an assistant or a second, they should either be shooting from the opposite side of the processional doors or from above in the balcony, provided the church has one.

12. PHOTOGRAPHING THE DRESS

*T*he wedding dress is the pièce de résistance—just thinking about how you're going to photograph it induces a nervous shudder and makes your hands clammy, doesn't it? Well, don't let that big white wedding gown psych you out or make you second-guess yourself; shooting wedding dresses should be really simple and fun!

THE DRESS AS YOU FIND IT

The first thing I do when arriving at the bride's location is ask where the wedding dress is located. Then I ask for permission to handle it or move it from its location if necessary. I always begin by photographing the dress exactly as it is before I begin making modifications or changing its location.

Roughly 75 percent of my best, favorite dress shots are scenes that I have not altered in any way—only documented. Ideally, I prefer to use natural or available light; since I try to use my camera's lowest ISO and an aperture of at least f/8, which means a good sturdy tripod is an absolute must!

If shooting a long exposure from a tripod, I try to make at least three separate exposures—one each for the highlights, midtones, and shadows—in the event that I may wish to composite my final image, since my camera's sensor may not be able to capture the full dynamic range of the scene.

I try to work quickly, bearing in mind that a strong dress shot is essential, but with each tick of the clock I'm losing candids of the bride and bridal party preparations. Spend no more than fifteen minutes making your shots. Shoot

Roughly 75 percent of my best, favorite dress shots are scenes that I have not altered in any way—only documented.

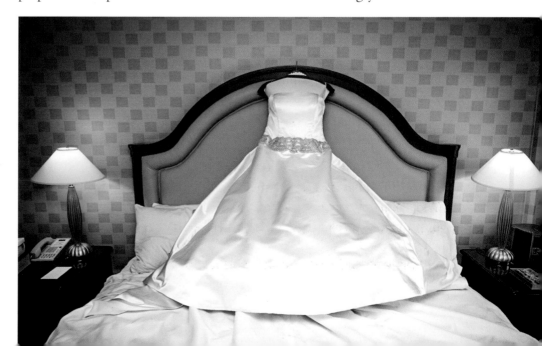

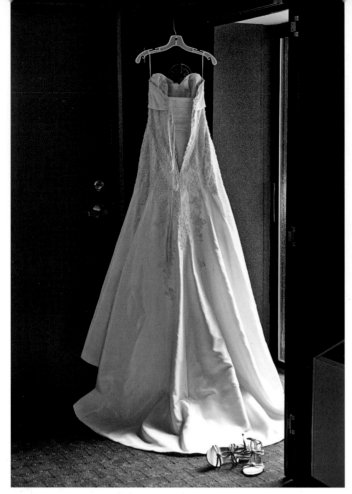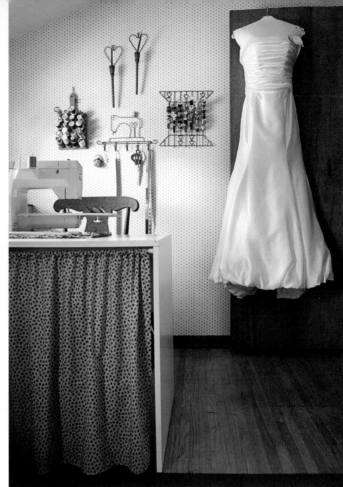

After taking a few photographs of the dress as it is when you locate it, remove any distracting objects or elements.

verticals of the entire dress, but also shoot some horizontals and detail shots of the dress's lace, buttons, embroidery, and beading.

If you need to use a flash, make sure to manually adjust your flash. Your camera's meter will want to produce a neutral 18 percent gray image when it sees all that white in the viewfinder. You may even have to set your flash to overexpose by as much as three stops!

Never use direct, non-diffused flash. Either bounce your flash off the ceiling, floor, a side wall, or the wall behind you. Side-lighting the dress (*i.e.,* bouncing off an adjacent left or right wall) produces the best results, since this method will reveal more texture in the dress than using evenly diffused light.

MAKE SMALL REFINEMENTS

After taking a few photographs of the dress as it is when you locate it, remove any distracting objects or elements. Usually, dresses have plastic shrouds, cardboard inserts or

tags. Remove any of these items or tuck them away so that they are not visible in the image.

Don't be afraid to handle or move the dress, but definitely practice extreme caution when doing this—especially if you're going to photograph the gown outdoors. If this happens to be the case, have either the bride herself or one of her bridesmaids do the handling.

Over the years dresses have become one of my favorite subjects to photograph. I'm a huge fan of natural environments and prefer the found environments to staged ones. However, it's important to shoot both and allow yourself multiple options—just in case.

FINAL THOUGHTS

Don't overthink this shot. Give yourself fifteen minutes and make it happen. Concentrate on making a well-composed, well-lit, and *sharp* image. Don't try to get overly fancy—sometimes simple and straightforward can produce the most striking image!

I'm sure you've heard the saying "it's the little things" or "the meaning is in the details." Your wedding clients couldn't agree more, which is why it's not only important to recognize the little things and details, but also to represent their symbolism and beauty in stunning artistic style.

RINGS

The ring shot may be one of the most important detail shots of the entire wedding day, but don't let the significance of this shot choke you up. Give yourself no more than ten minutes with the rings and take an assortment of shots from different angles. Shoot plenty of verticals and horizontals, and experiment with different surfaces in the background (*i.e.*, smooth, matte, glossy, textured, etc.).

To really capture the diamond, its cut and facets, the ring's setting, and any intricate inlays, patterns, or scrolling on the band, you will need a true (1:1) macro lens. If you plan on using a tripod, you will need a set of sturdy legs with an adjustable center column that allows you maximum closeness to your subject.

To really capture the diamond, its cut and facets, and the ring's setting you will need a true (1:1) macro lens.

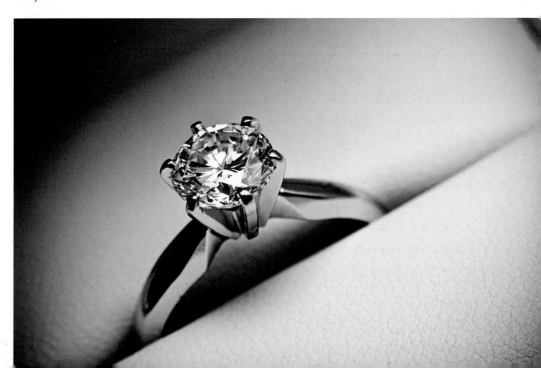

Personally, I prefer to shoot rings without a tripod. I usually set my camera's ISO to 400 or 800, power my flash up as high as it will go, and use my lens's smallest aperture so that I can achieve a maximum depth of field. Stopping down is extremely important, especially when working with macros. When you are focused only an inch or two away from your subject, f/16 may only provide a quarter inch of sharpness—which is why it is also important to take many shots, to ensure that at least one is sharply focused in the intended area(s) of focus.

Shooting shiny or reflective materials is always a challenge. When using electronic flash to illuminate a diamond set in gold, silver, or platinum, you may notice that the band appears dark and reflects only a small highlight near its outer edge; this specular highlight is your flash head reflecting off the band itself. When it comes to metals, you can't directly illuminate them since they don't absorb light, they only reflect it. Therefore, it's important to place the ring near other reflective surfaces. It would be ideal to have a light tent available at every location—but where's the fun or challenge in that?

I bounce my flash for most of my ring shots. I place the ring on a clean, evenly contoured surface near a white wall in a room that preferably has a white ceiling. A corner is the most ideal location, since you are technically bouncing your flash off of three surfaces instead of one or two. I also make sure to utilize my flash's plastic diffuser cover when shooting rings.

If you're attempting this without a tripod, concentrate on your breathing; even the slightest movement will throw your image out of focus. Sometimes, even just depressing the shutter can compromise your focus. I've gotten into the habit of setting my macro to manual, setting the focus to the lens's closest focusing distance, and using my body to focus rather than using the focusing ring to try and achieve focus. As soon as I see the diamond come into focus, I slowly squeeze the trigger—and voilà!

SHOES

I'm guessing that the story of Cinderella's glass slipper never loses its magic, because I have yet to meet a bride who doesn't absolutely want a shot of her shoes. For some brides, their shoes are thee most critical and defining articles of their ensemble.

Photographing the shoes is not dissimilar from shooting the dress; it can quickly turn into an overwrought and frustrating feat (no pun intended). With shoes, I give myself no more than five minutes to make my shots. I shoot both verticals and horizontals, as well as a variety of perspectives, arrangements, and environments.

There will be those rare occasions when you luck out and discover the bride's shoes in a picture perfect "as is" composition. However, the other 99 percent of the time, you may find yourself pulling your hair out and questioning which is more difficult: refolding a world map or composing a pair of wedding pumps.

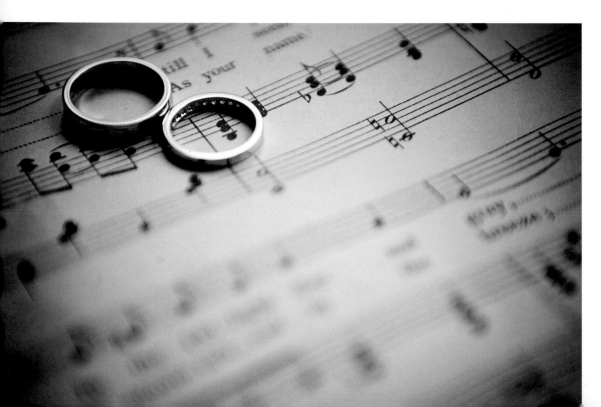

I bounce my flash for most of my ring shots. I place the ring on a clean, evenly contoured surface near a white wall in a room that preferably has a white ceiling.

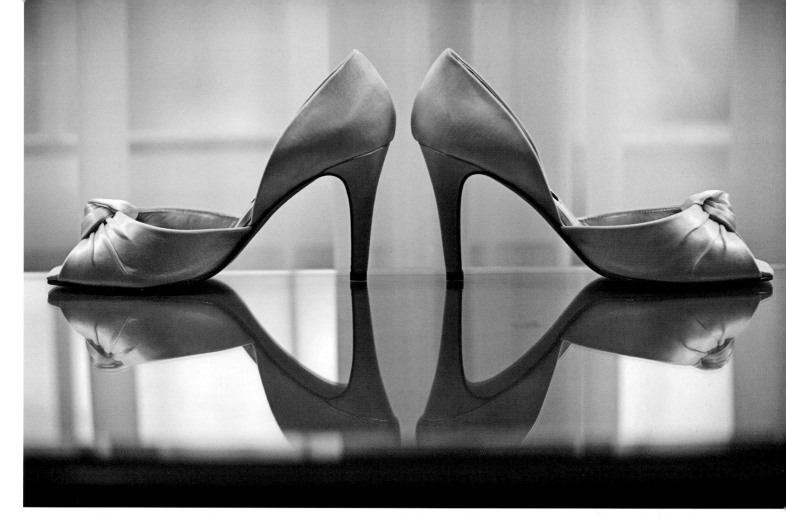

Window ledges are great framing and compositional devices, especially if you wish to photograph the shoes using only available light. I also like reflective surfaces like marble or glass tabletops.

If relying solely on your own improvisational skills feels too risky, research shoe advertisements on the web. Remember, they don't necessarily have to be wedding-related to inspire ideas. Personally, I like to flip through fashion magazines to kick-start my creative process. I also like to look at other wedding photographers' web sites and see the various ways they've approached shoe shots—then I try to take it step further or alter it a bit and add my own signature.

Window ledges are great framing and compositional devices, especially if you wish to photograph the shoes using only available light. I also like reflective surfaces like marble or glass tabletops. If preparations are taking place at an upscale hotel, you might be able to find a finely upholstered chair; leather, suede, corduroy, and velvet all lend themselves to shoe shots.

I usually set my camera's ISO to 400 and adjust my aperture at f/8 so I have at least two to three inches of depth of field. This ensures that details such as the straps, closures, patterns, and studded jewels can be keenly discerned in the final photograph.

If shooting the shoe(s) from a frontal angle, be sure to focus one to two inches behind the toe to maximize your lens's hyperfocal distance. Shooting the shoe(s) from a side angle is often trickier; try focusing on the heel rather than the edge of the shoe for maximum hyperfocal effectiveness.

I really enjoy shooting the ornate and opulent features of the churches where my couples wed.

Sometimes, if I'm really desperate and no one's looking, I'll toss them up in the air like dice and pray for snake eyes or a pair of sixes. You'd be surprised how well this technique can work—but this is a secret you shouldn't share with your bride.

RELIGIOUS ICONOGRAPHY

Whether you are commissioned to document a traditional Catholic, Jewish, or Indian wedding, religion often plays a pivotal role in the pairing of the bride and groom. Most couples will select a church, temple, or mosque that holds

historical relevance and value to them. In many cases either the bride or groom—or both—attended Sunday school or worshipped from a young age at the chosen religious venue. They will certainly want photographs of the structure's interior, exterior, architectural details, and religious iconography (*i.e.,* murals, mosaics, altars, statuary, and votives).

I try to arrive at the church fifteen to twenty minutes before the guests arrive. This not only gives me time to acquaint myself with the floor plan of the ceremonial space, but also ample opportunity to document the aforementioned details. I use available light and shoot with a tripod as much as possible so I can achieve a low ISO and maximize my depth of field by stopping down to f/22 in most cases. To further ensure the sharpness of my photographs, I lock the camera's mirror in an up position and use either the camera's self-timer or a cable release so there is absolutely no risk of camera shake while making my exposures.

While every place of worship has its own rules regarding photography during the wedding ceremony, I have yet to encounter a church that prohibits photography of its religious iconography. However, if you ever feel uncertain about shooting a particular scene or subject, simply ask any of the presiding officiants just to be sure.

Personally, I really enjoy shooting the ornate and opulent features of the churches where my couples wed. Not only do these images come in handy when designing client albums, but you can also license these images for stock. Since you're making photographs of objects, you won't even need a model release! However in very rare instances you may need to obtain a property release, but I have not encountered this exception in my fifteen-year career.

FOOD

Food is absolutely my favorite wedding-day detail to photograph. (My biggest dilemma is usually whether to shoot it or eat it!) I've talked to a number of wedding photogs about shooting food and most seem rather apprehensive about approaching this subject. Many seem to believe that the only way to make stunning food shots

A good food shot should make you want to call in sick and spend all day indulging at your favorite restaurant or bakery.

is to hire a food stylist. Don't get me wrong, food stylists can make even a mound of raw meat appear mouthwatering, but you can make deliciously divine food photos without them—I promise!

The secret to great food photography is lighting. I rarely use available light when shooting food, unless I'm outdoors and the natural light is ideal. The majority of your food shots will take place indoors, so familiarize yourself with bounce and off-camera flash techniques. Directional lighting is critical, as it helps to accentuate the food's texture, contrast, and color saturation.

Food photos should have a life of their own and seduce the viewer's appetite—a good food shot should make you want to call in sick to work and spend all day indulging at your favorite restaurant or bakery. If you've seen food shots that appear flat and anything but appetizing, it's likely they were shot using a direct flash or with evenly diffused lighting.

When shooting plated foods, less is more—and simple is simply gorgeous! Don't shoot a pile of food and expect it to look like anything but a pile of food. Try to isolate by zooming, cropping, or (if the situation calls for it) physically removing extraneous or distracting items. For example, shooting one piece of sushi often yields better results than trying to photograph the entire roll.

As with all detail shots, you should shoot a variety of orientations, angles, and perspectives. My most successful shots are owed to experimentation, so play around and try new approaches with each food item you encounter.

I rarely use a tripod. Most of my shots are hand-held while bouncing my flash off of the ceiling, an adjacent wall, or the floor. When it comes to food, I prefer a shallow depth of field; I try to open up as much as possible, so most of my shots are taken between f/4 and f/2.8. Using a shallow depth of field often produces more flattering results because it helps to eliminate foreground and background clutter. Additionally, it prevents the viewer's eye from wandering out of what I refer to as the "yum zone."

Again, there is great potential for building your stock photo archive while shooting food. I would say that

roughly 30 percent of my stock image sales are food and beverage shots that I've captured while documenting weddings.

TABLE SETTINGS

Couples go to great expense not only to provide exquisite meals for their guests, but also to serve those meals in extravagant dining environments. You will want to gain access to the dining hall or ballroom and photograph the table settings before the guests are allowed entrance.

Be sure to photograph the flatware, glassware, eating utensils, centerpieces, menu cards, and wedding favors. I also take a few wide-angle environmental shots before and after guests arrive.

A useful tip for shooting the reception hall after the guests have taken their seats is to make your exposure using only available light. Stop down to f/16 and lower your ISO until you can achieve an shutter speed of at least three to four seconds. Using long exposures with moving subjects can produce superb results. Visually, it not only provides a sense of mood and environment, but also motion and energy—and you won't have to worry about unflattering images of guests while they're chewing their food! When editing these images, try not to color correct them. I find that they have a much greater impact when I edit them to appear natural rather than neutral.

Depending on the venue, I may use a tripod and rely on available light or shoot a combination of both bounce-fill and available light by using a drag shutter technique—usually ISO 800 and f/2.8–3.2 at ¹/₂₅ second.

Be sure to photograph the flatware, glassware, eating utensils, centerpieces, menu cards, and wedding favors. I also take a few wide-angle environmental shots.

14. CAMERA SYSTEMS AND PHOTO EQUIPMENT

I have yet to meet a photographer who doesn't fawn over photo gear. No matter what system you shoot, I'll bet that you're like me and you spend at least a hour or two a week on B&H Photo or Adorama's web site, surfing camera porn and compiling your ultimate camera gear wish-list. For me, the smell of new camera equipment can induce a euphoria that even chocolate can't compete with.

However, when it comes to making our final purchases, we must be realistic and conservative in our spending. It's important to get the best equipment without blowing your budget—but even more important is getting the right equipment.

I remember lusting for a fisheye lens during my first years as a wedding photographer. In fact, I even contemplated selling a kidney just to get one. When I finally got it, though, it just sat and collected dust in the bottom of my bag. All in all, I may have made ten images over two seasons with that lens. Eventually I sold it at about a 30 percent loss and learned a valuable lesson: cool isn't always practical!

When it comes to camera systems, I recommend investing in either Nikon or Canon products. I have owned and clocked countless hours on both systems, but prefer Canon's internal stabilization (IS) lens technology to Nikon's. However, when it comes down to the wire between these two thoroughbreds, it's literally a photo finish. They are both great systems that offer a superb line of optics and accessories catering to every avenue of professional and creative interest.

The smell of new camera equipment can induce a euphoria that even chocolate can't compete with.

BODIES

We'll first start off by discussing the differences between DSLR camera bodies, which are broken down into three categories: professional bodies, prosumer bodies, and entry-level bodies.

Professional Bodies. These camera bodies are quite cumbersome, as they are built tough to meet the most challenging demands of professional photographers. Pro bodies are not only made to endure rugged everyday use, they are hermetically sealed with rubber gaskets (weather seals) that safeguard against inclement weather. With an internal housing constructed from magnesium al-

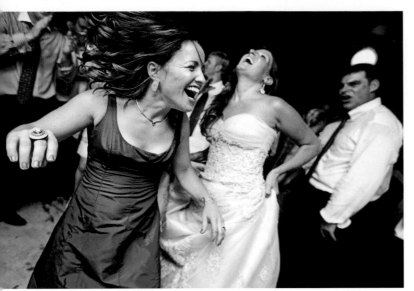

I rely on prosumer for receptions since they are much lighter than pro bodies.

loy, these workhorses can withstand a lot of punishment.

Pro body DSLRs usually have shutters rated around 300,000 activations and offer the most expansive user-adjustable controls (*i.e.,* white balance bracketing, shutter speed and flash controls, and even customizable user-created shooting modes). These cameras also have robust internal processors and image buffers, which allow for high-speed continuous (or "burst") shooting—even in RAW capture mode. If you're wondering about image quality, pro bodies tip the scales when it comes to megapixels, as most of them are fitted with a full frame image sensor (*i.e.,* 36x24mm).

You certainly won't find a pop-up flash or dials sporting cute little decals of mountains or flowers. However, you will find a hefty price tag; these are what I refer to as the "bank breakers" of DSLR bodies. If you're just beginning your business or you're a newcomer to photography, I would hold off on getting a pro body until you start generating some real cash flow.

Prosumer Bodies. These bodies are ideal for any hard-working wedding professional who demands speed, performance, and reliability. Most of these bodies are comprised of metal alloy and polycarbonate materials, which greatly reduces the body's overall weight while still providing remarkable strength and rigidity. However, don't expect a prosumer body to survive the Iditarod or

the Baja 1000; most do not have the same weather protection as pro bodies. It's also important to note that the shutter activation rating of these bodies is only about a half to a third of pro bodies (*i.e.,* 100,000 vs. 300,000).

While offering just as much control as pro bodies, you won't find as many custom settings and menus on these bodies. Additionally, the internal image processors and buffers in these cameras aren't quite as peppy as their pro-body predecessors. Whereas most pro bodies offer a full-frame sensor (*i.e.,* 36x24mm), prosumer models are more commonly fitted with smaller image sensors, which results in optical magnification. This means that a standard 50mm lens may suddenly have the effective focal length of a 70mm lens when used on a prosumer body.

In addition to having a pop-up flash, prosumer bodies also have hot shoes that can accommodate any of the camera manufacturer's electronic flash units or wireless transmitters. These bodies are available by themselves, but you will more commonly see them sold in kits containing one or two prosumer lenses. You will find that most high-end prosumer cameras are, on average, only about half the cost of pro body DSLRs.

Personally, I'm a huge fan of prosumer bodies; they combine quality with economy. I rely on them for receptions since they are much lighter than pro bodies. In fact, the camera technology in prosumer bodies has become so advanced that I've really had to pause and ask myself whether or not an upgrade to a pro body was really worth the doubling in cost.

Entry-Level Bodies. Entry-level DSLR bodies are engineered for the needs of novice shooters. You will find these cameras cheaply priced and readily available at most consumer electronics stores and even Wal-Mart. These cameras rely on goof-proof interfaces that limit most shooting to predefined settings and programs that offer limited control. These cameras are extremely lightweight as they are constructed entirely out of plastic (polycarbonate) and have absolutely no weather protection.

While entry-level bodies are ideal for anyone wishing to explore the basic features and the overall feel of a DSLR, they are inappropriate for professional wedding photography; the liability is tremendous. At best, they

are last-resort back-up cameras. You will notice that these bodies are highly popular among most wedding guests; if you do find yourself in a jam, commandeering one shouldn't prove to be too difficult.

LENSES

While it's hugely important that you purchase a quality camera body, it's even more important to have a premium assortment of lenses. I'm the type of photographer who would much rather prefer to have a superior lens and a midrange camera body than a pro body fitted with a prosumer lens. Newcomers often overlook the importance of quality optics, but anyone who owns or has shot with a pro grade lens understands that glass is one area where you don't want or cut corners.

Lens Speed. Wedding photojournalism is synonymous with inopportune and unfavorable lighting conditions, which means that the quality of your images, as well as your reputation, is riding on the light-gathering ability of your lenses. By allowing more light to reach the image sensor, faster lenses produce a much brighter image within the viewfinder, which allows them to focus much more quickly than lenses with smaller apertures that only gather half or a third as much light. Faster lenses also al-low you to shoot at higher shutter speeds, making it easier to stop action.

It is important that you have at least one "fast" lens in your arsenal (*i.e.,* f/1.2, f/1.4, or f/2.0). In fact, lens speed should be one of the most important factors to consider prior to purchasing a lens. Unfortunately for many of you who are working with a limited budget, lens speed bears a direct relationship with lens cost (faster lenses are more expensive). Starting out, you might not be able to afford more than one or two fast lenses, so consider used equipment and keep in mind that third-party lens manufacturers—such as Tamron, Sigma, and Tokina—also make fast and affordable optics. A 24–70mm f/2.8 lens produced by Canon sells for roughly $1,300 brand new, while an equivalent Sigma sells for roughly $900 brand new. Whether you have to buy used or buy a third-party lens, make sure that you've got speed on your side.

Focal Lengths. Fisheye lenses are extreme wide-angle lenses that produce hemispherical images—like the view you might see through a hotel door peephole. Usually ranging in focal length from 8 to 16mm, fisheye lenses create a highly distorted 180-degree image that is either circular (*i.e.,* perfectly round, leaving the corners dark) or full frame (where the image is rectilinear and covers the

The distortion created by very wide-angle lenses can sometimes be used to great effect.

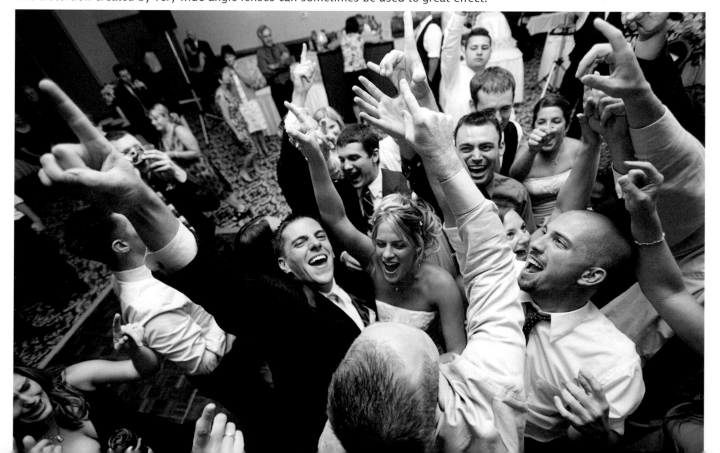

frame from corner to corner). Usually priced in around $500–600, this is an extremely "cool" lens, but not very practical for wedding photography.

When it comes to wide-angle lenses, the two most common focal lengths are the 24mm and 35mm. When used with a full-frame sensor (*i.e.,* 36x24mm), the 24mm lens provides 84 degrees of coverage and the 35mm provides 63 degrees of effective coverage. These lenses often have a very close minimum distance focusing range (*i.e.,* a foot or less), which is ideal for separating subjects from their background environments. While magnifying the distance between the foreground and background, wide-angle lenses also create moderate image distortion—especially with subjects not parallel with the focal plane or subjects placed near the edges of the image frame. The cost of these lenses varies drastically based on the speed (the maximum aperture) of the lens; the low end is around $300 and the high end is around $2,000.

An ultra-wide lens has a focal length that is shorter than the short side of the camera's image sensor (*i.e.,* less than 24mm when used on a full-frame DSLR). Because their hyper-focal distances are very shallow, these lenses consistently produce sharp images—from foreground to background—even when shooting at the lens's maximum aperture. Another advantage is the compactness of these lenses; because of their short focal length, these lenses can be hand-held at longer shutter speeds without camera shake becoming an issue. To mitigate image distortion, most ultra-wides are engineered with optical rectilinear correction, which drastically reduces spherical distortion.

Again, the cost of these lenses varies drastically based on the maximum aperture; the low end is around $500 and the high end is around $2,000.

Normal lenses produce a distortion-free perspective that most closely resembles how the human eye sees (hence their name). For DSLRs that have a full-frame image sensor, a normal lens will have a focal length of 50mm. Comparatively, these might seem like ho-hum lenses, but they do have their advantages. Because these are prime (or "fixed") lenses, they usually have a large maximum aperture (*i.e.,* f/1.2, f/1.4, or f/1.8), which makes them ideal for low light situations. Normal lenses are bright, have quick focusing optics, and can (sometimes) double as a macro, since many have a minimum focusing distance of as close as 1.5 feet. Personally, I rely on my normal lens for most of my indoor ceremony shots. Depending on their maximum aperture, a normal lens will run between $100 and $1,500.

Telephotos allow the photographer to get considerably closer to subjects that are far away—they are the spyglasses of photo lenses. Most standard telephotos fall within the focal length range of 100mm to 300mm. These lenses have a very narrow angle of view and are great for blurring backgrounds for portraits and compressing distances between foreground and background elements. This foreshortening characteristic is ideal when photographing portraits, as it tends to have a "slimming" effect on subjects. Personally, I use a 200mm for most, if not all, of the portrait sessions of my brides and grooms. When the wedding photojournalist wishes to get close to a sub-

Telephoto lenses have a very narrow angle of view and are great for blurring backgrounds for portraits.

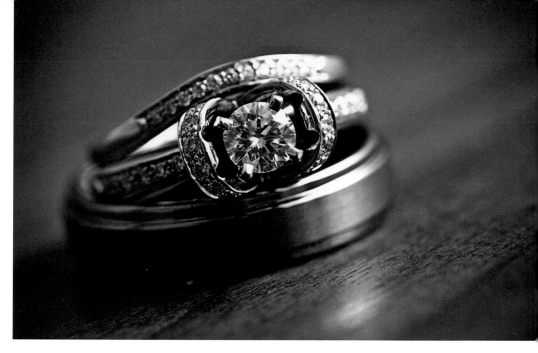

Macro lenses allow the photographer to take larger-than-life images of the most miniscule subjects—rings, cuff links, beading, embroidery, etc.

ject without becoming conspicuous, the telephoto lens is the perfect solution. Depending on the focal length and maximum aperture, these lenses can range from $500 to $5,000.

Macro lenses allow the photographer to take larger-than-life images of the most miniscule subjects—rings, cuff links, beading, embroidery, etc. The two most common focal lengths are 60mm and 105mm. Because the minimum focusing distance of most macros is just a few inches, depth of field is drastically reduced. To ensure subject sharpness an aperture of f/11 or f/16 is often needed—unless extreme foreground and background blurring is desired. Most macros have a maximum aperture of f/2.8, which also makes them quite useful in low-light situations when shooting portraits. Most macros are priced within the $500 range.

Fixed Lenses *vs.* Zooms. Zooms are mechanical lenses comprised of various lens elements, which allow the focal length and angle of view to be varied by rotating the barrel of the lens. Zooms are quite popular because they allow the photographer to cover a wide range of focal lengths without having to change lenses. In fact, some zooms can cover well over 300 millimeters of focal range.

Prime (or "fixed") lenses don't have as many internal moving parts as zooms; accordingly, they weigh considerably less than zooms. Prime lenses are also are considerably cheaper than most high-quality fast zooms. For example, a 24–70mm zoom with a max aperture of f/2.8 is going to cost you around $1,000, while a 50mm with a max aperture of f/1.4 will cost you around $300. Throughout the wedding day, I alternate between zooms and fixed lenses. In my experience, primes do produce a superficially sharper image. However, the argument over quality is really just overblown geek-speak; our clients don't obsess over pixels or know the first thing about chromatic aberration. My suggestion is to invest in both; own at least one intermediate high-quality zoom and a couple of primes to cover your other focal ranges until you can afford an assortment of high-quality zooms. (In my opinion, the speed and flexibility that a fast zoom provides is well worth the expense; I rely on my Canon 24–70mm f/2.8 L USM so frequently that it might as well be welded to my camera body.) However, if you prefer to manually zoom—to zoom by walking—then primes are definitely the way to go.

ELECTRONIC FLASH

This is another vital piece of equipment that you really don't want to skimp on. Fist of all, you'll want a unit that corresponds with your camera's TTL light-metering system. It should also have strong output (or "guide number"), a fast recycle time, and a head that tilts and swivels. If you're shooting a Canon system, I highly recommend the 580EX II or the 430EX II. For Nikon users, I recommend the SB-900 or the SB-600. A good flash will cost you between $200 and $400. A truism for almost all

photo gear is that you most certainly do get what you pay for—just keep that in mind.

THE WEDDING PHOTOGRAPHER'S ESSENTIAL EQUIPMENT LIST

I'm sure you're probably looking at all this information and thinking, "Yeah, that's great—but I still don't know what I need to be adequately outfitted for my first wedding!" So let's discuss the must haves.

Body. First of all, you need a dependable body that allows you full control to shoot manually (M), aperture priority (A), shutter priority (S), or programmed (P) if you wish to shoot in automatic mode. Unless you have a lot of surplus startup cash, I would spare the expense of a pro body and purchase a midlevel prosumer body. If you're just starting to shoot weddings professionally, I would hold off on purchasing a backup camera body and just rent or borrow one for your first few weddings to keep costs to a minimum.

Earlier, I suggested investing in either a Nikon or Canon system. The reason for this is twofold: not only do they both produce a wide range of superior products, but in the event that you might need to rent or purchase a backup or emergency replacement equipment, you'll have a much easier time locating what you need by avoiding secondary brands.

Lenses. When it comes to lenses, you'll definitely want to be able to cover all focal ranges from 24mm to 200mm. I suggest at least one fast, high-quality zoom (such as a 24–70mm f/2.8). Two other must-haves are a couple of fast primes: a wide (50mm f/1.4) and a normal (28mm f/1.8) lens. A fast telephoto zoom (70–200mm f/2.8) is ideal—but if the cost is prohibitive, you'll just have to purchase two prime telephotos (a 100mm f/2.8 and a 200mm f/2.8) instead.

Flash. It is ideal to have two (or even three or four) units, depending on your lighting setup and preferences. With a budget in mind, however, you can just purchase one premium flash unit for now, then rent or borrow extras/spares until you're generating some income. I would advise you to stick with a flash made by your camera's manufacturer—one that has a tilt/swivel flash head and a relatively high output and fast recycle time. You will want to also purchase at least four sets of rechargeable batteries for each flash that you own or use. Last but not least, you will want to buy a dedicated off-camera hot-shoe cord, which will allow you to use your flash off-camera (*i.e.*, on a flash bracket).

Memory. Considering that you will likely be shooting in RAW, I would advise getting at least 32 gigabytes of storage. Ideally, I like to have 64 gigabytes of memory for each wedding I shoot—but I'm also a high-volume shooter using a pro body that captures very large image files. With memory prices at an all time low, there is no excuse to skimp. Make sure you go with a name brand (*i.e.*, Sandisk or Lexar) and also be sure to get UDMA cards, which have write speeds far superior to non-UDMA cards.

Bags. Women love shoes and accessories—and, well, I love camera bags. I have one in just about every size, shape, and color you can imagine. Lowepro professionally endorses me and I absolutely love the products they make; but since we all have unique styles and tastes, I would also suggest looking at Tamrac, Think Tank, and Crumpler's bags.

Stay away from cheap bags; they are often poorly designed, clunky, uncomfortable, and use fabrics and closures that make excessive noise. I can't tell you which bag or carrying system is right for you, but don't make your selection based on a bag's ability to accommodate every single extraneous piece of equipment you own. I like to break my equipment down into two bags: a small shoulder bag that stores my long lenses, flash and accessories, and a hip bag that holds my fast primes.

Saving Some Money. You should be able to save 30 to 40 percent by buying used bargain-grade lenses from KEH.com; the 50mm f/1.4 can be substituted for the 50mm f/1.8. SB900 flash units may be substituted for SB800 units. SanDisk 8 gigabyte Extreme IV cards may be substituted for slower cards or small capacities from other manufacturers.

THE BASICS: NIKON

$2,000 BUDGET
Nikon D90—$810
Nikon D90—$114*
Nikon 20mm f/2.8—$38*
Nikon 35mm f/2—$360
Nikon 85mm f/1.8—$450
Nikon SB600—$26*
Nikon SB600—$26*
Sandisk 8gb Extreme III SDHC—$30
Sandisk 8gb Extreme III SDHC—$30
Sandisk 8gb Extreme III SDHC—$30
Lowepro Stealth Reporter
 D650— $150
Nikon EN-EL3e—$40
Nikon EN-EL3e—$40

Total Investment:
$2,144 + tax and shipping

$5,000 BUDGET
Nikon D700—$2,400
Nikon D700—$254*
Nikon 24mm f2.8—$360
Nikon 50mm f1.4—$325
Nikon 85mm f1.8—$450
Nikon 70-200mm f2.8—$91*
Nikon SB900—$470
Nikon SB900—$52*
Sandisk 8gb Extreme IV—$80
Sandisk 8gb Extreme IV—$80
Sandisk 8gb Extreme IV—$80
Lowepro Stealth Reporter
 D650—$150
Nikon EN-EL3e—$40
Nikon EN-EL3e—$40

Total Investment:
$4,872 + tax and shipping

$10,000 BUDGET
Nikon D700—$2,400
Nikon D700—$2,400
Nikon 14-24mm f/2.8—$1,800
Nikon 50mm f/1.4—$325
Nikon 70-200mm f/2.8—$2,000
Nikon SB900—$470
Nikon SB900—$52*
Sandisk 16gb Extreme IV—$110
Sandisk 16gb Extreme IV—$110
Lowepro Magnum 400 AW—$200
Nikon EN-EL3e—$40
Nikon EN-EL3e—$40

Total Investment:
$9,947 + tax and shipping

** Denotes gear that should be rented.*

THE BASICS: CANON

$2,000.00 BUDGET
Canon EOS Rebel T1i—$630
Canon EOS Rebel T1i—$79*
Canon 18-55mm f/3.5-5.6—$130
Canon 50mm f/1.4—$370
Canon 70-200mm f/4—$600
Canon 430EX II—$27*
Canon 430EX II—$27*
Sandisk 8gb Extreme III SDHC—$30
Sandisk 8gb Extreme III SDHC—$30
Sandisk 8gb Extreme III SDHC—$30
Lowepro Stealth Reporter
 D650—$150

Total Investment:
$2,103 + tax and shipping

5,000.00 BUDGET
Canon 50D—$940
Canon 50D—$154*
Canon 17-40mm f/4—$700
Canon 50mm f/1.4—$370
Canon 70-200mm f/4—$600
Canon 100mm f/2.8—$620
Canon 580EX II—$395
Canon 580EX II—$395
Sandisk 8gb Extreme IV—$80
Sandisk 8gb Extreme IV—$80
Sandisk 8gb Extreme IV—$80
Lowepro Stealth reporter
 D650—$150

Total Investment:
$4,564 + tax and shipping

$10,000.00 BUDGET
Canon EOS 5D Mark II—$2,700
Canon EOS 5D Mark II—$280*
Canon 16-35 f/2.8—$1,420
Canon 24-70 f/2.8—$1,280
Canon 50mm f/1.4—$370
Canon 70-200 f/2.8—$1,700
Canon 100mm f/2.8—$620
Canon 580EX II—$395
Canon 580EX II—$395
Sandisk 16gb Extreme IV—$110
Sandisk 16gb Extreme IV—$110
Lowepro Magnum 400 AW—$200

Total Investment:
$9,580 + tax and shipping

** Denotes gear that should be rented.*

15. PRICING YOUR WORK

*I*t's an unfortunate fact, but many who are new to the business of professional wedding photography grossly undercharge for their services and end up losing money during their first season. Many of these undercutting newcomers become so dispirited—after six months of working non-stop for next to nothing or less than nothing—that they resign their interests in professional wedding photography and ultimately decide it's not for them. While the praise we receive from satisfied clients is greatly appreciated, it simply isn't enough to cover our expenses. So, before you establish your wedding-day rates and packages, here are a few questions that you should consider.

Many who are new to the business grossly undercharge for their services . . .

WHAT ARE YOUR EXPENSES?

Do you operate your business from home or are you leasing a commercial space? Did you attend a college, certificate program, or workshop where you received formal training in photography? Do you rent or own your photography equipment? Will you be traveling considerable distances for the weddings you book? How do you edit your clients' images—what kind of computing hardware and software does your work require? Will you be hiring an assistant or a second shooter? What kind of products will your business use (*i.e.,* prints, albums, etc.)? How much money will you be spending on advertising? The list could go on and on, but you get the gist; we're trying to determine your business's yearly operating expenses—your overhead.

While the praise we receive from satisfied clients is greatly appreciated, it simply isn't enough to cover our expenses.

Much more goes into the creation of each image than the time it took to shoot it and the paper it is printed on.

WHAT IS YOUR TARGET MARKET?

Almost all young wedding photographers want to shoot the big weddings or destination weddings—and many even aspire to shoot celebrity weddings. But, while I sit here and wait for Jennifer Aniston's agent to call, I can tell you that the "big weddings" will remain out of your reach until you develop a strong portfolio and build a solid reputation within your market. It's true that photographers whose packages begin at $3,000 book more affluent clients than those whose packages start off at $1,000—however, if you're a photographer who's fresh out of school or just beginning your business, you will need to start off by targeting a less elite and discriminating audience.

WHAT ARE YOUR PLANS FOR GROWTH AND EXPANSION?

Unquestionably, you will need to plan for the road ahead, which requires a great deal of deliberation and foresight.

Would you like to upgrade your camera equipment or computers? Are you interested in purchasing a booth at next year's big bridal expo or securing a future ad spot in your area's regional wedding magazine? Whether it's something as small as wanting to upgrade your business's printed materials or something as big as wanting to relocate your business from your home to a commercial space, your yearly operating expenses are sure to increase.

So ask yourself some questions. How do you want your business to grow? Are you most concerned with upgrading your gear, or are your concerns more weighted toward advertising? Prioritization when it comes to assessing which costs are essential and which costs are secondary isn't always an obvious or simple task. Nevertheless, you need to make sure that your present rates will not only cover your current expenses, but also leave enough extra for next year's anticipated expenses and growth.

Don't blindly follow the business model of another photographer. The fact of the matter is, you don't know what the other person's operating expenses are.

WHAT DOES YOUR COMPETITION CHARGE?

Newcomers commonly establish their prices based on their competitors' rates and packages. This isn't entirely the wrong way to go about establishing your pricing, but only if you've first considered all of the above.

Don't blindly follow the business model of another photographer. The fact of the matter is, you don't know what the other person's operating expenses are. Furthermore, you don't know if the other person's business is profitable or even sustainable! Your competition may not rely on wedding photography as their primary source of income—maybe they only need to book four or five weddings a year; maybe they're independently wealthy and have a penchant for wedding photography; maybe they work for free. Whatever the case may be, don't base your rates based *solely* upon what others are charging.

However, I do encourage you to examine the pricing structures of other photography studios in your area so you can establish, from a client's perspective, how quality and services are reflected in pricing. If the average bride in your area expects to pay $2,000 to 3,000 for her wedding photography, you may want to align your business model, expenditures, overhead, and subsequent pricing structure to coincide with your market's expectations—otherwise, you could find yourself fighting an uphill battle.

My best advice to those of you just starting out is to price yourself low enough to secure bookings but high enough to keep your business out of the red. Don't expect your first year of business to yield remarkable profits. Your first year in business should be spent focusing on these primary goals:

1. Satisfying the clients you book.
2. Honing your skills and developing your portfolio.
3. Building relationships with other area wedding vendors.

If the competition among photographers in your area is fierce, you may have to lower your package prices to remain viable. If so, make adjustments on the back end to balance your expenses with your income. This may mean shooting alone or forgoing the expense of an equipment upgrade, but profitability is paramount.

On the other hand, supply and demand may fall in your favor; you might be able raise your rates sooner than expected. In this case, reinvest in your business to ensure your clients are receiving the highest quality products and services available. Sometimes, I like to think about costs and expenses as having a relationship similar to that of aperture and shutter speed; if one variable changes, the other variable must be adjusted to compensate for that change—or else an undesirable outcome may occur.

HOW DOES THIS PLAY OUT?

Establishing a budget for your studio's yearly expenditures is crucial to the success and growth of your new business. Plan out your expenses and determine what costs are essential and what casts are extraneous. It's highly unlikely that you will need the industry's most advanced pro DSLR or every pro grade lens manufactured by your camera's maker. Ultimately, your rates and packages should be determined equally between these two factors:

1. Yearly operating expenses.
2. Your market's expectations.

HOW LOW CAN YOU GET YOUR OPERATING EXPENSES AND STILL MEET YOUR MARKET'S EXPECTATIONS?

Begin by assessing your market's expectations—what do most brides in your coverage area expect to pay for a wedding photographer? Then, ask yourself how many weddings you can expect to book during your first season. If you determine that your basic wedding package should $1,500 and you expect to book at least ten weddings during your first year, that's $15,000 gross income. It's possible that you'll sell a few albums and print packages, as well, which could boost your gross by $2,000 to $3,000. However, for all practical purposes, you should err on the side of undervaluation in your estimated gross income.

If your anticipated yearly gross is $15,000 you would not want your business's first year of expenses to exceed a budget of more than $8,000 to $9,000. Although many of your start-up expenses will be tax deductible, you may not book as many weddings as originally anticipated. Furthermore, you will likely incur a few unforeseen or overlooked expenses along the way. Last but not least, after all your yearly debts have been resolved, you still need to pay yourself!

If your are starting your business from scratch, without the aid or assistance of credit or loans, your first year's objective should be to break slightly above even. Bear in mind that many of your start-up expenses will not factor into your following year's expenses, which means your second season will yield more cash flow for savings and reinvestment.

CONCLUSION

It's imperative that you understand the multifarious mix of concerns integral to owning your own business. Those outside of or new to this profession look at wedding photography as a quick way to get rich—after all, most of us make anywhere from $2,000 to $3,000 for each wedding that we shoot. What others fail to consider is the quotient of income divided by expense. Additionally, most people who are not in business for themselves don't have to worry about paying quarterly taxes or affording the cost of a small business health-care plan.

Understanding, identifying, and anticipating cost is critical to the success of your wedding photography business. Determine your short-term goals as well as your long-terms goals, then devise a budget and business plan that will allow you to systematically achieve them. Understand that pricing isn't an arbitrary art form, and that determining your rates should entail a lengthy process of deliberation. You may not be able to start out charging $3,000 to $5,000 for your basic wedding package—but if you consistently book, shoot, and satisfy an intermediate clientele, you will be able to increase your prices and profits, developing your business at a steady rate year after year.

16. PACKAGES

Now that you've carefully considered the costs involved in starting up your new business, and determined what your basic rate should be, it's time to think about how you want to package your services. When it comes to wedding photography packages, brides' top-three concerns are:

1. How much do your packages cost?
2. How much time or coverage is included?
3. Will they receive a disk containing all of the high-resolution images?

MY BASIC PACKAGES

My business model employs three separate packages with additional à la carte options—custom albums, parent albums, print packages, canvas wraps, etc. My package structure breaks down into three tiers: a basic package, an intermediate, and a premium package.

The most unique and appealing feature of my packages is that each of them includes unlimited coverage. That's correct: whether a client selects my basic, intermediate, or premium package, they receive the same level of attention and coverage for their wedding day. The cost of my packages increases based solely on the products included in each package.

I like to keep things as simple as possible. My basic package includes only my time, coverage, and image delivery—no products. My intermediate package offers all of the aforementioned, but also includes a custom deigned, forty-page flush-mount album. My premium package is identical to my intermediate package, but includes two additional duplicate flush-mount albums—or "parent albums," as they are often referred to.

Also, included in each of my packages is a DVD set containing *all* of the images shot during my client's wedding day. This means that I release the full-resolution "digital master" files (both edited and unedited versions) to my clients with each package. Some clients will even request the RAW files, which I will also gladly release to them. I actually offer this as an à la carte item; it's listed under "digital archive." This option allows my clients to pay an additional fee to have me supply them with a portable hard drive contain-

> My basic package includes only my time, coverage, and image delivery—no products.

If a bride is seeking the services of a wedding photojournalist, she expects to have her entire day documented—not just whatever she can cram into a six-hour slot.

ing their wedding's full digital archive—usually 80 to 100 gigabytes of images.

TIME COVERAGE

If you're considering a packaging model in which your time is divided differently for each package (for example, your basic package only provides six hours of coverage, your intermediate provides eight hours, and your premium provides full-day or unlimited coverage), I encourage you to reconsider. In my experience, brides don't want to tailor their wedding-day schedules around a photographer's time allotment. If a bride is seeking the services of a wedding photojournalist, she expects to have her entire day documented—not just whatever she can cram into a six-hour slot.

Brides who want their whole wedding-day documented will be far more likely to choose a photographer whose packages include full-day coverage—even if this necessi-

tates a higher price point. The last thing a bride wants to worry about on her wedding day is how much time is left on her photographer's meter—or how much she's going to be charged for exceeding her time allowance.

Personally, I have discovered that most brides are simply turned off by prorated wedding photography packages; they want to hire a photographer they feel is committed to them, not the clock. I can't tell you how many brides disclose to me that this is a determining factor when choosing their wedding photographer. If you do decide to put together your packages using time partitions, you will be subject to scrutiny from brides who suspect that your pricing is established purely on an hourly basis. You may find yourself in a perpetual state of negotiations with brides who expect you to lower your rates because they only require your services for three to fours hours—or brides who feel entitled to a refund because they did not use all of their allotted time.

My studio receives a large number inquiries from brides requesting coverage for just their ceremonies or receptions.

Full-day shooters are not exempt from this scrutiny—especially when dealing with brides who don't desire or foresee a need for more than six to eight hours of coverage. Every year, my studio receives a large number of inquiries from brides requesting coverage for just their ceremonies or receptions. These clients are solely interested in economy; they usually don't want to pay more than $500 to $1,000 for a wedding photographer. Generally speaking, these are not the clients I am interested in booking for my peak-season Saturday weddings. However, if their wedding happens to fall on an odd day of the week or on a day that I don't already have booked or anticipate book-

ing, I will entertain their request and negotiate an hourly rate—absolutely! Just bear in mind that no matter which pricing model you employ, brides will sometimes attempt to negotiate with you for a reduced rate.

If you choose to package your services on a per-hour basis, your biggest concern should be sending the wrong message to your prospective clientele. We are not hourly employees or laborers; we are not freelancers nor moonlighters. We are *professionals* who charge for a full service and a product that cannot be pared down or distilled into hourly increments. The only exception would be if the overwhelming majority of brides in your coverage area request packages based around time allowances. Then, by all means, adjust your packaging structure to meet the demands of your market.

PRODUCTS

Before you start shopping for album and print vendors to supply products for your packages, you may want to consider "shoot-and-burn" packages—especially if you're just starting out. These packages provide the client with digital images only; you shoot, edit, and then deliver the client their wedding images on a disk. Usually, there are no physical products involved in this structure, unless the client specifically requests prints or albums. I'm a big fan of shoot-and-burn packages for a couple of reasons.

Lower Cost. First, since the photographer won't be supplying the client with prints or albums, he or she is spared the cost of studio sample albums or other presentation products. This is ideal for first-year wedding photographers who are still in the process of building their portfolios and may not want to design a studio sample album until they've produced more work.

Lower Time Commitment. If this is your first year of shooting weddings professionally, you probably won't want to take on the burden of being responsible for producing books, albums, prints, etc. By keeping things simple, you can focus all of your energy and attention on more important things, like honing your shooting and editing skills, search engine optimization for your web site, networking with other vendors in your area, and booking more weddings!

PRODUCT VENDORS

Coffee table albums, magazine albums, and flush-mount albums are more than just presentational trends, they have become the industry's mainstays for how the wedding-day story is conveyed. There simply isn't a more powerful presentation than a well-designed album—or a more persuasive selling tool than a well-designed studio sample album. Approximately 75 percent of the packages I sell include at least one album.

If you decide that you want to include presentational products in your packages, or make prints and albums available to your clients upon request, you should request literature and sample albums from a wide variety of vendors. Most vendors offer drastically reduced discounts and—in some cases—free sample albums for wedding photographers. I've had many years to test out a range of products and the following are the vendors I think are worth taking a look at.

Low Rangewww.mpix.com
www.asukabook.com

Mid-Rangewww.graphistudio.com
www.imagecapsule.com

High Rangewww.queensberry.com
www.renaissancealbums.com

A THREE-TIERED APPROACH

When it comes to creating packages for your services, many photographers use a three-tiered approach. If you choose to use this model you will want to offer your clients three different package or "investment" options—along with a side-order menu for à la carte items.

Basic Package. You studio's basic wedding package should include only the bare essentials: your time, images, editing, and delivery. This is your most competitive package, so you will want to keep your costs to a minimum. As a future investment incentive, you may want to include a credit toward an album or print package.

Intermediate Package. This package should be similar in structure to your basic package with a couple of ad-

ditional perks thrown in. Since you will likely be charging 20 to 30 percent more for this package, you will want to sweeten the deal with an album or print package—or additional time/travel allowances. Your intermediate package may also include an assistant or second shooter.

Premium Package. This is your studio's first-class, five-star, premium wedding package. As your most comprehensive package, it should include extended coverage, a second shooter, a flush-mount album, parent albums, and possibly a print package. This package will likely bear a price tag twice the amount of your basic package. You will have significant costs wrapped-up in this package, so price it accordingly.

Your premium package should include extended coverage, a second shooter, a flush-mount album, parent albums, and possibly a print package.

HOW SHOULD I NAME OR REFER TO MY PACKAGES?

If you visit other photographers' web sites, you might notice that in addition to using a three-tiered structure for their packages, they often use catchy names to identify their packages—like, "Icon, Celebrity, and Artistic," or "Ebony, Ivory, and Jade." The possibilities are endless. Personally, I rely on the use of numbers to reference my packages—I call them packages one, two, and three.

If you decide to use a more creative naming convention, be mindful of your market and avoid overly ambiguous names or names that might strike a client as being pretentious or condescending (*i.e.,* "Million Dollar Couple, Professional Couple, and The Launching Pad"—no kidding, I actually just pulled those directly from a photographer's web site). Remember, not everyone will be interested in or able to afford your premium package, so don't use a naming system that demeans or belies your basic package.

SHOULD I BE WILLING TO NEGOTIATE?

My policy on negotiation is to always remain open to adjusting your rates—especially if this is your first wedding season. This doesn't mean you should give your services away for free or at cost, but be flexible with your packages, no matter how they are structured.

My studio receives package inquiries from forty to fifty brides a year whose weddings are planned for an odd date (not a Saturday). I also receive a fair number of inquiries from brides seeking only partial coverage for their wedding events. Last but not least, I would estimate that roughly 25 percent of *all* clients I consult with attempt to negotiate with me on my package pricing.

Friday and Sunday Weddings. Most brides who plan their wedding events for a Friday or Sunday wedding do so because it's common for vendors to offer discounted rates on these days. That said, it's likely that a bride who has planned her wedding for either a Friday or Sunday is on a budget and searching for discounts anywhere she can find them. You can approach this situation one of two ways.

1. You can take the position that the service you provide for a Saturday wedding is no different than the service you would be providing for a wedding on any other day of the week and respectfully decline to negotiate your rates.
2. You can seize the opportunity to collect some additional income and satisfy yet another set of clients who will likely refer other brides to your business!

Partial Coverage Requests. No matter how comprehensive your coverage may be, you will still receive inquiries from brides who have no interest in having their

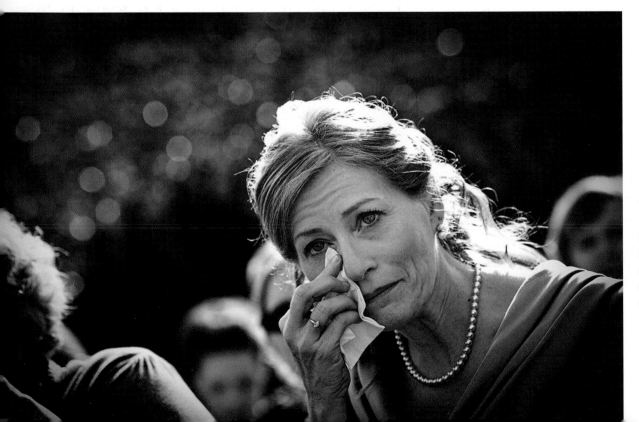

I rely on the use of numbers to reference my packages—I call them packages one, two, and three.

morning rituals immortalized. Some brides only wish to have their ceremonies or receptions documented. From time to time, you may even receive partial package inquiries from brides who get married in a different state or country and then choose to host their reception at a later date in your area of coverage.

I strongly urge you to establish a partial coverage package for such requests. However, I would refrain from listing this package on your web site or printed materials; make this pricing available upon request only. Partial coverage inquiries should never take top priority. Ideally, you want to book all your peak-season Saturday dates at your full rate. However, if you receive a partial request for an odd day or for a Saturday that you don't anticipate booking otherwise (*i.e.,* the event date for the inquiry is only two or three months away) then, by all means, book the wedding!

General Negotiations. Whether the item in question is a new car or a box of records at a rummage sale, people love to haggle over price—bargaining is in our blood! When the economy took a turn for the worse back in 2008, every bridal magazine and wedding planning web site jumped on the bargaining bandwagon and encouraged brides to negotiate with their vendors for discounted rates.

During that year I noted an increase to almost 40 percent among clients inquiring about the "flexibility" of my pricing. It was a bit frustrating at first—especially since no one knew how bad things would get or how the economic downturn would impact the wedding industry. Amid the uncertainty, I followed my principles and booked even more weddings in 2008 and 2009 than the previous years. Though I didn't offer discounts to everyone, I did what I had to do in order to fill my schedule and secure bookings for my following season.

My advice is to never be overly eager to reduce your rates. Be selective about the clients to whom you offer discounts. If someone is inquiring a year in advance for a June or July wedding and they want you to negotiate your price, there's a high probability that you will book that date at your full rate with another couple, so stick to your guns. I usually put the "negotiators" and "fence-sitters" on my low-priority list and let them sweat it out for a few weeks. In many cases, you'll call their bluff and they'll promptly return to book the date with you. It's a lot like playing poker; when the chips are down, play conservatively and never gamble more than you can afford to lose—or you can go all in and risk a stroke.

CONCLUSION

Don't blow a chance to make some extra money, even if you have to shave 15 to 25 percent off your package price. Would you be willing to leave $1,000, $2,000, or even $3,000 sitting on the table because you were unwilling to lower you rate by a few hundred dollars?

If that question doesn't compel you to think differently about negotiating, I'll re-configure the question: Would you or would you not be willing to pay $300 to make $1,200? If your basic package is set at $1,500, and to secure a booking you have to reduce your package price by 20 percent, that's a $300 reduction from your $1,500 package—which leaves you with $1,200 dollars of gross profit. Would you seriously be willing to decline $1,200 of gross profit? To be honest, it's been quite some time since I offered a $1,500 package—but even now I wouldn't be willing to walk away from an opportunity to make $1,200 in one day's time.

When I began my business, I was quite humble—and also hungry for business. My strategy was to book as many weddings as I could possibly fit into one season without double-booking myself. If a bride contacted me about a wedding date that was only two or three months away and she had a budget of $500 for photography, I would absolutely book it. My strategy was fairly straightforward: if I could make a couple hundred bucks on a day that I wouldn't otherwise book or be working, I chose to work—I chose to make money by exploiting every opportunity that presented itself.

I still abide this principle today—after all, you never know when brides are going to stop calling you. In that sense, I make it a point to never get too big for my britches or pass up an opportunity to boost my yearly income—no matter how marginal the profit may be.

17. THE WEDDING PHOTOGRAPHER'S CONTRACT

Owning and operating your own professional wedding-photography business requires a great deal of investment—from the thousands of dollars we fork over for equipment to the countless hours spent refining our skills, building our portfolios, researching our competitors, optimizing our web sites, targeting our market, promoting our businesses, and consulting with clients. We put our blood, sweat, and tears into what we do, so it's important that, while ensuring the best for our clients, we protect our *own* interests and investments, as well. Aside from business liability and equipment insurance, the wedding photography contract is perhaps one of the most important safeguards you will need to secure for your business before booking your first client.

If you're not already a member of the PPA (Professional Photographers of America), I encourage you to purchase a membership. The PPA offers a host of online resources, including contracts and agreements for wedding pho-

Not all photographers rely on the same business model, so we each have concerns specific to our own individual businesses.

tographers. If you search the web, you're likely to find samples of other photographer's contracts or basic templates floating around. However, I would advise against using a contract that hasn't been reviewed or approved by an attorney or a trusted organization, such as the PPA.

Not all photographers rely on the same business model, so we each have concerns specific to our own individual businesses. All contracts adhere to a fairly standard format, but you may wish to amend the terms and conditions of your contract to align with your business model. The language of a contract is crucial, so it's important to use clear and concise terminology; this is especially important if you plan to draft your own or make changes to an existing contract. The following sections detail a few mandatory stipulations your contract should include.

CONTRACT PAGE

This is usually your contract's cover page; it should include basic contact information for all signing parties entering into the sales agreement.

1. Full legal names of each client.
2. Permanent addresses of each client.
3. Home phone, cell phone, and work phone numbers of each client.
4. E-mail addresses of each client.
5. The date, time, and location for each venue where the photographer will be providing coverage.
6. A full description of services being purchased (*i.e.*, twelve hours of photography coverage, including an assistant or a second shooter, prints, albums, etc.).
7. Lines for the subtotal, sales tax, deposit, and remaining balance.
8. Three signature lines for the clients and the photographer.

TERMS AND CONDITIONS

The terms and conditions page is usually printed on the reverse side on the contract page or supplied as an accompanying document. If your terms and conditions page ex-

We put our blood, sweat, and tears into what we do, so it's important that, while ensuring the best for our clients, we protect our *own* interests and investments, as well.

ists as a separate document, be sure you include date and signature lines for both clients and the photographer. The contract's terms and conditions should outline the individual clauses of contingency that govern the agreement. Here are a few examples of such clauses:

I. **Failure to Perform.** If the photographer cannot perform any part this agreement due to injury, sickness, or any other causes beyond their control, then the photographer shall return the deposit to the client but shall have no further liability with respect to the agreement.

II. **Cancellation.** If the client shall cancel this agreement or reschedule their event date for a date that the photographer is unavailable, any deposit paid to the photographer will be forfeited.

III. **Copyright and Reproductions.** The photographer retains official copyright for the purposes of advertising, promotions, and stock licensing. The client is granted permission to reproduce and distribute photographs only with written consent from the photographer.

Deposits ensure that if a client cancels their contract you will be able to recoup the expenses incurred to generate that booking.

CANCELLATIONS

As I have discovered over the years, the cancellation clause is one of your contract's most important terms and conditions. Unfortunate as it is, some couples decide that marriage isn't the right decision for them. Another cause for cancellation could be an illness, death, or emergency that forces the couple to reschedule their wedding date. If this happens, they will likely return to you and ask to have their deposit refunded. Every photographer approaches these situations differently, but I advise you put into practice a standard no-refund policy for cancellations and postponements.

Consider this, you pay X amount of money every year to promote and advertise your business so you can secure bookings for each upcoming season. Most couples book their wedding photographers eight to twelve months in advance. If a client returns to you in the weeks or months prior to the date of

their planned event and wishes to cancel, it is highly unlikely that you will be able to book that date with another couple. In fact, you'll probably have turned down at least five or six other inquiries for that exact date already.

Deposits ensure that if a client cancels their contract you will be able to recoup the expenses incurred to generate that booking. However, there might be extenuating circumstances that require special consideration. Personally, if I am able to re-book a cancelled date with a new client, as a courtesy, I will refund the cancelled party's deposit. Another decisive factor could be if you live in a small community and fear that upsetting a particular client could be detrimental to your business's reputation. My advice is to always protect your interests and make sound decisions based on the immediate and future concerns of your business. Sometimes doing what's right for your business doesn't sit right with a client, and that's an unfortunate fact that you just have to accept.

IMAGE LICENSING

A decade ago, I could expect to earn an additional $1,000 in print sales at each wedding. Reorders accounted for 15 to 20 percent of my business's annual gross; nowadays, that number has fallen off to around 5 to 7 percent. However, while print demand among our clients has decreased, demand within the broader market (*i.e.*, print/ad media) has been growing steadily year by year. Last year, image-licensing sales (*i.e.*, stock photography) accounted for approximately 20 percent of my studio's gross sales.

To garner that additional income, I never once had to locate, crop, re-size, or color profile a single file for a client. In fact, aside from FTPing images to my various stock agencies, I never even had to break a sweat or spare a second from my day. The real beauty of stock photography is that the images I made as far back as ten years ago are still generating revenue! I can just hear all the defeatists and naysayers seething about microstock agencies who have turned stock photography into a veritable photographic flea market. It's true—the stock photography market is not what it was in its heyday, but it is still a lucrative industry and can provide strong supplemental income during the slow times.

Copyright. Remember, by default of proprietary authorship, unless we legally renounce or transfer copyright of our work to a third party, we always retain and own full rights to our photographs. That means that so long as we have a release from our subjects, we can sell *any* image we make as stock.

Model Releases. My studio's wedding contract is very comprehensive and includes a model release that nine out of ten couples happily provide their John Hancocks on. You're probably wondering, "What bride and groom would ever agree to having their wedding photos sold as stock?" That was my initial concern too, but surprisingly, most of my couples actually get excited at the prospect of one of their images appearing before the public in print.

My studio's wedding contract is very comprehensive and includes a model release that nine out of ten couples happily provide their John Hancocks on.

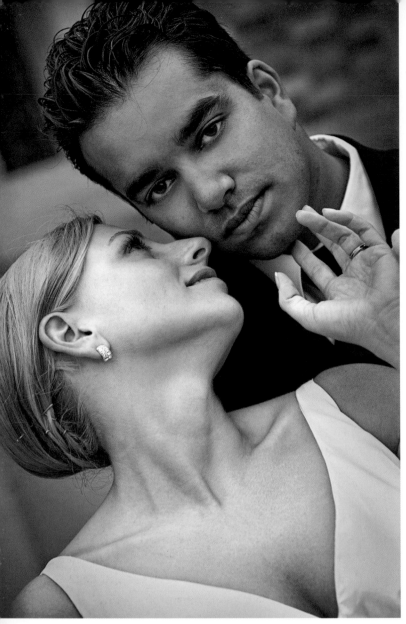

Ensure that your business's contract addresses all pertinent and critical aspects of how you plan to provide your clients with products and services.

Don't get me wrong—occasionally I do have a couple who will respectfully decline, which is entirely within their right, but the majority never so much as bats an eyelash.

Getting Listed with an Agency. Most stock photo agencies have a section titled "submissions" or "for photographers." For those that don't prominently display their submission policies, you may have to send an e-mail inquiry to obtain the guidelines.

It's common that they will want to see a portfolio or body of work consisting of at least one- to two-hundred images, so comb through your archives and select your finest photos for review. It used to be that "stock photog-

raphy" was synonymous with "generic images," but these days, stock agencies are looking for expressive and edgy photos that have strong subject matter—mostly human interest, rather than scenes or still-lifes.

In the past, there were only a few large stock agencies, like Getty, Corbis, and Comstock; nowadays, there are hundreds—if not thousands—of agencies that comprise the stock industry. I won't attempt to list them all, but my top suggestions would be: www.images.com; www.masterfile.com; www.alamy.com; www.agefotostock.com; www.jupiterimages.com; and www.superstock.com

If you're like me, you also shoot far more than just weddings. If you shoot wildlife, landscape, travel, or an even more specific genre, check out the comprehensive stock photo directory at www.aphotoeditor.com to find the agency that's right for you.

Photography is all about improvisation and problem-solving—and so is business. For those creative enough to see the opportunity, the demand for post-wedding sales has not disappeared, it has only shifted. There are countless alternatives for professional photographers to generate revenue with their images, and listing your photographs with a stock photo agency is a surefire way to get your work in front of a global market whose demands will ensure that your images will passively produce profits!

CONCLUSION

Having a well-conceived and well-written contract that addresses the agreement between the clients and photographer is not only fundamental to the practice of professional wedding photography, but also to the establishment of trust between both parties entering into the agreement. Due diligence is a must, so do your homework and research to ensure that your business's contract addresses all pertinent and critical aspects of how you plan to provide your clients with products and services. Contracts and deposits should be dealt with at the time of signing—and always be sure to make a copy of the contract for your clients, while retaining the original for yourself. If you're interested in learning more about contracts, or obtaining a contract for your professional wedding business, please visit www.ppa.com.

AESHA AND NATALE

Aesha and Natale were married in Rochester, NY, at St. Stanislaus, which is an opulent, yet unassuming gem located amid the distressed façades and urban infrastructure of the inner city.

I had the pleasure of meeting with Aesha many months prior to her wedding. Aesha is a striking and vivacious woman whose beauty and grace captivated me; I would later find out that she was the only female African-American to become a corps member of the New York City Ballet, and that her life story was one great triumph and success as an acclaimed American ballet dancer.

Natale was unable to attend the consultation, but the way Aesha spoke of their relationship provided me with a detailed and compelling portrait of their rapture with one another. I immediately felt a sense of connection with both of them and was excited about capturing such a profound love on film.

The weather conditions on their wedding day were ideal, sunny and comfortably warm with a slight breeze. However, the time they had selected for their portraits session fell during that inauspicious hour when the sun hangs directly overhead. To make matters worse, we were running out of time even

Aesha and Natale's wedding.

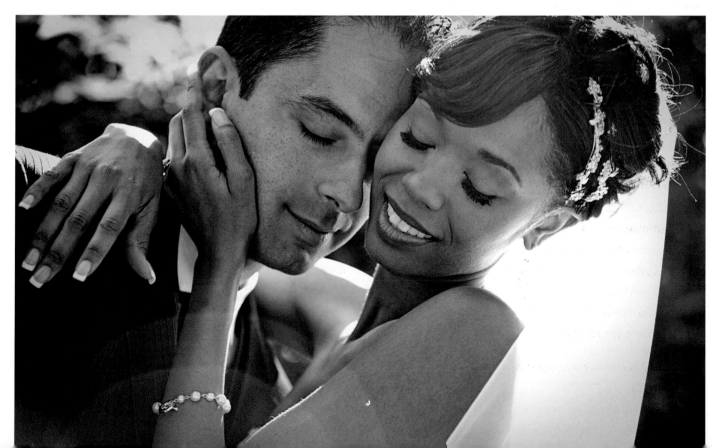

before we arrived at our location. With only fifteen minutes to find a location and make their portraits, I was becoming quite anxious. I signaled for the limo driver to pull over and we popped out near a shaded spot at the edge of the woods—and that's where the magic happened. It was one of those rare occasions when everything falls into place and works in your favor.

Usually, the couples I work with require some coaching and direction; most require time to loosen up and lower their guard. This was not the case for Aesha and Natale. I don't recall giving any direction to ether of them. They quietly convened in the shade of a large oak and began to kiss and caress one another's faces. They had no inhibitions; they were one of the most amorous couples I've ever photographed. At times, I found myself so awestruck by the intensity of their interaction, I almost forgot to release the shutter!

From an aesthetic perspective, I love the position of Aesha's hands cradling Natale's face, Aesha's smile, and Natale's serene expression. I love the rich, subtle skin tones and the glow caused by the backlight. To me, this image is a moment of uncompromising honesty.

I made this image with Canon's EOS 1Ds Mark III, fitted with a Canon 70–200mm f/2.8L IS USM. I captured this image in RAW at ISO 640, shooting at f/4.0 at $\frac{1}{200}$ second. I captured the image using only available light and allowing natural lens flare to occur by removing the lens hood. I processed the image in Adobe Camera Raw and Photoshop CS4, doing some slight retouching in the under-eye area of both Natale and Aesha and giving the image a warm-toned monochromatic finish using a hue/saturation adjustment in Photoshop.

ERIC AND ELIZABETH

Eric and Elizabeth visited my studio to discuss the details of their wedding. Elizabeth was the quintessential bride-to-be, gushing over every sample image; Eric half-smiled while feigning interest.

The day of the wedding, Elizabeth was almost unrecognizable—replaced by a frenzied drama junkie. An impending wedding can (and often does) transform the demeanor of the bride, but there are exceptions where

an exorcism could easily be warranted. This was one of those situations. Liz was flying around the twenty-fifth floor of the Hyatt in her bathrobe, shouting orders at her bridesmaids like an Army sergeant. I escaped and fled to the church with my ears still ringing with shell shock.

After their ceremony we mustered the troops at the Marine Park in Irondequoit Bay for some formal wedding party pictures. To my surprise, it was Eric who was patient and collected as we broke away from the wedding party for the bride and groom portraits. I asked them each to take a deep breath and embrace—but through the viewfinder they appeared painfully awkward, so I lowered my camera and began to approach them. On my way down the pier, I could hear Liz scolding Eric for kissing her and smudging her makeup. Within moments, their bickering had evolved into a full-fledged fight, so I told them I would return in a few minutes.

As I hustled across the marina to rejoin the wedding party, I could hear the happy couple's arguing growing more intense. The wedding party quickly informed me that these skirmishes between Liz and Eric were part of their charm and anything but unusual. In fact, by this time, the wedding party was in full spectator mode—shouting for their favorite team and heckling the opposition! At the crescendo of their quarreling, a strong gust of wind blew Liz's veil into her face and had her flailing her arms like a windmill—as if she was trying to swat a swarm of invisible bees. Suddenly, the whole wedding party erupted with laughter, which was the moment I made this image.

From an aesthetic perspective, I love the composition and utilization of the camera's full frame. I could neither predict nor observe what incited the sudden outburst of laughter, so I had to react very quickly to capture the four groomsmen in this arrangement. I love that they are all in different stages of laughter and that they are all visible within the image. I really like the two groomsmen in the foreground, out of focus with the sharpest focus falling on the groomsman in the middle—the one most engrossed in his own amusement.

It's always thrilling to capture strong emotion, but this was a particularly rewarding image to make, given the circumstances that led up to it. Some fancy footwork was

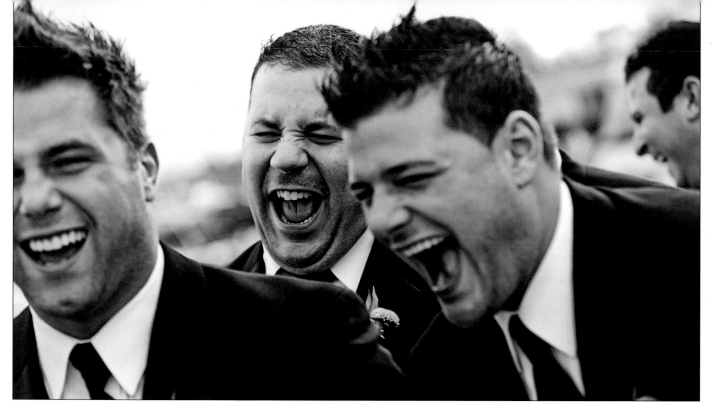

Eric and Elizabeth's wedding.

required, but I was able to maneuver to fit the guffawing groomsmen into the composition for the big payoff.

From a technical perspective, this image was made using my Canon EOS 1Ds Mark III fitted with a Canon 70-200mm f/2.8L IS USM. I captured this image in RAW at ISO 400, shooting at f/4.0 at $1/400$ second. It was made using only available light on an overcast day. I processed this image in Adobe Camera Raw and Photoshop CS4. I increased the blacks in Camera Raw, adjusted the curve for increased contrast, dropped the saturation by 100 percent, then added a slight sepia tone to the overall image. No retouching or cropping was applied to this image.

COURTNEY AND RYAN

Courtney and Ryan were married in historic New Harmony, IN, a rural community situated around the remnants of George Rapp's envisioned utopia. Founded in 1814, and located right off the Wabash River, the town has a distinct and rich history that attracts many soon-to-be wedded couples from the Midwest. The Roofless Church, one of town's most famous architectural landmarks, was the chosen venue for this outdoor ceremony.

I first met with Courtney and Ryan when they came to my Evansville, IN, studio. They had already booked me for their wedding and were interested in having engagement photos made. It was immediately clear that these two shared a very profound and poetic love. Needless to say, I counted the days remaining until their wedding.

Courtney and Ryan were incredibly calm and collected on the day of their wedding, as each of them dressed and prepared in the quiet of their individual rooms. The day was gorgeous; the sun was diffused by patches of pillowy clouds and the oppressive humidity that usually plagues Indiana summers seemed to have held its breath for their special day. In fact, everything was playing out *so* perfectly that I started to feel the presence of doubt biting its nails in the back of my mind.

After finishing the couple's pre-ceremony portraits, we began walking to the Roofless Church where the ceremony was set to begin in fifteen minutes. (It's important to note that the Roofless Church is actually an enclosed courtyard; the architect's concept was that only one roof, the sky, could embrace all worshipping humanity.) I made a few photos of the guests, who had already been seated, then headed to the back of the church. As I stood waiting with Courtney and her bridal party, with three minutes remaining, a sudden storm blew in and doused us with waves of pounding rain.

It was mass hysteria—we literally had nowhere to go, and by the time we sought shelter under the church's central structure, we were completely drenched. After five minutes of deluge, however, the rain relented a bit and Courtney and Ryan decided that the show must go on. Courtney, along with her father, her twin flower girls, and her two maids of honor, gathered under a canopy of umbrellas and made their way down the aisle. While my shoes squished with every step, and I feared that my camera wouldn't fire, I made this image.

Aesthetically, I love this image for its uniqueness, but I like how the varied head heights create a sideways S pattern, helping the eye move through the image. I love the expression on everyone's faces—and that Courtney has the biggest smile. Also, I really enjoy the frozen droplets of rain in the right corner and the slight visual effect caused by the rain on my lens in the left corner.

Technically, this image was captured in RAW using a Nikon D200 fitted with a Nikon 14mm f/2.8. My shutter speed was 1/250 second at f/5.6, shooting at an ISO of 800. I processed the image with Adobe Camera Raw and added only a slight bit fill light. I reduced the image's saturation by 100 percent and added warmth in Photoshop using a color adjustment layer.

ELIZABETH AND BEN

Elizabeth and Ben were married at Christ Episcopal Church in Pittsford, NY. Elizabeth worked in Washington, DC, at the Pentagon, and Ben worked for the Secret Service. You would assume that these two would be strictly business, but they were, in fact, one of my most zany and entertaining couples.

I first discovered just how silly they were when I shot their engagement session. They were interested in replicating the look of a photo booth and wanted to use cue cards for some improvised antics. It's rare to see full-grown adults channel their inner child and let loose, but these two wrote the book on regression.

On their wedding day, however, Elizabeth's nerves started to kick in. We arrived at the church around noon; this is where Liz and her bridesmaids had decided to dress and do final touch-ups to their makeup.

I had never visited this church, but Liz quietly informed me that the minister had upset quite a few family members during the previous evening's rehearsal, informing them that there was a zero tolerance policy in effect regarding *all* photography. Liz was practically in tears, fearing that I wouldn't be allowed to photograph their ceremony. I informed Liz that I would respect her wishes;

Courtney and Ryan's wedding.

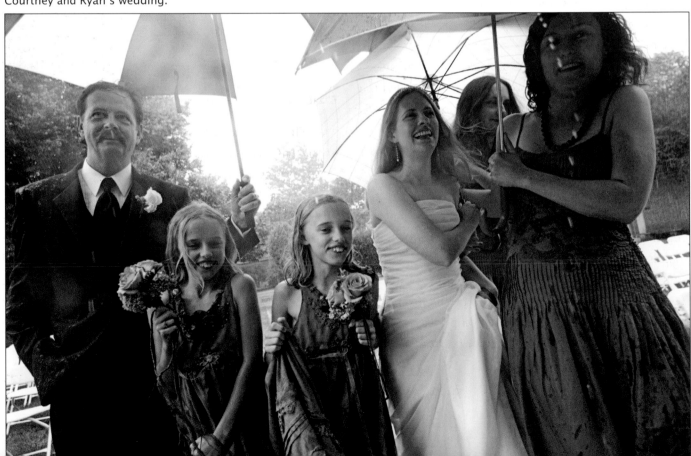

if she wanted me to break the rules and be up front documenting her ceremony, that's where I would be.

Not one minute following our discussion, I was grabbed by the shoulder and shouted at, "Are you the photographer!?" I disregarded the discourteous inquiry and proceeded to photograph Liz as her mother began lacing her dress. The room grew quieter as everyone's attention drifted in the direction of yet another brusque inquisition, "Sir, I am talking to you—lower your camera!"

I quickly made eye contact with Liz. She gave me a nod and I turned around to respond. I thrust my right hand forward and said, "Please excuse me, I try not to dignify such impoliteness with a response—but you seem to be oblivious to social etiquette. How may I help you?"

The minister asked to speak to me in the hallway and I declined. I informed her that I was working and anything she needed to discuss with me she could do so in front of my client. She began to huff and in a stammering voice told me that absolutely *no* photography was allowed during the ceremony. I quickly revisited Liz with my gaze and could see the tears swelling in her eyes; it was clear that she wanted me to stand my ground. I rarely speak so candidly with church officiants, but I stood up, lowered my camera, and simply said, "Liz and Ben are my clients and they have both requested that I disregard the church's no-photo policy—and that's precisely what I plan to do. If you wish to stop me, you will have to call the police and have me forcibly removed for trespassing. I promise: taking such action will turn the whole congregation against you. Furthermore, if I am prevented from documenting my clients' ceremony, I will be sending you an invoice for the remaining balance on their wedding contract."

Everyone in the room returned an affirming grin. After a few snorts and guffaws, the minister said, "If that's how it's going to be, after today, you will be barred from this church." The room slowly started to resume as they began pinning on the veil, but the minister remained standing in the door, scowling at Liz. Sensing the minister's presence, Liz glared back in the officiant's direction. That's the moment when I made this photograph!

Aesthetically, I love the vertical composition and how it frames Liz amidst the three sets of hands pinning her

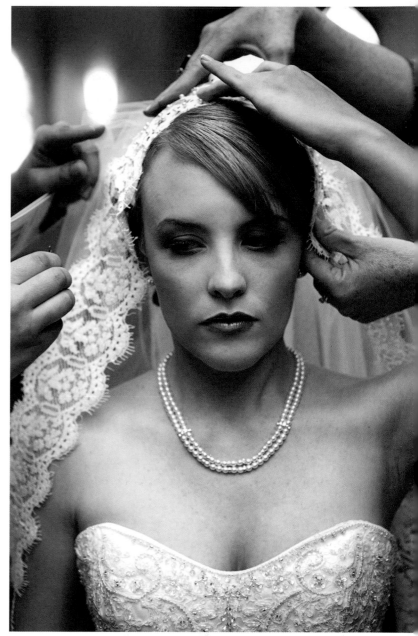

Elizabeth and Ben's wedding.

veil. The combined light from my bounced flash and the room's ambient light creates a soft effect that accentuates every bead, sequin, and subtlety in Liz's expression.

Technically, this image was captured in RAW while shooting with my Canon EOS 1Ds Mark III. The shutter speed was set at $1/160$ second with an aperture of f/4.0 at ISO 800. My flash was aimed upward and back toward the wall behind me. I edited the image in Adobe Camera RAW, where I adjusted the color temperature by adding some magenta, then I added some black and a bit of contrast. Voilà!

CONCLUSION

*P*rior to establishing a successful photography business, and even before I owned a camera, I was making images and collecting moments. In that sense, I have always been impelled by an inexplicable fascination with the visual—specifically people and their relationships with one another.

As a photographer, I have always sought a greater awareness/understanding of my "self," and the world around me through the apprehension of image/moments, which is something I believe to be universal for all visual artists, and especially photographers. I believe it's what connects us all at our core—that insatiable drive to explore, question, critique, and express the self.

I wrote this book in hopes of empowering others by providing a rich and diverse array of resources, and also to encourage and inspire those who possess an entrepreneurial spirit—those who are serious about making a career out of what they love. Above all, I wrote this book hoping to embolden others by sharing my passion and enthusiasm for photography, which really is the most essential ingredient for success in this business.

And, while it is possible for anyone to pick up this text and start booking weddings, achieving true success has much more to do with how you regard yourself and those around you, what kind of person you are and strive to be, rather than how cunning or cutthroat you can be as a businessperson.

So, the advice I wish to end with is that if you love yourself and you love what you do, if you remain loyal to the passions and processes that led you this far, success will surely follow.

> If you remain loyal to the passions and processes that led you this far, success will surely follow.

INDEX

OTHER BOOKS FROM
Amherst Media®

JEFF SMITH'S
Studio Flash Photography

This common-sense approach to strobe lighting shows working photographers how to master solid techniques and tailor their lighting setups to individual subjects. *$34.95 list, 8.5x11, 128p, 150 color images, index, order no. 1928.*

Just One Flash

A PRACTICAL APPROACH TO LIGHTING FOR DIGITAL PHOTOGRAPHY

Rod and Robin Deutschmann

Get down to the basics and create striking images with just one flash. *$34.95 list, 8.5x11, 128p, 180 color images, 30 diagrams, index, order no. 1929.*

WES KRONINGER'S
Lighting Design Techniques

FOR DIGITAL PHOTOGRAPHERS

Design portrait lighting setups that blur the lines between fashion, editorial, and traditional portrait styles. *$34.95 list, 8.5x11, 128p, 80 color images, 60 diagrams, index, order no. 1930.*

CHRISTOPHER GREY'S
Lighting Techniques
for Beauty and Glamour Photography

Create evocative, detailed shots that emphasize your subject's beauty. Grey presents twenty-six varied approaches to classic, elegant, and edgy lighting. *$34.95 list, 8.5x11, 128p, 170 color images, 30 diagrams, index, order no. 1924.*

Photographing Jewish Weddings

Stan Turkel

Learn the key elements of the Jewish wedding ceremony, terms you may encounter, and how to plan your schedule for flawless coverage of the event. *$39.95 list, 8.5x11, 128p, 170 color images, index, order no. 1884.*

UNLEASHING THE RAW POWER OF
Adobe® Camera Raw®

Mark Chen

Digital guru Mark Chen teaches you how to perfect your files for unprecedented results. *$34.95 list, 8.5x11, 128p, 100 color images, 100 screen shots, index, order no. 1925.*

BRETT FLORENS'
Guide to Photographing Weddings

Brett Florens travels the world to shoot weddings for his discerning clients. In this book, you'll learn the artistic and business strategies he uses to remain at the top of his field. *$34.95 list, 8.5x11, 128p, 250 color images, index, order no. 1926.*

Corrective Lighting, Posing & Retouching

FOR DIGITAL PORTRAIT PHOTOGRAPHERS, 3RD ED.

Jeff Smith

Address your subject's perceived physical flaws in the camera room and in postproduction to boost client confidence and sales. *$34.95 list, 8.5x11, 128p, 180 color images, index, order no. 1916.*

Wedding Photography

ADVANCED TECHNIQUES FOR WEDDING PHOTOGRAPHERS

Bill Hurter

The advanced techniques and award-winning images in this book will show you how to achieve photographic genius that will help you win clients for life. *$34.95 list, 8.5x11, 128p, 150 color images, index, order no. 1912.*

Master Posing Guide for Wedding Photographers

Bill Hurter

Learn to create images that make your clients look their very best while still reflecting the spontaneity and joy of the event. *$34.95 list, 8.5x11, 128p, 180 color images and diagrams, index, order no. 1881.*

Professional Wedding Photography

Lou Jacobs Jr.

Explore techniques and images from over a dozen top wedding photographers in this revealing book, taking you behind the scenes and into the minds of the masters. $34.95 list, 8.5x11, 128p, 175 color images, index, order no. 2004.

Creative Wedding Album Design

WITH ADOBE® PHOTOSHOP®

Mark Chen

Master the skills you need to design wedding albums that will elevate your studio above the competition. *$34.95 list, 8.5x11, 128p, 225 color images, index, order no. 1891.*

500 Poses for Photographing Women
Michelle Perkins

A vast assortment of inspiring images, from head-and-shoulders to full-length portraits, and classic to contemporary styles—perfect for when you need a little shot of inspiration to create a new pose. *$34.95 list, 8.5x11, 128p, 500 color images, order no. 1879.*

500 Poses for Photographing Brides
Michelle Perkins

Filled with images by some of the world's best wedding photographers, this book can provide the inspiration you need to spice up your posing or refine your techniques. *$34.95 list, 8.5x11, 128p, 500 color images, index, order no. 1909.*

50 Lighting Setups for Portrait Photographers
Steven H. Begleiter

Filled with unique portraits and lighting diagrams, plus the "recipe" for creating each one, this book is an indispensible resource *$34.95 list, 8.5x11, 128p, 150 color images and diagrams, index, order no. 1872.*

Digital Photography Boot Camp, 2nd Ed.
Kevin Kubota

Based on Kevin Kubota's sell-out workshop series and fully updated with techniques for Adobe Photoshop and Lightroom. A down-and-dirty course for professionals! *$34.95 list, 8.5x11, 128p, 220 color images, index, order no. 1873.*

Sculpting with Light
Allison Earnest

Learn how to design the lighting effect that will best flatter your subject. Studio and location lighting setups are covered in detail with an assortment of helpful variations provided for each shot. *$34.95 list, 8.5x11, 128p, 175 color images, diagrams, index, order no. 1867.*

Step-by-Step Wedding Photography
Damon Tucci

Deliver the images that your clients demand with the tips in this essential book. Tucci shows you how to become more creative, more efficient, and more successful. *$34.95 list, 8.5x11, 128p, 175 color images, index, order no. 1868.*

The Best of Wedding Photojournalism, 2nd Ed.
Bill Hurter

From the pre-wedding preparations to the ceremony and reception, you'll see how professionals identify fleeting moments and capture them in an instant. *$34.95 list, 8.5x11, 128p, 150 color images, index, order no. 1910.*

Existing Light
TECHNIQUES FOR WEDDING AND PORTRAIT PHOTOGRAPHY
Bill Hurter

Learn to work with window light, make the most of outdoor light, and use fluorescent and incandescent light to best effect. *$34.95 list, 8.5x11, 128p, 150 color photos, index, order no. 1858.*

THE KATHLEEN HAWKINS GUIDE TO
Sales and Marketing for Professional Photographers

Create a brand identity that lures clients to your studio, then wows them with great customer service and powerful images. *$34.95 list, 8.5x11, 128p, 175 color images, index, order no. 1862.*

Master Lighting Guide
FOR WEDDING PHOTOGRAPHERS
Bill Hurter

Capture perfect lighting quickly and easily at the ceremony and reception. Includes tips from the pros for lighting individuals, couples, and groups. *$34.95 list, 8.5x11, 128p, 200 color photos, index, order no. 1852.*

MORE PHOTO BOOKS ARE AVAILABLE

Amherst Media®
PO BOX 586
BUFFALO, NY 14226 USA

Individuals: If possible, purchase books from an Amherst Media retailer. Contact us for the dealer nearest you, or visit our web site and use our dealer locater. To order direct, visit our web site, or send a check/money order with a note listing the books you want and your shipping address. All major credit cards are also accepted. For domestic and international shipping rates, please visit our web site or contact us at the numbers listed below. New York state residents add 8.75% sales tax.

Dealers, distributors & colleges: Write, call, or fax to place orders. For price information, contact Amherst Media or an Amherst Media sales representative. Net 30 days.

(800) 622-3278 or (716) 874-4450
Fax: (716) 874-4508

All prices, publication dates, and specifications are subject to change without notice.
Prices are in U.S. dollars. Payment in U.S. funds only.

WWW.AMHERSTMEDIA.COM
FOR A COMPLETE CATALOG OF BOOKS AND ADDITIONAL INFORMATION